Visualizing *the* Web

COMMUNICATIONS

Susan B. Barnes
General Editor

Vol. 1

The Visual Communications series is part
of the Peter Lang Media and Communication list.
Every volume is peer reviewed and meets
the highest quality standards for content and production.

PETER LANG
New York • Washington, D.C./Baltimore • Bern
Frankfurt • Berlin • Brussels • Vienna • Oxford

Visualizing *the* Web

EVALUATING ONLINE DESIGN FROM A VISUAL COMMUNICATION PERSPECTIVE

EDITED BY Sheree Josephson, Susan B. Barnes, & Mark Lipton

PETER LANG

New York • Washington, D.C./Baltimore • Bern
Frankfurt • Berlin • Brussels • Vienna • Oxford

Library of Congress Cataloging-in-Publication Data

Visualizing the Web: evaluating online design from a visual communication
perspective / edited by Sheree Josephson, Susan B. Barnes, Mark Lipton.
p. cm. — (Visual communication; v. 1)
Includes bibliographical references and index.
1. Web site development. 2. Visual analysis. 3. Visual communication.
4. Information visualization. I. Josephson, Sheree. II. Barnes, Susan B.
TK5105.888.V555 006.7—dc22 2010037545
ISBN 978-1-4331-1145-7 (paperback)
ISBN 978-1-4331-1144-0 (hardcover)
ISSN 2153-277X

Bibliographic information published by **Die Deutsche Nationalbibliothek**.
Die Deutsche Nationalbibliothek lists this publication in the "Deutsche
Nationalbibliografie"; detailed bibliographic data is available
on the Internet at http://dnb.d-nb.de/.

The paper in this book meets the guidelines for permanence and durability
of the Committee on Production Guidelines for Book Longevity
of the Council of Library Resources.

© 2010 Peter Lang Publishing, Inc., New York
29 Broadway, 18th floor, New York, NY 10006
www.peterlang.com

Printed in the United States of America

Contents

Acknowledgments

This book was many years in the making. As the field of visual communication emerges as an important area of inquiry in the digital age, it was important for us to select a collection of essays that would stand the test of time. With this in mind, the large number of essay submissions was vetted through a double-blind review, and we thank the many reviewers who offered their views as to what would be valuable to future students of our discipline. In addition, several people read early versions of these collected essays and provided valuable input: Patrick Holland, Suzanne McCullagh, Ian Reilly, Andrew Townsend, Sean Yo, and Marie Radford. In the late stage of the book, Ron Hendricks helped with the formatting and layout. We also want to acknowledge the time of work of Matthew Watson, Lindsay Munro and Barbara Bernstein for their dedication to our project. Our respective universities and departments provided support, and we must acknowledge the help these institutions provided. Mary Savigar, Sophie Appel, Catherine Tung and all of the staff at Peter Lang have our appreciation for making this book a reality. Finally, we want to thank our families for their unending support and love.

Introduction

Visualizing the Web

Sheree Josephson
Susan B. Barnes
Mark Lipton

We all see Web sites—and there are a lot to see. In July 2008 Google search engineers gazed in awe at statistics showing the number of unique URLs on the Web—1 trillion, as in 1,000,000,000,000 (Alpert & Hajaj, 2008), and they reported that the number of Web pages grows by several billion each day. The average U.S.-based Internet user visits more than 80 domains each month, logs about 2,600 page views, and spends just 56 seconds on each Web page (NielsenWire, December 2009). During approximately 64 hours online every month (Nielsen-Wire, December 2009), Web users see a visual landscape filled with eye-popping color, animation, video, photographs, illustrations, graphics, logos, advertising, navigation, headlines, text, hyperlinks, search boxes, and more.

Over the years, a great deal has been learned about how to create, navigate, and map this visual landscape. For example, if you want to learn how to make the number of URLs a trillion-and-one, you will find a wealth of information on the technical and functional aspects of Web site design. If you need advice on navigating or surfing the Web, you can ask almost any teacher, librarian, or even elementary school–age child. As for mapping all this digital information, Google is now on its way to following links for a quadrillion URLs. However, there is a relative lack of literature emphasizing how to analyze the visual and aesthetic aspects of Web page design.

This introduction reviews some of the recent scholarly literature evaluating various visual aspects of Web page design. These studies use a variety of research methodologies and come from varied fields of interest, including graphic design, marketing, journalism, human-computer interaction, information technology, visual perception, and cognition.

The next eight chapters show how Web page design can be analyzed specifically from a *visual communication* perspective. *Visual communication* is an emerging field, which has its roots in and makes its connections to numerous disciplines

concerned with the creation, perception, and interpretation of visual messages. The scholars featured in this volume describe research methodologies in this new transdisciplinary field of *visual communication*. Their work allows us to see the sites from new visual vantage points—metaphorical, cultural, and rhetorical; cognitive, perceptive, and evaluative; and as socially constructed, by the visually literate. Following these eight chapters by visual communication scholars is an interview with Hillman Curtis, one of the foremost Web page designers in the world. His innovative and award-winning work has led critics to confer upon him the moniker of the "Michael Jordan" of Web page design (Handler, 2003). Curtis provides insight into the process of creating Web sites that are both visually pleasing and usable.

Visual Appeal and Aesthetics

Due to the trillion URLs currently found on the Internet, Web page designers have to work hard to grab attention, to stand out. "Attention Web designers: You have 50 milliseconds to make a good first impression!" exclaims the title of a 2006 study (Lindgaard et al., 2006) designed to ascertain how quickly people form an opinion about a Web page's visual appeal. Some researchers (Tractinsky et al., 2006) argue that there may be even less time—as little as 10 milliseconds. These studies suggest that visual appeal and aesthetics factors are detected first when someone opens a Web page. And extreme attractiveness ratings—both positive and negative—appear to be formed faster than moderate evaluations (Tractinsky et al., 2006).

This almost-instantaneous first impression of the visual appeal of Web pages appears to persist, to remain consistent over time. Fernandes (2003) showed participants 100 Web pages for half a second (500 milliseconds), asking them to rate visual appeal on a scale of "very attractive" to "very unattractive." To evaluate the reliability of the ratings, participants repeated the procedure with the same pages in a different random order. Ratings of visual appeal for both viewings were extremely highly reliable.

The opinion that a Web page is extremely appealing may persist even after the user encounters usability problems. One study (Lindgaard & Dudek, 2002) found that participants continued to highly value a Web page that they found to be "extremely" visually pleasing even after they were unable to successfully complete a task. Apparently, the visual enjoyment of a Web page may be strong enough to overcome subsequent experience with that page.

Hartmann, Sutcliffe and de Angeli (2007) suggest how expressive aesthetics can override a user's poor usability experience, determine user satisfaction, and even positively influence content (p. 26). Kim and Fesenmaier (2008) discover "that visually appealing stimuli are the most important tool for converting Web site lookers to users and/or making them stay longer on the Web site" (p. 10). These researchers boldly demonstrate that visually appealing design-related features are primarily what drive people's first impressions of a Web site. Their research findings also clearly identify usability as "the second-most-important driver of first-impression formation, followed by credibility" (p.10).

Research shows that credibility is itself impacted by visual appeal with Web sites possessing higher aesthetic treatment also judged as having higher credibility (Robins & Holmes, 2008). Karvonen (2000) similarly found that beauty and simplicity in Web page design affect viewers' feelings of online trust, concluding that a discussion about Web page quality or even usability is actually a discussion of aesthetics.

However, visual appeal and aesthetics—like beauty—are concepts difficult to define. In the early days of the World Wide Web, Foss (1993) took on this challenge. She said visual appeal is simply what attracts viewers to visual messages, emphasizing that something novel or interesting is required to draw their interest. On a practical level then, Web designers must create pages that move past the ordinary or their work won't get noticed on the Internet with more than a trillion sites to be seen.

A number of researchers are striving to identify some general visual characteristics that may affect the immediate impression of visual appeal. Other researchers are concentrating their efforts to study particular visual practices widely accepted to be aesthetically pleasing or appealing to Web users.

Visual Characteristics and Usability

Lindgaard et al. (2006) asked Web page viewers to offer their opinion on seven general Web design characteristics: simple-complex, interesting-boring, clear-confusing, well designed-poorly designed, good use of color-bad use of color, good layout-bad layout, and imaginative-unimaginative. Only two of the seven characteristics—complexity and clarity—were not highly correlated with visual appeal. Furthermore, Lindgaard et al. found that those five visual characteristics highly correlated with visual appeal were also highly correlated with each other. This line

of research provides a valuable look at the overall characteristics that contribute individually and collectively to make a Web page visually appealing.

More commonly, researchers study what may be termed visual practices. In particular, they investigate how best to use animation, navigation, layout, white space, fonts, and visuals of various kinds. A variety of research methodologies are used in these studies.

Animation has been studied using electrocardiograms and eye trackers. Fang-fang and Shyam (2004) investigated the effects of pop-up windows and animation in banner ads on online users' orienting responses using an electrocardiogram to measure heartbeats per second. They found that pop-up ads elicited stronger orienting responses than banner ads but noted no difference in orienting responses for animated versus static banner ads. Using a paper-and-pencil recall questionnaire, they found that ad recall was higher for pop-ups than banners. In an eye-tracking study, Josephson (2004) concluded that location was more important than animation in determining whether or not Web users look at banner advertisements. Placing an ad on the top of the page as opposed to the bottom dramatically increased the chances that a viewer would pay attention to it. Movement in the banner advertisement only slightly increased the chances it was noticed. Faraday and Sutcliffe (1999) compared four designs of animation in their eye-tracking study. Based on their results, they recommend that contact points or co-references between animation and text should be designed into Web pages.

Originally attributed to Euclid, the Golden Section has been used to achieve visual harmony in many contexts (Stuart, 2006). Now it is being applied to Web page design. The Golden Section helps to determine size, proportion and layout in design projects. It is frequently used to determine the screen ratio—32:68, for example—between the navigation and content areas. Using a computer-controlled experiment where participants completed an information-retrieval task, results showed that the effect of screen ratio (i.e., between the width of the menu area for navigation and the content area that displays information) on task performance and subjective outcomes was statistically significant (van Schaik & Ling, 2003). However, surprisingly, this research demonstrated that the Golden Section as a screen ratio resulted in poor task performance in terms of speed, accuracy, and display quality. Best ratios were 23:77 for speed; 23:77, 28:72 and 33:67 for efficiency; and 28:72 for display quality (van Schaik & Ling, p. 192). From this study, it appears that the most pleasing proportion depends on the purpose of the design.

White space, the empty area between elements in a graphic composition, is an important design tool used to separate and group the parts of a Web site. Howev-

er, most recommendations about white space on the Web do not distinguish the varied uses to which white space can be applied. One study (Zdralek, 2003) found that the amount of white space used in "gutters" did not affect the speed of in-page navigation.

The management of white space and clutter is important to the design of user interfaces and information visualizations, allowing improved usability and aesthetics. Yet, clutter is not a well-defined concept in the layout of Web pages. Rosenholtz et al. (2005) presented a "Feature Congestion" measure of display clutter. This measure is based upon extensive modeling of the saliency of elements of a display, and upon a new operational definition of clutter, emphasizing the two features of color and luminance contrast. Results showed good agreement between observers' rankings and this measure of clutter.

The readability and legibility of typefaces on the Web has been studied by a number of researchers by measuring reading speed and efficiency, by tracking eye movement, and by gauging opinion. Bernard et al. (2002) concluded that the sans serif typeface Verdana is the best choice for onscreen type because it is read fairly quickly, is perceived as being legible, and is the most preferred. Josephson's results (2008) concurred. The font designed specifically to be read onscreen was processed more quickly with fewer regressions or backward eye movements—and it was preferred by the most readers.

The power of pictures in all media, not just the Web, is widely accepted. In a study of use of pictures in an Internet news magazine, Knobloch, Zillmann and Callison (2003) found viewers were more likely to read articles associated with "threatening" rather than with "innocuous" images, and they were likely to spend more time with those articles. In addition, articles without images received the least amount of selective reading. In an eye-tracking study by the Poynter Institute (2007), researchers found that large photos and documentary photographs drew more eyes than small photos or staged pictures. Poynter's results also showed navigation was the first stop for online readers.

To study Web navigation, Sorrows (2006) asked participants to recall from memory possible navigation paths and URLs. Results validate a theory that three types of characteristics—visual, structural, and semantic—are important for effective landmarks on a Web site. Two measures of landmark quality were used to examine the characteristics of landmarks: one, an algorithm that incorporated objective measures of the visual, structural, and semantic characteristics of each Web page; and the second, a measure based on the experimental data regarding

subjects' knowledge and evaluation of the page. Significant positive correlations were found between the objective and subjective landmark measures.

Another study (Zimmerman & Walls, 2000) reported preliminary analyses of research designed to compare the navigational patterns users follow on Web pages organized in Web structure and Web pages organized in hierarchical structure. The results suggest no significant differences in participants' perceptions of the navigation of the sites and the sites' ease of use.

The evaluation of these various visual characteristics and the production of well-designed pages have become important discussion topics in the literature of Web page design. In the field of human-computer interaction, researchers (e.g., de Marsico & Levialdi, 2004; Strain & Berry, 1996) argue there is much to be gained by understanding users' expectations and experiences in navigating this digital world, an approach that might be termed user-empowered design. Singh, Dalal, and Spears (2005) concluded that to design aesthetically pleasing and effective Web pages, it is necessary to account for the fundamental drivers of users' perception of Web pages. They proposed a theoretical framework to measure the users' reactions to home pages, an approach they hope can serve as a guide to Web page design along with heuristic and intuitive approaches. Similarly, researchers such as Park, Choi, and Kim (2004) have compared users' needs and designers' desires, finding that users do not always experience the kinds of impressions that designers intend to convey through their Web pages.

In a related line of user-related research, Park (2007) seeks to define some fundamental characteristics of design for the online experience by looking to examples where online participation is both immersive and empowering for the Web viewer. Park's work draws on principles of co-creation from "Net art" and the capacity of users to create alternative identities and experimental modes of being. It seeks to identify those characteristics that make online experiences truly compelling, re-conceptualizing the relationship between user experience, interaction processes, and design elements. This research contributes to the field of Web design by offering a conceptualization of the user experience that escapes the current limitations of both graphic design, which is focused on the visual, and usability design, which is focused on functionality.

Visual Characteristics and Interactivity

An important characteristic of functionality is interactivity because the interaction between Web site and user is what makes a site successful. Steuer's (1992)

definition of interactivity is "the extent to which users can participate in modifying the form and content of a mediated environment in real time" (p. 84). Liu and Shrum (2002) explored the definition and influence of interactivity on advertising. They describe three aspects of interaction, which include user-machine, user-user, and user-message. Barnes (2003) agrees with these three aspects; however, she defines them as human-computer interaction, interpersonal interaction, and information interaction.

A number of communication scholars (Kiousis, 2002; Mcmillan, 2002; Richards, 2006; and Sundar, Kalyanaraman, & Brown, 2003) have researched the topic of interactivity. Mcmillan (2002) developed a four-part model of cyber-interactivity. The model includes feedback, mutual discourse, monologue, and responsive dialogues. These elements are designed as a heuristic device to help Web designers think about their creative process. One aspect of the method, for example, describes how designers might increase feedback opportunities by increasing participants' level of control over the communication process (p. 285). Feedback is also discussed by Kiousis (2002). He believes that feedback or the ability for receivers of messages to respond to senders is a major component of many interactivity conceptions, saying "Communication is seen as a dynamic, interdependent process between senders and receivers" (p. 359). In addition to sending and receiving messages, Richards (2006) examines the generation aspect of interactivity. Instead of viewing interactivity as a communication process, Richards explores the activity of interactivity and the production of interactive products, today called user-generated content.

Business scholars have researched many aspects of interactivity. Shaw (2001) examined the relationship between interactivity and stickiness in Web sites, saying "Stickiness involves retaining users and driving them into the site" (Shaw, 2001, p. 4). She analyzed the differences between .com and "not.com" Web sites. The relationship between the user and marketing Web sites (.com) is a topic of great interest to business scholars. Others who have done research in this area are Hoffman and Novak (1997); Ko, Cho, and Roberts (2005); Liu and Shrum (2002); and Sicilia, Ruiz and Munuera (2005). In marketing, interaction is researched to better understand how users are searching and retrieving information.

Visual Search and Information Retrieval

Various visual characteristics—especially color, layout, motion, and fonts—have been studied extensively in regard to visual search of Web pages. In addition, cha-

racteristics of the Web users—especially age differences—factor prominently into some studies on search behavior. Finally, usability research often focuses on how to make pages more "friendly" so that users can quickly accomplish their tasks or find the information they are seeking.

In a study that varied color combinations on six mock Web designs, the perceived attractiveness of the page as determined by users was found to have a statistically significant effect on their perseverance with the search task (Nakarada-Kordic & Lobb, 2005). In another study, pages with higher contrast between text and background color led to faster searching and were rated more favorably by visual searchers (Ling & van Schaik, 2002). Research (van Schaik & Ling, 2001) examining the effect of background contrast combined with frame layout showed an effect of layout both on accuracy and speed measures with frames located at the top left of the screen leading to better performance. While no main effect of contrast was found in this study, there was an interaction between layout and contrast in reaction time.

In an eye-tracking study using realistic Web pages (Grier, 2004), participants searched for specific targets, but neither motion nor position dominated target detection or gaze behavior. In another eye-movement study, this one evaluating specific design features for a prototype Web portal application (Goldberg et al., 2002), researchers found a preference for horizontal over vertical search and that header bars are not reliably visited or used for navigation cues.

Link colors and format have also been commonly studied in visual search studies. Ling and van Schaik (2004) investigated whether there is an effect of link format on speed and accuracy of visual search in both the navigation and content areas of Web pages. The format of links was found to affect the speed of visual search in both areas, but not accuracy. Participants expressed the highest preference for bold and underlined links, regardless of screen area. Pearson and van Schaik (2003) concluded that the design convention of blue links should be retained because responses for blue were found to be significantly quicker than red. An effect of presentation position was also found, with support for menus on the left or right with evidence that Web users might have formed automatic attention responses to specific Web page designs. Halverson and Hornof (2004) conducted a study offering empirical support for the design recommendation to differentiate visited and unvisited links by color.

Line length, alignment, and font have all been studied in regards to information retrieval in Web pages. Varying text presentation has been found to have a significant effect on task performance with wider line spacing and left alignment

leading to better accuracy and faster reaction times (Ling & van Schaik, 2007), longer line lengths facilitating better scanning, and shorter line lengths leading to better subjective outcomes (Ling & van Schaik, 2006).

The intersection of visual and semantic properties has been another popular topic for scholars studying visual search on Web pages. One study showed how the visual salience of items interacts with semantic cues about the usefulness of the distal sources of information (Tomborello & Byrne, 2005). Another showed that not only does visual discriminability play a role in target detection during search but also that the semantic relatedness between the target and distractor affects detection.

How the age of Internet users affects search on Web pages has been studied by several researchers. Reaction time, eye movements, and errors were measured during visual search of Web pages to determine age-related differences in performance as a function of link size, link number, link location, and clutter (Grahame, La-berge, & Scialfa, 2004). Increased link size from 10- to 12-point improved performance, whereas increased clutter and number of links hampered search, especially for older adults. Results also showed that links located in the left region of the page were found most easily. In another eye-movement study on the effects of age, Josephson and Holmes (2004) found preliminary evidence that older adults who are avid Internet users are able to rapidly and accurately find information, while children who have never known a world without the Web don't behave all that much differently from teens or adults who performed the task most efficiently.

Bing et al. (2004) used eye-movement measures to explore whether individual differences of subjects as well as Web site complexity and page order of viewing impacted ocular behavior. Results indicated gender differences and page-order differences. A scanpath analysis (simply put, the path our eyes follow when looking at an image) revealed that the complexity of Web page design influences the degree of scanpath variation among different subjects on the same Web page.

Search is often used to determine the usability of a Web site, but other tasks may be used as well. Russell (2005) measured users' eye movements while they completed a series of tasks on one of three e-commerce Web sites. This study found a high level of agreement in eye-tracking measures and traditional usability performance measures. For example, the number of fixations correlated to time spent on task.

The usability of Web sites displayed and viewed on smaller and smaller screens is becoming an increasingly important issue. With the increase in personal digital assistants (PDAs) and cell phone ownership and a rise of wireless services,

Web users are increasingly browsing the Internet on palm-sized screens. However, the tiny screens of mobile devices limit the usability of information browsing and searching. Researchers (e.g., Ahmadi & Kong, 2008) are working on methods to adapt a desktop presentation of visual information to a mobile presentation. Ahmadi and Kong's work analyzes both the document object model (DOM) structure and the visual layout to divide original Web pages into several subpages, each of which includes closely related content and is suitable for display on small screens.

Visual Information Processing

It's one thing to find information on a Web page, but another to visually process it. Visual information processing is the ability to recognize, interpret, understand, and recall what is seen in order to integrate that information with other sensory information and past experience in order to act appropriately on the environment—in this case, the Web. Visual information processing is impacted by a person's ability to distinguish visual similarities and differences and figure from ground, to fill in partially complete visual information, to realize visual form constancy when objects are shown in various orientations, to perceive spatial relationships and visual sequence, among other things.

Some authors (e.g., Marks & Dulaney, 1998) present a number of principles of visual information processing relevant to the design of Web pages in the hopes that such principles will aid designers in developing Web pages that are easy to search and browse and that promote interaction. Some of the topics discussed are distal and proximal stimuli, data-driven processing and conceptually driven processing in perception, sensory constraints on perception (contrast sensitivity and spatial frequency, perceiving and depicting depth and distance), and organizational principles in visual information processing (pattern recognition, the role of scene context in object recognition, the role of context in word recognition, perceptual processes in reading, attention and visual search processes).

The phrase to describe the "organizational principles in visual information processing" mentioned above is the Gestalt effect. The Gestalt effect has to do with the form-forming capability of the visual sense such that figures and wholes are perceived, instead of simple lines and curves. Hsiao and Chou's (2006) work specifically looked at this theory. After experimental research, they proposed a perceptual measure combining Gestalt grouping principles and "fuzzy entropy" to determine the Gestalt-like perceptual degrees for home-page design.

On the Web, problems with visual information processing can interfere with visual performance, the ability to sustain visual attention, and the ability to comprehend and manipulate visual information.

Visual Attention

Visual attention is the orienting of attention to specific kinds of Web content on a page. Eye-tracking studies are a popular way to study what Web page viewers look at as they make their way through visual imagery on the Internet.

Faraday (2000) proposed a model of how users search for information on Web pages that emphasizes Salient Visual Elements (SVEs), which capture attention and draw the eyes to them. The six SVEs most likely to determine the first fixation on a Web page in hierarchical order of importance are motion, size, image, color, text style, and position. Once Web viewers select an entry point, Faraday asserts, they employ Gestalt grouping principles to define the boundaries of the area surrounding the entry point and then scan that area in the normal reading order of the native language. In a later eye-tracking study, Faraday (2001) explored how visual information is viewed on a Web page. He found that larger text was dominant over small, bold and hypertext links were looked at longer than normal text, and when text and images were of similar size that text was more likely to be an entry point.

To track how attention is shifted as viewers look at a Web page, Josephson and Holmes (2002) tested the somewhat controversial and often-discussed theory of visual perception—that of scanpaths. In 1971, Noton and Stark (1971) defined "scanpaths" as repetitive sequences of fixations and saccades that occur upon re-exposure to a visual stimulus, facilitating recognition of that stimulus. Support was found for this theory. Josephson and Holmes (2002) found a statistically significant main effect for cross-viewing comparisons, reflecting a linear trend in which eye paths across a visual stimulus became more alike over time as the same Web user repeatedly viewed the image.

Visual Rhetoric

In addition to visual aesthetics, usability, and the interactivity of Web pages, many designers and scholars are considering the rhetorical effectiveness of Web designs. They are realizing how important it is to effectively communicate the intended message of the designer to the viewer. Ingram (2006), who focused her research on

evaluating the rhetorical effectiveness of higher education Web-page design, claimed that the challenge in creating rhetorically effective Web pages emerged because of the rapid lateral diffusion of HTML, which left a void in theoretical knowledge of Web-page design based on principles of human communication.

Zimmerman (1999) argued that the addition of the rhetorical perspective is critical to the understanding of visual images, including Web pages. She said this perspective should be added to Lester's (2005) six analytical perspectives—personal, historical, technical, ethical, cultural, and critical—essential to an understanding of visual images. In her opinion, only by adding this additional perspective—the rhetorical perspective—can we better analyze and understand Web pages. Sullivan (2001) called for "safe visual rhetoric" to be practiced on the World Wide Web. She discussed the differing concerns and aims that arise from visual design traditions that focus on "prose graphics" versus those that focus on "theatrical graphics," those that really persuade.

Welch (1999) examined the study of rhetoric in terms of electronic media. She identifies nine oral features of electronic rhetoric that can be applied to the Web. The features are: (1) the Web is additive rather than subordinate; (2) the Web is aggregative instead of analytic; (3) the Web is redundant; (4) the Web is conservative; (5) the Web is close to the human lifeworld; (6) the Web is agonistically toned, (7) the Web is participatory instead of objectively distanced; (8) the Web is homeostatic; (9) and the Web is situational rather than abstract. Training in electronic rhetoric involves both visual and verbal abilities. Barnes (2003) said, "By exploring both the content and visual design, Web users can begin to identify the persuasive techniques used by website creators" (p. 111). Welch's electronic rhetoric attempts to make users aware of the persuasive process used in Web sites. One persuasive technique often used in Web sites is visual metaphor.

Visual Metaphor

Kaplan (1990) contends, "In addition to fostering understanding, metaphors serve a rhetorical function by directing attention to some aspects and qualities of objects and minimizing or masking other features" (p. 44). One of the ways pictures, graphics, icons, and other visual images communicate and summarize information is through known visual symbolic connections. Willis (1999) explained that pictures can be used in Web design to present the main content of the Web message in condensed quick-reference visual shorthand, which offers visual metaphors to help cue general references in the viewer's memory. This cueing gives the viewer

help with immediate understanding of the presented information and memory storage for retrieval when the viewer wants to search the Web for this information again. Techniques for generating, recognizing, and visualizing structure that could be used to help ease the complexity in the design of Web sites was proposed by Joyce et al. (1996).

Techniques of visual metaphor are integrated into the computer-mediated experience. Since the first use of the desktop metaphor by Xerox Parc and Apple (Barnes, 2002), metaphors have been part of the user experience. First through human-computer interaction and later in computer-mediated communication, metaphors have helped users to conceptualize computer and Internet spaces. For example, the use of the room metaphor in chat rooms helps to make people think they are talking to someone, rather than writing. Other metaphors include e-mail to conceptualize sending a written letter or message, and the discussion list to foster the idea of sharing ideas with others. Metaphors support the visual thinking process and help people to perceive cyberspace.

Visual Thinking and Mental Models

Complexity of design in Web sites raises the issue of visual thinking. In 1954 Arnheim wrote the book *Art and Visual Perception*. Since that time, a number of scholars have conducted research on visual reasoning and visual cognition. Two examples are Gardner's (1982) *Art Mind and Brain: A Cognitive Approach to Creativity* and Barry's (1997) *Visual Intelligence*. Both of these authors utilize a cognitive approach to explore visual thinking skills.

Similarly, Glenberg (2002) uses a cognitive approach to explore text and images on computers. He relates the abstract symbols of words to the "perceptual symbols" of objects that we see. Comprehending symbols is often "based on perceptual details relevant to forming the symbolic form of experience" (p. 33). Mental images in this context are perceptual images that add meaning to the symbols, often words, being presented. His theory helps designers mesh text and images together. In contrast, Marsh and White (2003) developed a taxonomy of relationships between words and images for Web designers, saying, "The taxonomy develops a common, standardized language for expressing relationships between images and text" (p. 662). Understanding how to present image and text together is an important aspect of Web design.

In a marketing context, Stern, Zinkhan, and Holbrook (2002) created the Netvertising Image Communication Model (NICM), which "reflects the transi-

tional process by which organized stimulus imagery leads to perceiver construction of mental images" (p. 16). The model modified attributes from historical sources to fit the Internet environment. These include "(1) media representation; (2) number of message elements, multiple sensory inputs (words, pictures, movement, sound); (3) nature of message elements, vividness (concrete expressions); (4) format, 'edutainment' (information and entertainment); (5) consumer response, mental picture, and (6) behavioral responses in the marketplace" (p. 19). Their goal is to better understand how stimulus imagery leads to the construction of mental imagery.

In addition to mental imagery, designers also need to be aware of mental models when designing Web pages. Licklider and Taylor introduced the concept of mental models in 1968. They argued that mental models were necessary in computer-mediated communication for people to understand the communication task they were performing. Barnes (2003) explained, "Mental models are the models that people have of themselves, others, the environment, and objects, with which they interact" (p. 15). We use mental models in computer-based communication to better understand the context of the communication. In Web design, mental models are constructed by the designer when he or she frames the Web site as a game, newspaper, or entertainment site. The overall concept for the site helps to establish the mental model.

However, understanding these models can change based on the cultural background of individuals.

Visual and Cultural

As the Internet continues to expand, its content becomes increasingly diverse. A 2002 survey of Web pages ("Internet statistics," n.d.) determined that by far most content was in English (56.4%). The next most popular content was in German (7.7%), French (5.6%), and Japanese (4.9%). A more recent study documented Web searches were being done in 75 languages (Gulli & Signorini, 2005). As Web pages have appeared in more and more languages, studies about cultural and language differences have emerged.

One study (Rau, Qin, & Jie, 2007) investigated the effect of visually rich Chinese Web portals and floating animations on visual search between Chinese users and German users. Results indicated that participants using simple Web portals searched faster, made fewer errors and were more satisfied than participants using the portals filled with a huge amount of information and excessive visual stimuli.

People searching pages with randomly floating animations were found to use significantly more time compared with those searching pages with no animations. Noiwana and Norciob (2006) investigated, in an experimental study, the effects of animated graphic colors on attention and perceived usability of users. Participants searched for target words from text on Web pages containing three animated banner graphics. The results from this study suggested that there are possible cultural differences in interacting with a computer interface.

In a study evaluating the differences in visual components of the design of 900 university Web sites from 45 countries and regions, Callahan (2007) asked this question: Does the design of user interfaces vary across cultures? And if differences in interface design exist across cultures, could they be measured using Hofstede's (2001) five dimensions of culture: power distance, individualism/collectivism, masculinity/femininity, uncertainty avoidance, and long-/short-time orientation. Using content analysis on page layout, directionality, symmetry, length, and color scheme, as well as the presence of news and search engines, results showed significant differences across countries with the exception of page symmetry and centralization. In terms of Hofstede's dimensions, significant correlations were found for the dimensions of power distance and individualism/collectivism.

A cross-language study (Parush et al., 2005) investigated interactions among four visual layout factors in Web page design—quantity of links, alignment, grouping indications, and density—in two experiments, one with pages in Hebrew, entailing right-to-left reading, and the other with English pages, entailing left-to-right reading. Some performance patterns measured by search times and eye movements were similar between languages. Overall, performance was poor in pages with many links and variable densities.

Visual Remediation and Evolution

Another new and rich area of Web-page design research centers on the concepts of visual remediation and the evolution of the Web. Bolter and Grusin (2000) offer a theory of mediation for the digital age that challenges the assumption that digital technologies such as the World Wide Web must divorce themselves from earlier media for a new set of aesthetic and cultural principles. They argue that new visual media achieve their cultural significance by paying homage to and by rivaling and refashioning earlier media, and call this refashioning "remediation." In the case of the Web, Bolter (2000) says it refashions almost every previous visual and textual medium.

Cooke (2001, 2005) conducted several studies using the theory of remediation as a framework. In one study (2001), she analyzed the visual dimensions of news by tracing the interaction of its formal design qualities in print, television, and the Web. Design trends that emerged from this study demonstrate that each medium not only adapts the basic structural navigation and graphical elements of earlier document design, but also influences the visual rhetoric of the other media. The implications for design on the Web include using the modular structure that the news media favors in order to enhance the visual relationship between text and graphic elements, providing more "windows of entry" for users to ease non-linear approaches to documentation, using hypertext-like navigation design elements to help users locate related information, and including graphic elements to aid users who scan for information. In her more recent study, Cooke (2005) explored the longitudinal visual development of five major newspapers, seven networks and cable news programs, and 12 Web sites, finding that a visual convergence of media has become more pronounced over the decades as the acceleration of information has increased over time.

In another longitudinal study of the evolution of Web site design patterns, Ivory and Megraw (2005) analyzed more than150 quantitative measures of interface aspects for 22,000 pages and more than 1,500 sites that received ratings from Internet professionals. They demonstrated that Web site design is a "moving target" (p. 493). Since 2000 many Web pages contradict heuristics from the literature with greater numbers and types of links, more graphical ads, changes in color usage, and in other design practices.

Visual Automated Analysis

The above-mentioned study by Ivory and Megraw (2005) is one in recent years utilizing automated analysis tools to analyze visual aspects of Web pages. Their tool—WebTango—uses quantitative measures, empirical data to develop guidelines, and profiles as a comparison basis. Their approach makes it possible to conduct "context-sensitive analysis" such as the site's genre or the page's style. Sheffield Hallam University has also developed a graphical identity support tool (GIST), which works like robots or spiders used by search engines such as Google, but instead of crawling sites for text content, it takes a thumbnail grab of each Web page and analyzes the visual content (Harwood, 2005). This tool is being used to analyze the visual appearance of Web sites to ensure brand and design consistency. Faraday (2000) has automated the process of visually critiquing Web

pages via visual hierarchy rules to gain a greater understanding of what "good Web page design" means.

Visual Prediction

Some researchers have used quantitative analyses to make predictions about how viewers will look at and rate Web pages. Ivory, Sinha, and Hearst (2001) reported that page-level metrics, including overall page characteristics, predicted whether experts would highly or poorly rate a site, with accuracies ranging from 67 to 80 percent. A year later, they (Ivory & Hearst, 2002) extended this work with a much larger set of measures (157 versus 11), over a much larger collection of pages (5,300 versus 1,900), achieving much higher overall accuracy (94 percent on average) when contrasting good, average, and poor pages. They also created statistical profiles of good sites, and applied them to an existing design, showing how that design could be changed to better match high-quality designs.

Some of the same researchers involved in the studies described above (i.e., Sinha et al., 2001) were involved in an empirical analysis of criteria for award-winning Web sites. They examined the Webby Awards 2000 database to understand which factors distinguish highly rated Web sites from those that receive poor ratings. For the 2000 awards, the Web sites were categorized into 27 topical categories, and experts were recruited for each of these topic areas. The 3,000 Web sites were rated according to visual design, content, structure and navigation, functionality, interactivity, and overall experience. The authors found that the content criterion was by far the best predictor of the overall experience criterion, while the visual criterion was the worst predictor of the overall experience.

Researchers have developed many criteria to determine whether or not a Web site uses "good" or "bad" design. This volume adds to the many research studies discussed above by focusing on the *visual communication* perspective. It describes many different *visual communication* approaches to the study of Web design.

This Volume

The volume contains eight chapters each outlining a separate methodology for evaluating imagery on the Internet from a visual communication perspective as well as an interview with Hillman Curtis, one of the premier Web page designers. Rhetoric, remediation, eye tracking, visual culture, visual literacy, cognition, and usability are all discussed to demonstrate the multidisciplinary nature of *visual*

communication. These diverse research styles use both qualitative and quantitative approaches to their studies.

Sally Gill (Chapter One) uses concepts of remediation to conduct a metaphorical analysis of the Web. She opens this volume with an argument that the Web has evolved from a textual medium to a visual and spatial one. She states that the page metaphor is no longer applicable to the Internet, stating that "Web pages"—text-heavy, vertical scrolling electronic documents—have been replaced by "Web spaces"—media-rich screens where people interact with each other and engage in a variety of activities. Prompted by the desire to create onscreen Web *spaces* rather than Web *pages*, communication designers with backgrounds in art and design draw upon visual and spatial metaphors borrowed from architecture and CD-ROM design. Their terminology—portal, site, site map, image map, information architecture, navigation, browser window—is now part of the Web lexicon. Gill argues that as we observe shifts in creative practice, it is important and appropriate to re-examine the language we use to guide, describe, and analyze that practice. She concludes that Web pages will continue to have a place on the Web, but the page as dominant metaphor no longer provides an accurate conceptual model for either users or designers.

Susanna Paasonen (Chapter Two) situates her discussion of Web sites in the framework of visual media culture—specifically in the histories of the visual practices that precede and run parallel to the development of the Web as a visual medium. She points out that while Web design is a young profession and Web aesthetics have only a brief history, Web graphics appear less novel when considered in the context of earlier visual practices such as print graphics, cartoons, photographs, digital imaging, animation, cinematography, and television. Situating Web visuals in a graphic continuum, Paasonen argues, need not lead to the aesthetic, technological, or historical reduction of Web aesthetics to visual conventions already introduced and circulated in other media. Rather, Paasonen sees historical frames of interpretation as essential to a contextual understanding of how Web visuals develop, how they are used, and how they become situated within broader visual media culture. This contextual understanding of Web aesthetics and visual rhetoric is necessary to understand the development of the Web as a visual communication medium.

Valerie V. Peterson (Chapter Three) makes an argument for using a rhetorical approach—specifically an elemental rhetorical schema—to analyze the visual and spatial medium of the Web. However, while visual rhetorical analysis usually begins the task of visual criticism by identifying *the image*, Peterson's schema begins

the critical task by assessing visual *elements*. She believes this shift in approach avoids many pitfalls—primarily the complexity of perception where vision is not a simple matter of image identification but a matter of piecing together various visual elements. Furthermore, Peterson believes the elemental rhetorical approach appropriately recognizes the postmodern characteristics of Web visuals— fragmented, polymorphous (shape-shifting), polyvocal (many-voiced), and often without explicit or identifiable authors or purposes, or with multiple authors or purposes. According to Peterson, postmodern characteristics are typically overlooked in more traditional rhetorical analysis of Web site visuals.

Craig Baehr (Chapter Four) says the cognitive aspect—how readers think both visually and spatially—has largely been ignored in Web-based environments. His use of the term Web environment (not unlike Gill's Web space metaphor) is purposeful, as he maintains that viewers respond in similar ways to visual stimuli on the Web and visual stimuli in the environment, as suggested by both Gestalt theory and visual thinking. One thing Baehr recommends is that designers realize the user's interpretation goes beyond the perception of the individual visual objects and extends to their spatial configurations on the screen. He also encourages designers to visualize the paths viewers will take as they navigate through Web space. Baehr argues that heuristics for Web site analysis and design require a more complex understanding of user perception and thought than most Web designers are currently employing. A proper understanding of Web sites involves how users think both visually and spatially in solving problems, interacting, and forming concepts about how visual and textual content relate in a site. According to Baehr, only when heuristics are applied that consider these approaches in Web design, will the visual and spatial thinking needs of users be met.

Sheree Josephson (Chapter Five) discusses eye-tracking research as a means of measuring what *elements* are viewed and what *path* is followed as the eyes navigate the Web environment. The eyes are always on the move, making two to five brief stops every second. These quick eye movements, which largely go unnoticed in everyday experience, are necessary for a physiological reason. Detailed visual information can only be obtained through the fovea, the small central area of the retina that has the highest number of photoreceptors. During a fixation, only a small area of the available visual information is selected at any time for intensive processing essential to perception of detail. Josephson discusses how eye-movement apparatuses can record eye-fixation location and duration, as well as scanpath information. She also describes a number of data analysis techniques used to analyze eye-movement data in order to give researchers a glimpse into what

is happening in the brain as a viewer perceives and processes visual imagery on the Web.

While eye-tracking research could be used to evaluate the usability of a Web site, it is just one approach that could be used to look at the visual landscape. Roxanne O'Connell (Chapter Six) proposes a number of usability evaluation methods, including those designed to analyze prototypes and functions throughout the design process, and those used to analyze existing Web sites for improvement and/or socio-technical study. However, O'Connell points out that since the mid-1990s millions of Web sites have launched, largely without any user testing. As a result, she says the Webscape has become littered with confusing and unusable interfaces. According to O'Connell, "Until now, the Web has been a rapidly growing metropolis with no city planning, ordinances, or zoning. The result is often bad or inadequate signage, traffic jams at every intersection, time wasted, mounting frustration, and an overall lack of enthusiasm for making the trip into town." O'Connell's usability evaluation methods help to ensure the trip is worth it. Her step-by-step suggestions are helpful for either design or research, but many are useful for both.

Ulla Bunz and Juliann Cortese (Chapter Seven) discuss in detail one particular usability study with a method designed to elicit terminology, descriptions, and factors from people's use of Web sites—in their own words. Bunz and Cortese believe usability is socially constructed when users interact with a Web site and meaning is created. Specifically, the study asked two research questions: What personal criteria do Web users apply to assess a Web site? and Do Web site criteria perceived positively by subjects match those criteria advocated by the usability literature? Results showed that many of the criteria identified by the Web users were similar to the ones defined in the literature although Web users did not seem aware that they were using formal criteria but instead relying on personal opinions. However, differences emerged when Web users ranked sites based on their experience and then evaluated the same sites based on a usability scale. Results showed that as long as a Web site reaches a certain level of usability, people can make do with it—and may actually enjoy the experience.

Finally, Susan B. Barnes (Chapter Eight) argues that Web users must become visually literate in the new languages—for example, hypertext—introduced into the communicative process by this new medium. Since few visual or verbal symbolic codes, including those used on the Web, have meaning in themselves, users must learn meaning through formal education, exposure to media messages, and interaction with others. Barnes presents a number of critical questions—about

design, usability, and navigation—for Web users to consider when conducting a visual analysis of a Web site. Barnes believes that an awareness of the visual design issues illuminated by these questions combined with some common sense will enable people to better understand how Web sites convey visual messages to users. As the Web becomes a more mainstream medium, users need to develop a set of critical visual skills to understand how Web images can be used to facilitate navigation, manipulate feelings, and persuade viewers to think and feel in certain ways. In Barnes' words, users must become visually literate.

These chapters provide diverse approaches to the examination of visual imagery on Web sites—from the qualitative approach used to understand visual literacy to the quantitative use of eye-tracking equipment. *Visual communication* is a diverse field of study, and we hope that these examples will broaden the discipline and inspire new research to analyze the 1 trillion-plus Web pages. This visual landscape filled with eye-popping color, animation, video, photographs, illustrations, graphics, logos, advertising, navigation, headlines, text, hyperlinks, search boxes, and more is ready to be analyzed from a *visual communication* perspective.

References

Ahmadi, H., & Kong, J. (2008). Efficient Web browsing on small screens. *Proceedings of the Working Conference on Advanced Visual Interfaces*, (pp. 23-30). Italy: Napoli.

Alpert, J., & Hajaj, N. (2008, July 25). We knew the web was big. Retrieved May 6, 2009, from http://googleblog.blogspot.com/2008/07/we-knew-web-was-big.html

Arnheim, R. (1954). *Art and visual perception*. Berkeley, CA: University of California Press.

Barry, A. S. (1997). *Visual intelligence*. Albany, NY: State University of New York Press.

Barnes, S. B. (2002). The development of graphical user interfaces and their influence on the future of human-computer interaction. *Explorations in Media Ecology*, 1(2), 81-95.

Barnes, S. B. (2003). *Computer-mediated communication: Human-to-human communication across the Internet*. Boston, MA: Allyn & Bacon.

Bernard, M. L., Lida, B., Riley, S., Hackler, T., & Janzen, K. (2002). A comparison of popular online fonts: Which size and type is best? *Usability News*, January, 4(1).

Bing, P., Hembrooke, H. A., Gay, G. K., Granka, L. A., Feusner, M. K., & Newman, J. K. (2004). The determinants of Web page viewing behavior: An eye-tracking study. *Proceedings of ETRA 2004: Eye Tracking Research & Applications Symposium 2004*, (pp. 147-154). Texas: San Antonio.

Bolter, J. D. (2000). Remediation and the desire for immediacy. *Convergence*, 6(1), 62-71.

Bolter, J. D., & Grusin, R. (2000). *Remediation: Understanding new media*. Boston: MIT Press.

Callahan, E. (2007). Cultural differences in the design of human-computer interfaces: A multinational study of university Web sites. *Dissertation Abstracts International*, 68(07A), 2703.

Cooke, L. M. (2005). A visual convergence of print, television, and the Internet: Charting 40 years of design change in news presentation. *New Media & Society*, 7(1), 22-46.

Cooke, L. M. (2001). Remediation and the visual evolution of design. *Dissertation Abstracts International*, 62(06A), 1973.

deMarsico, M., & Levialdi, S. (2004). Evaluating Web sites: Exploiting users' expectations. *International Journal of Human-Computer Studies*, 60(3), 381-416.

Fangfang, D., & Shyam, S. (2004). Orienting response and memory for Web advertisements: Exploring effects of pop-up window and animation. *Communication Research*, 31, 537-567.

Faraday, P. (2001). Attending to Web pages. *Proceedings of Computer-Human Interaction 2001*, (pp. 159-160).

Faraday, P. (2000). Visually critiquing Web pages. *Proceedings of the Sixth Conference on Human Factors & the Web*. Retrieved September 16, 2005, from http://www.tri.sbc.com/hfweb/faraday/FARADAY.HTM

Faraday, P., & Sutcliffe, A. (1999). Authoring animated Web pages using 'contact points.' *Proceedings of the SIGCHI Conference on Human Factors in Computing Systems: The CHI is the Limit* (pp. 458-465).

Fernandes, G. J. (2003). Judging Web page visual appeal. MAI, 41(06), 1,832.

Foss, S. K. (1993). The construction of appeal in visual images: A hypothesis. In D. Zarefksy, (Ed.), *Rhetorical movement: Essays in honor of Leland M. Griffin* (pp., 210-224). Evanston, IL: Scott Foresman.

Gardner, H. (1982). *Art, mind, and brain*. New York: Basic Books.

Glenberg, A. M. (2002). The indexical hypothesis: Meaning from language, world, and image. In N. Allen (Ed.), *Working with words and images* (pp. 27-42). Westport, CT: Ablex Publishing.

Goldberg, J. H., Stimson, M. J., Lewenstein, M., Scott, N., & Wichansky, A. M. (2002). Eye tracking in Web search tasks: design implications. *Proceedings of the Symposium on Eye-tracking Research & Applications*, (pp. 51-58).

Grahame, M., Laberge, J., & Scialfa, C. T. (2004). Age differences in search of Web pages: The effects of link size, link number, and clutter. *Human Factors*, 46(3), 385-398.

Grier, R. (2004). Visual attention and Web design. *Dissertation Abstracts International*, 65(07B), 3,738.

Gulli, A., & Signorini, A. (2005). The indexable Web is more than 11.5 billion pages. In *International World Wide Web Conference: Special Interest Tracks and Posters of the 14th International Conference on World Wide Web*, (pp. 902-903). Japan: Chiba.

Halverson, T., & Hornof, A. J. (2004). Link colors guide a search. *CHI '04 Extended Abstracts on Human Factors in Computing Systems*, (pp. 1367-1370).

Handler, S. (2003). Hillman Curtis: Web and graphic design innovator. Retrieved February 8, 2009, from http://www.glidemagazine.com/articles/47585/hillman-curtis-web-and-graphic-design-innovator.html.

Hartmann, J., Sutcliffe, A., & de Angeli, A. (2007). Towards a theory of user judgment of aesthetics and user interface quality. *Special Issue: Aesthetics of Interaction*, 15(4), 1-30.

Harwood, S. (2005). Sheffield University develops Web page design analysis tool. *New Media Age,* 11.

Hoffman, D., & Novak, T. P. (1997). 'A new marketing paradigm for electronic commerce', *Information Society,* 13(1). 43-54.

Hofstede, G. (2001). *Culture's consequences: Comparing values, behaviors, institutions and organizations across nations.* Thousand Oaks, CA: Sage Publications.

Hsiao, S., & Chou, J. (2006). A Gestalt-like perceptual measure for home page design using a fuzzy entropy approach. *International Journal of Human-Computer Studies,* 64(2), 137-156.

Ingram, B. R. (2006). Cyberspace communication 2.0: Viewing higher education Web page design through the lens of visual rhetoric. *Dissertation Abstracts International,* 67(04A), 1136.

Internet statistics: Distribution of languages on the Internet (n.d.). Retrieved March 3, 2009, from Netz-tipp.de/languages.html.

Ivory, M. Y., & Hearst, M.A. (2002). Statistical profiles of highly-rated Web site interfaces. *Proceedings of the Conference on Human Factors in Computing Systems.* CHI Letters, Vol. 4 (pp. 367-374). MN: Minneapolis.

Ivory, M. Y., & Megraw, R. (2005). Evolution of Web site design patterns. *ACM Transactions on Information Systems (TOIS),* 463-497.

Ivory, M. Y., Sinha, R. R., & Hearst, M. A. (2001). Empirically validated Web page design metrics. *Proceedings of the SIGCHI Conference on Human Factors in Computing Systems,* 3(1), (pp. 53-60).

Josephson, S. (2008). "Keeping your eyes on the screen: An eye-tracking study comparing sans serif and serif typefaces," *Visual Communication Quarterly,* 5(1-2), 67-79.

Josephson, S. (2004). Using eye tracking to study visual imagery on the Web. In K. Smith, G. Barbatsis, S. Moriarty, & K. Kenney (Eds.), *Handbook of visual communication: Theory, methods, and media* (pp. 63-80). Mahway, NJ: Lawrence Erlbaum Associates.

Josephson, S., & Holmes, M. E. (2004). Age differences in visual search for information on Web pages. *Proceedings of ETRA 2004: Eye Tracking & Research Applications Symposium (p. 62).* *TX:* San Antonio.

Josephson, S., & Holmes, M. E. (2002). Visual attention to repeated Internet images: Testing the scanpath theory on the World Wide Web. *Proceedings of ETRA 2002: Eye Tracking & Research Applications Symposium* (pp. 43-49). LA: New Orleans.

Joyce, M., Kolker, R., Moulthrop, S., Shneiderman, B., & Unsworth, J. M. (1996). Visual metaphor and the problem of complexity in the design of Web sites: Techniques for generating, recognizing and visualizing structure. *Proceedings of the Seventh ACM conference on Hypertext.*

Kaplan, S. J. (1990). Visual metaphors in the representation of communication technology. *Critical Studies in Mass Communication,* 7, 37-47.

Karvonen, K. (2000). The beauty of simplicity. *Proceedings on the 2000 Conference on Universal Usability.* ACM Press.

Kim, H., & Fesenmaier, D. R. (2008). Persuasive design of destination Web sites: An analysis of first impression. *Journal of Travel Research,* 47(1), 3-13.

Kiousis, S. (2002). Interactivity: A concept explication. *New Media & Society,* 4(3), 355-383

Knobloch, S. H. M., Zillmann, D., & Callison, C. (2003). Imagery effects on the selective reading of Internet newsmagazines. *Communication Research*, 30, 3-29.

Ko, H., Cho, C-H, & Roberts, M. S. (2005). Internet uses and gratifications: A structural equation model of interactive advertising. *Journal of Advertising*, 34(2), 57-70.

Lester, P. M. (2005). *Visual communication: Images with messages*, 4th edition. Cengage Learning.

Licklider, J. C. R., & Taylor, R. (1968, April). The computer as a communication device. *Science and Technology* [Online].

Lindgaard, G., & Dudek, C. (2002). User satisfaction, aesthetics and usability: Beyond reductionism. In J. Hammond, T. Gross & J. Wesson (Eds.) "Usability gaining a competitive edge." *Proceedings IFIP 17th World Computer Congress*. Canada: Montreal.

Lindgaard, G., Fernandes, G., Dudek, C., & Brown, J. (2006). Attention Web designers: You have 50 milliseconds to make a good first impression! *Behaviour & Information Technology*, 25(2), 115-126.

Ling, J., & van Schaik, P. (2007). The influence of line spacing and text alignment on visual search of Web pages. *Displays*, 28(2), 60-67.

Ling, J., & van Schaik, P. (2006). The influence of font type and line length on visual search and information retrieval in Web pages. *International Journal of Human-Computer Studies*, 64(5), 395-404.

Ling, J., & van Schaik, P. (2004). The effects of link format and screen location on visual search of Web pages. *Ergonomics*, 47(8), 907-921.

Ling, J., & van Schaik, P. (2002). The effect of text and background colour on visual search of Web pages. *Displays*, 23(5), 223-230.

Liu, Y., & Shrum, L. J. (2002). What is interactivity and is it always such a good thing? Implications of definition, person and situation for the influence of interactivity on advertising effectiveness. *Journal of Advertising*, 31(4), 53-64.

Marks, W., & Dulaney, C. L. (1998). Visual information processing on the World Wide Web. In C. Forsythe, E. Grose, & J. Ratner (Eds.) *Human factors and Web development* (pp. 25-43). Mahwah, NJ: Lawrence Erlbaum Associates.

Marsh, E. E., & White, M. D. (2003). A taxonomy of relationships between images and text. *Journal of Documentation*, 59(6), 647-672.

Mcmillan, S. J. (2002). A four-part model of cyber-interactivity. *New Media & Society*, 4(2), 271-291.

Nakarada-Kordic, I., & Lobb, B. (2005). Effect of perceived attractiveness of Web interface design on visual search of Web sites. *Proceedings of the Sixth ACM SIGCHI New Zealand Chapter's International Conference on Computer-Human Interaction: Making CHI Natural, CHINZ '05*, ACM Press.

NielsenWire (2009, December). Top U.S. Web brands and site usage: December 2009. Retrieved March 1, 2010, from http://blog.nielsen.com/nielsenwire/online_mobile/top-u-s-web-brands-and-site-usage-december-2009.

Noiwana, J., & Norciob, A. F. (2006). Cultural differences on attention and perceived usability: Investigating color combinations of animated graphics. *International Journal of Human-Computer Studies*, 64(2), 103-122.

Noton, D., & Stark, L. (1971). Scanpaths in saccadic eye movements while viewing and recognizing patterns. *Vision Research*, 11, 929-942.

Park, J. Y. (2007). Empowering the user as the new media participant. *Digital Creativity*, 18(3), 175-186.

Park, S., Choi, D., & Kim, J. (2004).Critical factors for the aesthetic fidelity of Web pages: empirical studies with professional Web designers and users. *Interacting with Computers*, 16(2), 351-377.

Parush, A., Shwarts, Y., Shtub, A., & Chandra, M. J. (2005). The impact of visual layout factors on performance in Web pages: A cross-language study. *Human Factors*, 47(1), 141-157.

Pearson, R., & van Schaik, P. (2003). The effect of spatial layout of and link colour in web pages on performance in a visual search task and an interactive search task. *International Journal of Human-Computer Studies*, 59(3), 327.

Poynter Institute (2007). Eyetracking the news: a study of print and online reading. Retrieved February 21, 2008, from http://eyetrack.poynter.org/keys_07.html

Rau, P. P., Qin G., & Jie, L. (2007). The effect of rich Web portal design and floating animations on visual search. *International Journal of Human-Computer Interaction*, 22(3), 195-216.

Richards, R, (2006). Users, interactivity and generation. *New Media & Society*, 8(4), 531-549.

Robins, D., & Holmes, J. (2008). Aesthetics and credibility in Web site design. *Information Processing & Management*, 44(1), 386-399.

Rosenholtz, R., Li, Y., Mansfield, J., & Jin, Z. (2005). Feature congestion: A measure of display clutter. *Conference on Human Factors in Computing Systems*, (pp. 761-770).

Russell, M. C. (2005). Investigating contributions of eye-tracking to website usability testing. *Dissertation Abstracts International*, 66(09B) 5130.

Shaw, D. (2001). Playing the links: Interactivity and stickness in .com and "not.com" web sites. *First Monday* [Online], 6(3).

Sicilia, M., Ruiz, S., & Munuera, J. L. (2005). Effects of interactivity in a web site. *Journal of Advertising*, 34(3), 31-45.

Singh, S. N., Dalal, N., & Spears, N. (2005). Understanding Web home page perception. *European Journal of Information Systems*, 14(3), 288-302.

Sinha, R., Hearst, M., Ivory, M., & Draisin, M. (2001).Content or graphics? an empirical analysis of criteria for award-winning Web sites. Webby Awards and International Academy of Digital Arts & Sciences. Retrieved March 3, 2009, from http://webtango. berkeley.edu/ papers/ hfw01/sinha_hfw01.pdf.

Sorrows, M. E. (2006). Recall of landmarks in information space. *Dissertation Abstracts International Section A: Humanities and Social Sciences*, 66:9-A(3), 137.

Stern, B. B., Zinkhan, G. M., & Holbrook, M. B. (2002). The netvertising image: Netvertising image communication model (NICM) and construct definition. *Journal of Advertising*, 31(3), 15-27.

Steuer, J. (1992). Defining virtual reality: Dimensions determining telepresence. *Journal of Communication*, 42(4), 73-93

Strain, H. C., & Berry, P. M. (1996). Better page design for the World Wide Web. *Online Information Review*, 20(5), 227-238.

Stuart, S. N. (2006). Golden sections. *Australian Senior Mathematics Journal*, 20(1), 60-64.

Sullivan, P. (2001). Practicing safe visual rhetoric on the World Wide Web. *Computers and Composition*, 18(2), 103-121

Sundar, S. S., Kalyanaraman, S., & Brown, J. (2003). Explicating web site interactivity: Impression formation effects in political campaign sites. *Communication Research*, 30(1), 30-59.

Tamborello, F. P., & Byrne, M. D. (2005). Information search: The intersection of visual and semantic space. *CHI '05 Extended Abstracts on Human Factors in Computing Systems*. ACM Press.

Tractinsky, N., Cokhavi, A., Kirschenbaum, M., & Sharfi, T. (2006). Evaluating the consistency of immediate aesthetic perceptions of Web pages. *International Journal of Human-Computer Studies*, 64(11), 1071-1083.

van Schaik, P., & Ling J. (2001). The effects of frame layout and differential background contrast on visual search performance in Web pages. *Interacting with Computers*, 13(5), 513-525.

van Schaik, P., & Ling, J. (2003). The effects of screen ratio and order on information retrieval in Web pages. *Displays*, 24(4-5), 187-195.

Welch, K. E. (1999). *Electric rhetoric: Classical rhetoric, oralism and new literacy*. Cambridge, MA: MIT Press.

Willis, D. (1999). Effects of using enhancing visual elements in Web site design. *American Communication Journal*, 3:1. Retrieved March 1, 2010, from http://www.acjournal.org/holdings/vol3/Iss1/articles/Willis.htm.

Zdralek, J. (2003). White space: How much nothing should there be? *MAI*, 42, No.05, 1,886.

Zimmerman, B. B. (1999). A rhetorical approach to understanding images in the new "visual age." *Proceedings of the 17th Annual International Conference on Computer Documentation* (pp. 131-137). New Orleans, LA: ACM.

Zimmerman, D., & Walls, P. (2000). Issues in Web design: Exploring navigational patterns on the Web. *Proceedings of IEEE Professional Communication Society International Professional Communication Conference and Proceedings of the 18th Annual ACM International Conference on Computer Documentation: Technology & Teamwork, IEEE Educational Activities Department*.

Chapter One

From Page to Screen and Beyond
The Evolution of Web Metaphors and Their Impact on Communication Design

Sally Gill

When the World Wide Web made its public debut, the concept of "the page" served as a useful metaphor for guiding and instructing scholars, scientists, and researchers (the primary users of the Web in its early days) about how to conceive of, compose, and interact with information in the new medium. But considering how the Web has evolved in terms of authors, audiences, technologies, and purpose, how useful is the page metaphor today? This essay argues that the term "Web page" roots us in the wrong metaphor, and whether we engage in creative practice or critical analysis, using it as our conceptual model for communication design on the World Wide Web restricts our ability to fully realize the potential of the medium.

The time has come to stop using the term *Web page*. The word page roots us in the wrong metaphor, and whether we engage in creative practice or critical analysis, using *pages* for our conceptual model of communication on the World Wide Web restricts our ability to fully realize the potential of the medium.

To accept this hypothesis, it is necessary to understand the influence that metaphors have in guiding our understanding of the world and how we experience it. Therefore, what this essay offers is an examination of metaphors. It begins with a brief discussion of why metaphors matter and traces the evolution of metaphors that have been used to describe and define the World Wide Web since its inception. It continues with an analysis of how these metaphors have informed and in-

fluenced communication design, and concludes with a call to explore new metaphors for guiding both the creation and critique of human communication in the context of emerging technologies.

Why Metaphors Matter

Whenever a new technology is introduced, people often employ metaphors as conceptual models to help them define its use and potential. In *Interface Culture: How New Technology Transforms the Way We Create and Communicate,* Johnson (1997) noted: "Dreaming up metaphors for new machines has, of course, a long and distinguished history. Every age comes to terms with the latest technology by drawing upon imagery of older and more familiar things" (p. 16). Consider the term "horseless carriage." For a society familiar with horse-drawn transportation at the turn of the 20th century, it provided an appropriate conceptual model for understanding the odd contraptions built by Carl Benz, David Dunbar Buick, Louis Chevrolet and Henry Ford. "Wireless networking" is another example, positioning the new technology in terms of its advantage over its predecessor: wired networks. The "desktop" metaphor provides a way of conceptualizing and interacting with personal computers, enabling millions of people to create, edit, organize, access, print, and even dispose of digital data and documents that are part and parcel of the workplace, the office, the desk.

Just as new technologies evolve over time, so do the structures of human interaction with technology. The beige box originally intended to process words and data has evolved into a flat-screen home entertainment center, a marketplace, a reference library, a travel agency, and a kind of digital water cooler where we exchange news and gossip with people in our own communities and around the world. This evolution of function and form necessitates a corresponding evolution of metaphors; otherwise, we run the risk of inhibiting our ability to fully grasp the potential of this new technology, its unique properties, and how those unique properties might affect communicative purpose and practice.

A historical example of how a prevailing metaphor inhibited creative potential for a time can be found by looking to the early days of cinema. According to Mast and Kawin in *A Short History of the Movies* (2008):

> When the early films turned from scenic views to fictional stories, directors assumed that the poetics of the film were similar to those of the stage. Stage acting, stage movement, stage stories, stage players, and stage perspectives dominated the early story films. The camera was assumed to be a passive spectator in a theatre audience, and just as the specta-

tor has only one seat, the camera had only one position from which to shoot a scene. Time and experimentation revealed that the camera was anchored by analogy alone—and that the analogy was false (p. 1).

One can almost imagine the epiphany of some early 20th-century filmmaking pioneer: "Hey, we don't have to sit still. We're not someone in the audience who bought a ticket for a front-row center seat. We can get up and move around. We can move in really close, we can hover above, we can switch perspectives, we can cut, we can edit... Wow! We've been rooted in the wrong metaphor. We're not in the theater anymore." This hypothetical scenario is presented not to suggest its historical accuracy but to dramatize the conceptual shift that occurred.

Once narrative cinema let go of the metaphor of the stage, new cinematic conventions for storytelling were developed (and continue to be developed) that made maximum use of the unique properties of film, such as intercutting, the close-up, exchanging points of view. And just as the cinema screen was recognized as having the potential for creating a different kind of experience than that offered by the stage—one that is unique to cinema—the computer screen offers the potential for creating different kinds of experiences than those offered by the paper page—experiences that are unique to the visual, interactive environment of computer screens. Manovich (2001) points out in *The Language of New Media* that the "rapid transformation of culture into e-culture, of computers into universal culture carriers, of media into new media, demands that we rethink our categories and models" (p. 6). In order for cinema to realize its unique potential, it had to break free of its metaphorical ancestor, the stage. We are at a similar point in the evolution of the World Wide Web, as we realize its potential for moving beyond its metaphorical ancestor, the page.

In *City of Bits*, Mitchell (1995) says the most crucial task for the beginning of the 21st century is "one of imagining and creating digitally mediated environments for the kinds of lives that we will want to lead and the sorts of communities that we will want to have" (p. 5). "Imagining" and "creating" are conceptual acts that emerge from a conceptual system, and as Lakoff and Johnson (1980) point out in *Metaphors We Live By*, "our ordinary conceptual system... is...metaphorical in nature" (p. 3). This would imply that in order to perform Mitchell's crucial task of imagining and creating digitally mediated *environments*, we need guiding metaphors that are visual, spatial, verbal and even aural. After all, environments are spaces that surround and engage us through the use of color, form, texture, sound, and the written word. Environments are spaces we explore, where we teach and learn, where we engage in trade, and where we gather to exchange information

with friends and co-workers. Martinec and van Leeuwen (2009) remind us that "metaphors are of particular interest for new media design because they can combine creative and innovative expression with the verbal and visual realization of semantic structures" (p. 88).

At start-up, computers present us with a screen filled with iconic images of file folders, documents, printers, and other office metaphors. While each icon/visual metaphor is useful, it is when clicking on the Web browser icon and opening up a window to a world where we can engage in activities that take us beyond the desktop and its associated paperwork that the metaphor of the office, of the desktop, and of paper becomes inadequate. Kay (1990), a key member of the research team at Xerox PARC in the 1970s, credited with originating the idea of the desktop interface, felt that "the very idea of a paper 'metaphor' should be scrutinized mercilessly" (p. 199).

What metaphors, then, might best enable and guide us in performing the crucial task that lies before us? In order to answer that question, it is helpful to examine the metaphors that have been used in the past.

Metaphors for the Internet and the Web, Past and Present

Let us start by classifying metaphors for the Internet and the Web according to two categories: metaphors that refer to the entire network and metaphors that refer to the fundamental unit of what is presented on screen at any given time. Beginning with the former, the dominant metaphor in the 1990s was "the information superhighway." While it had explanatory power regarding the technical side of networks, transmission, and delivery of information, it was limited in its ability to illuminate our understanding of why people create and seek certain kinds of information, the variety of contexts in which they use information and negotiate meanings, or the most effective ways in which information might be presented. Thinking of the Internet solely as a high-tech highway fell short of considering the potential of the entire network; specifically, it didn't include the "sites" that individuals, and organizations were constructing, the places where users want to go—the Web's "destinations" so to speak. According to Cerf (1996), "this metaphor has very little ability to explain either where the Internet arose or where it could go" (p. x).

Another metaphor that *did* imagine the Web as a place/destination, gained popularity in the mid-1990s: "the digital frontier." This one, too, had certain

power to ignite the imagination. Perhaps due to nearly a century of Hollywood westerns forming our collective vision of life on the frontier, it offered a scenario of possible activities, struggles, and resolutions that would require our best efforts as society moved into new media territory. The frontier was an apt metaphor for the first decade or so; however, it no longer describes the Web as we know it today. As one self-proclaimed "digital pioneer" (Whittle, 1997) lamented:

> Many of us...already feel as if the frontier has given way to hordes of ranchers, miners, merchants, bankers, bandits, harlots, sheriffs, bartenders, and gunfighters, and we feel it won't be long before the prairie, mountains, forests, railroads, shacks, mines, and cabins give way to ribbons of pavement, parking lots, logging ventures, jets, skyscrapers, and suburbs. And what will it be then—an electronic nation? Somehow the metaphorical imagery is lost (p. 11).

By the beginning of the 21st century, the digital frontier had been colonized. As various constituencies explored the possibilities of how the Internet could be used to serve their purposes, the concept of the Internet *solely* as an information superhighway or a digital frontier soon gave way. The question becomes: What conceptual models took their place and shaped our thinking about the Internet and its potential? In *Internet Dreams: Archetypes, Myths, and Metaphors* (1997), Stefik, a research fellow at Xerox Palo Alto Research Center, explored four metaphors for "increasing our consciousness of invention" (p. xx) and four corresponding archetypes, aimed at helping us "create visions of what we want to be—as individuals and societies" (p. xxii). He foresaw the Internet as a site of cultural production and human expression that speaks to who we are, the kinds of activities we want to engage in, and the environments in which we live, work, and play. Although the World Wide Web is most often associated with the latest digital advances and technological wizardry, the metaphors and archetypes he presented have "deep and ancient roots in many cultures" (p. xxiii).

The first of Stefik's metaphors/archetypes is *Digital Library/Keeper of the Knowledge,* which emphasizes the Internet's capacity for the publishing and storing of collected knowledge and for the preservation and access of that knowledge in the service of community memory. Digital libraries, databases, and other online information services support the activities of the keeper of knowledge, the conservator who seeks to gather and preserve knowledge for future generations. Variations of this archetype include the museum curator, the scholar, the librarian, and the storyteller in oral traditions.

The second metaphor/archetype, *Electronic Mail/Communicator & Town Crier,* acknowledges the various ways in which the Internet facilitates communica-

tion. Personal messages can be sent between individuals, official public messages can be sent to groups and communities, and unofficial messages can be sent by "whistle blowers" who feel called upon to expose information that that couldn't be disseminated through official channels.

The Electronic Marketplace/The Trader, the third of Stefik's metaphor/archetype categories, describes the Internet as the place of commerce, for exchanging goods and promoting services. This metaphor is related to the ancient archetypes of the hunter, the gatherer, the merchant, and the sea trader, and to more contemporary archetypes who go into the world to make a living and who prepare for action and commerce such as the business executive or the bargain hunter.

Digital Worlds/The Explorer is the fourth set of metaphors/archetypes Stefik explored to help us conceive of the evolving nature of the Internet. Online technologies that allow for virtual reality, augmented reality, telepresence, and ubiquitous computing fire the imagination of the explorer and the adventurer, longing to explore new places and gain new experiences.

Reading the book again, years after its publication, one is struck by its prescience. The set of metaphors and corresponding archetypes that in the mid-1990s served as a helpful way of imagining and creating a World Wide Web that would one day satisfy an assortment of human needs, now appears as a logical way to categorize the Web as it exists today. Consider the content and activity one now finds on the Web: online versions of daily newspapers, weekly magazines, classic works of literature, and ancient artifacts. All are accessible any time of day or night. Amazon.com, eBay, iTunes, and even small, local retail enterprises can now reach customers worldwide. Blogs and online forums for communities of all kinds (neighborhood groups, sci-fi fans, practitioners of alternative therapies, people who grow African violets, etc.) allow people to make connections and exchange ideas. Promotional sites invite explorations into the "world" of the latest blockbuster movie, allow visits to distant locales via webcams, facilitate tours of hotels before reservations are made, or real estate access into the interior of homes while the purchase decision is being considered. YouTube has become the place to go for a broad range of visual experiences from historical clips that have been digitized to the latest hot topic of ephemeral pop culture. In *Convergence Culture: Where Old and New Media Collide* (2006), we can recognize several of Stefik's metaphors and archetypes in Jenkins' description of a convergence of online activities he calls "transmedia storytelling":

Transmedia storytelling is the art of world making. To fully experience any fictional world, consumers must assume the role of hunters and gatherers, chasing down bits of the story across media channels, comparing notes with each other via online discussion groups, and collaborating to ensure that everyone who invests time and effort will come away with a richer entertainment experience (p. 21).

The Web evolved from being thought of as a superhighway into a destination, into a *place* to go for information of all kinds, a *place* to conduct business, a *place* to exchange ideas with others, a *place* to explore and gain new experiences.

Those places are represented onscreen, which brings us back to the question about the most appropriate metaphorical language to use when referring to the fundamental unit of what is represented onscreen at any given time. The term *Web page* has been used since the Web went public in 1991, but as our primary, dominant metaphor, does it "increase our consciousness of invention" (Stefik, 1997, p. xx) or constrain it? In order to understand why the *page* became the dominant metaphor, it may be helpful to consider the original users of the Web and the producers of its early content. This is how Tim Berners-Lee first described what he termed "The WorldWideWeb (WWW) project" in his posting to the newsgroup "alt.hypertext" on August 6, 1991:

The WWW world consists of documents, and links. Indexes are special documents which, rather than being read, may be searched. The result of such a search is another ("virtual") document containing links to the documents found. A simple protocol ("HTTP") is used to allow a browser program to request a keyword search by a remote information server (Berners-Lee, 1991).

In the same posting, he explains further:

The project started with the philosophy that much academic information should be freely available to anyone. It aims to allow information sharing within internationally dispersed teams, and the dissemination of information by support groups. (Berners-Lee, 1991)

It is clear from Berners-Lee's initial descriptions that the World Wide Web was invented to serve scientists, researchers, and professors as a mechanism for storing, retrieving, searching, sharing, and displaying academic documents. The page was a handy metaphor for such users. What the screen represented, therefore, simulated the format and function of *pages* as we see and interact with them in books and scholarly journals. Hypertext links enabled readers to quickly and easily skip to another "page" in the same document, or even to a page in another document. In fact, the innovation of hyperlinks can be seen as operating in much

the same manner as a table of contents, footnotes, or an index in printed form. What was revolutionary was having *instant access* to a worldwide collection of documents, in this case a collection of academic writing, and being able to instantaneously follow connections between those documents via the innovation of hyperlinks. However, the World Wide Web did not remain the purview of the academy for long.

From Academics and Pages to Artists and Spaces

As noted earlier, by the mid- to late-1990s the World Wide Web was expanding to include sites for commercial enterprises, government agencies, public services, not-for-profit organizations, educational institutions, special interest groups and communities, and entertainment providers. About that same time, the development of new technologies, including Macromedia Flash, streaming audio and video, cable modems, and broadband enabled online screen representations to extend far beyond electronic page display. When those technical advances became available, media artists and communication designers began to see—and exploit—the potential the Web held for realizing their creative visions, reproducing what Bolter and Grusin call "the rich sensorium of human experience" (1999, p. 34). Such a relationship between art and technology has a long history, according to Tribe, the founder of Rhizome[1]:

> Art has always been bound up with technology, and artists have always been among the first to adopt new technologies as they emerge. We monkey around with new technologies in an effort to see what that can do, to make them do things the engineers never intended, to understand what they might mean, to reflect on their effects, to push them beyond their limits... But some technologies seem to hold considerably more promise for artists than others. The Internet is particularly ripe with the potential to enable new kinds of collaborative production, democratic distribution, and participatory experience" (Manovich, 2001, p. xi).

When artists and designers—people for whom the primary medium of communication was not the typed page, but the canvas, the video screen, the gallery installation space—started "to monkey around" with Web technologies, they brought to the new medium the notion that information was not something to be simply transferred but was something to be designed. They created screen spaces that enabled people to manipulate and interact with information and images in ways that simple hypertext links could not. Users were encouraged not only to access texts but to explore informational spaces resembling those which artists and

designers had been creating for years in film, television, video, CD-ROMs, and computer games. Although text had played a "privileged role in computer culture" (Manovich, 2001, p. 74) from the beginning, in the late 1990s content layout and design for the Web began to look and act less and less like pages. Berners-Lee's worldwide network for sharing academic documents had begun its evolution toward becoming a "meta-medium" (Manovich, 2001, p. 6) that catered to the needs of a widespread audience, a medium with its own unique characteristics based not on the textual properties of the *page*, but on the visual, spatial context of the interactive *screen*.

Prompted by the desire to create onscreen Web *spaces* rather than Web *pages*, communication designers with backgrounds in art and design drew upon visual and spatial metaphors borrowed from architecture and CD-ROM design. Their terminology—portal, site, site map, image map, information architecture, navigation, browser window—is now part of the Web lexicon. As we observe shifts in creative practice, it is important and appropriate to re-examine the language we use to guide, describe, and analyze that practice. Pages continue to have a place on the Web, but *the page as dominant metaphor no longer provides an accurate conceptual model.*

How Metaphors Inform and Influence Communication Design for the Web

Consider for a moment the differences between page and screen, and how each as a conceptual model determines how we are likely to approach it in terms of creative, interactive, and critical practice. A page is static, with an aspect ratio that is usually higher than it is wide. We associate pages with the act of reading, which tends to be "an ordered process requiring us to sit at a table, consume ideas from left to right" (Crowley & Heyer, 1999, p. 288). Text is the dominant feature of a page, and when graphics and photographs are used, more often than not they are displayed as illustrations subordinate to the text. Now consider the computer screen. It has an aspect ratio that is usually wider than it is high, similar to the screens we have grown accustomed to in movie theaters and at home on television. Our experience with cinema and TV has created certain expectations about screens. They represent spaces dominated by images where, guided by a director and camera operator, we survey environments, watch stories unfold, and observe relationships develop. The interactive screens of computer simulations and games have created additional expectations, representing visual spaces that allow us to

explore for ourselves, to move about and navigate along our own paths, seeking out information, testing different scenarios and variables, or even playing a part and interacting in an unfolding drama. Although even within screen contexts reading may be required—to help us establish time and place (film and TV) and to guide and/or supply us with the necessary information for achieving a desired goal (computer simulations and games)—reading onscreen differs from reading printed pages.

How do people read on the Web? According to research conducted by usability expert Jakob Nielsen, "They don't...instead, they scan...picking out individual words and sentences" (1997, para 1-2). Nielsen recommends, therefore, a scannable layout that includes "highlighted keywords; meaningful sub-headings; bulleted lists; one idea per paragraph; the inverted pyramid writing style, starting with the conclusion; and half the word count (or less) than conventional writing" (1997, para 3).

If we take Nielsen's findings and factor in the technological advances that have enabled the World Wide Web to represent a multitude of media in addition to text (i.e., audio, video, graphics, photography, animation, interactive simulations, and games), it becomes apparent that the *page* is too limited a metaphor for how information on the Web might be designed and organized, and how communication designers might mix a variety of media. In the early days, anyone who wanted to post a message attracted visitors to a Web site by displaying an HTML document—a simple Web page—that included hypertext links to other documents. Today, Web sites that follow the format of early Web pages by displaying primarily HTML text, punctuated only by blue underlined words to identify hyperlinks and requiring excessive vertical scrolling, look outdated. Visitors to these sites are likely to get the impression that the information is out of date or even question the veracity of the site. Advances in technology have enabled communication designers to add dimension to their messages with sound, animation, and rollover effects, and many audiences have begun to seek out and/or expect a certain amount of innovation. As Manovich (2001) was keen to point out in reference to new media:

> Cinema, the printed word, and HCI [Human-Computer Interaction] are the three main reservoirs of metaphors and strategies for organizing information... A digital designer can freely mix pages and virtual cameras, tables of content and screens, bookmarks and points of view. No longer embedded within particular texts and films, these organizational strategies are now free floating in our culture, available for use in new contexts. In this respect, the printed word and cinema have indeed become interfaces—rich sets of metaphors, ways of navigating through content (pp. 72–73).

An example of one of the first Web sites where digital designers drew from the reservoirs of cinema, the printed word, and HCI for new metaphors, organizational strategies, and navigation schemes is the site for the Academy Award-winning film *A Beautiful Mind* (http://www.abeautifulmind.com/main. html).

Rather than simply displaying information, the site seeks to create an experience by employing sound, animation, rollover effects, photography, video, text, and interactive code-breaking. The aspect ratio of the site mimics the dimensions of the cinema's wide screen and is at the same time slightly reminiscent of a university blackboard where John Nash (the film's main character) and his colleagues wrote and worked out scientific and mathematical formulas. Such formulas are, in fact, used as the main navigation scheme. Rolling the cursor over each of the formulas written near the bottom of the screen sets them into a spinning motion that ends by revealing the main content areas, which include "Dossiers" (information on the cast and filmmakers); "Raw Data" (synopsis, production notes, image gallery, video, information about Nash and his Nobel Prize essay, and links to other sites); "Formulas" (information about genius and math challenges); "Exercise Your Mind" (four interactive games and quizzes); and "Think" (a code-breaking challenge). A visitor to the site could also choose to explore the screen space the way a camera operator might navigate space when shooting a scene for film. By positioning the cursor in the main screen space, users can pan across a collage of images and links to topics as if they were moving the camera around 360 degrees at their own pace, stopping at any point, speeding up, slowing down, moving right or moving left. Clicking on a topic doesn't take the user to a "new page," but activates a small opening rather like an elevator door where subtopics rise up from the bottom. A click on one of the subtopics fills the wide-screen area with a new scene, which then provides the opportunity to engage in a number of activities, such as viewing video, perusing a picture gallery, reading production notes and biographies, playing a game, taking a quiz, or cracking a code.

The site was designed by Design Reactor, an interactive digital communications firm near San Jose, California. When asked about the conceptual approaches and metaphorical language design teams at Design Reactor used to guide and describe their work, then-Vice President Steve Hill said their goal was "to create holistic experiences and connect the visitor to the material emotionally through digital/online design and concepts." He further explained that this "has proven successful and often requires designs that break from the standard online page format" (personal communication, April 29, 2002). According to Jeff Dumo, the firm's director of new business development at that time, their design teams "ha-

ven't said *Web page* in a couple of years" (personal communication April 24, 2002). Although a consistent, definitive in-house terminology has not been specified, he said a few common terms for describing elements of a Web project are "screen," "sequence," and "destination." Design Reactor Web site developers aim "to create an experience and a sense of space," according to Dumo, and approach projects in the same way they approach projects for film, video, kiosks, DVD games, and CD ROMs.

It would appear then, that this interactive design group—with its emphasis on creating experience and a sense of space—had not only dropped the metaphor of the page for Web communication, but it had also begun to undertake the "crucial task" of the early 21st century that Mitchell described, of imagining and creating digitally mediated environments. In the Web site for *A Beautiful Mind (ABM)* we can also see the strategies that Manovich talks about (strategies borrowed from cinema, print, and HCI) are integrated with the metaphorical environments that Stefik imagined. First, as a "digital library" the *ABM* site provides information about Nash, along with a hypermedia tutorial illustrating his Nobel Prize-winning theory of equilibria in non-cooperative games (the Nash Equilibrium), a hypermedia timeline from 551 B.C. to 1942 describing geniuses in the arts, science, and philosophy, and links to other sites about Nash, game theory, genius, etc. Second, the *ABM* site serves a commercial purpose in the "digital marketplace" as a promotional vehicle for the film, and contains links enabling visitors to purchase the soundtrack and DVD. As a "digital world" it offers visitors the opportunity to explore the world of the film and to engage in interactive math and code-breaking challenges that prompt visitors to manipulate the visual environment onscreen as computer games do.

The Web site for *A Beautiful Mind* is cited as just one of the earliest examples in which communication design for the Web broke away from text-heavy, vertical scrolling electronic *pages*, toward media-rich, interactive screen *spaces* that serve as environments where people engage in a variety of communication activities. Those of us who are educators, students, and critics of new media should seek out further examples and analyze them with an eye toward revealing the underlying guiding metaphors so that we may expand our pool of conceptual models. The value of exploring and developing new metaphors is supported by Lakoff and Johnson's (1980) assertion that "new metaphors are capable of creating new understandings and, therefore, new realities" (p. 235).

Consider, for example, how historical archives, personal stories, public service information, environmental awareness, marketing promotions, fiction, and even

academic research might be communicated if we were to conceive of the Web in terms of screen spaces that contain:

- sequences
- scenes
- infoscapes
- destinations
- canvases
- signposts
- staging areas
- crystal balls
- foyers
- installations
- passageways
- express lanes
- channels
- worm holes

This list is in part a flight of fancy, but it also poses some interesting challenges. What visual, rhetorical, and navigational strategies might these metaphors suggest to contemporary communication designers working with the Web? What metaphorical insights might they suggest to the new media critic?

New Directions, New Challenges

The discussion thus far has focused on communication design for the Web as experienced on desktop computers. With a growing number of people accessing online content with smart phones and other handheld mobile devices, another set of challenges presents itself. In early 2010, the interactive editor for *Adweek* noted "a shift in digital away from users merely sitting in front of computer screens to using new digital tools to affect behavior in the physical world. The growing sophistication of smart phones is driving the creation of...location-based services, which promise to morph the Web from a solitary experience to a ubiquitous connector in the real world" (Morrissey, 2010). According to an editorial comment in *Communication Arts* (Coyne, 2010), "The idea that people will be sitting at home at a computer screen with a mouse is definitely going away" (p.10). While it is unlikely that desktop access to the Web will cease entirely in the near future, it is safe to say

that mobile access will only continue to increase, supported by new technical innovations prompting new conceptual models.

In 2009 a proliferation of Web applications designed specifically for mobile devices that used visual cues and prompts, and addressed specific user queries, became widely available and popular. Among the first to receive recognition for outstanding communication design for interactive media were two iPhone applications (apps): *2009 PGA Championship* and *The Next Move by Urban Daddy*. Mathew Ranauro, senior vice president and director of interactive at Publicis & Hal Riney in San Francisco, described the *2009 PGA Championship* app as "an example of where things are headed. Immersive and useful and all on a mobile device" ("2009 PGA Championship iPhoneApp," 2010). *The Next Move by Urban Daddy* was described by Rachel Pasqua, director of mobile strategy at New York-based iCrossing, as "one of the best branded entertainment apps available simply because it gives great recommendations according to where you are and who you're with" ("The Next Move," 2010).

Ranauro's reference to "immersive" experience and Pasqua's nod toward the benefits of designing Web communication that considers "where you are" echo what another interactive designer, Michelangelo Capraro, predicted in 2009 (Coyne, 2009): "A device that is location aware forces us to rethink what immersive is...you'll go somewhere and it will tie-in with what's on the mobile device and give you a multi-sensory experience" (p. 10).

Multi-sensory experiences are currently possible with any number of Augmented Reality (AR) apps for use on mobile devices with a compass sensor, high accuracy GPS capabilities, and a quality video camera. *Pocket Universe* developed for the iPhone, for example, allows users to point the phone/camera toward the night sky, and the screen "augments" the celestial reality by displaying information and additional links about the planet, star, or constellation being viewed. "You also get a list of meteor showers, lunar phases and a very nice 'tonight's sky' feature that tells you right away what's up and worth seeing" (Martin, 2009).

In his article that examined how AR apps combine the real world with virtual reality, Peri (2010) considered the possibility of what he called "historic AR": "How about pointing your camera at a site and seeing an historic building that was there in the past but no longer exists? How about viewing a battlefield from the Napoleonic Wars and seeing accurate images of the men that fought there?" (p. 42). Such possibilities that conceive of Web-based experiences as locational, spatial, and environmental, underscore the inadequacy of the page metaphor and support the recommendation to expand the conceptual models and metaphors

that frame our understanding of communication design for the Web. As a dominant metaphor, the "page" is simply no longer relevant.

The task of composing communication for the Web now prompts us to think beyond the concept of electronic pages, and to consider digitally mediated environments where text, imagery, audio, video, augmented reality, GPS and innovative technologies of the future can be integrated to create multi-layered experiences based on the particular interests and needs of the user at any point in time. As Cerf commented in 1996, "Even those of us (dinosaurs) who have been around since the Eocene of networking find it eye-opening to consider new metaphors to inform our thinking and to make facts become clearer in the telling" (Cerf, 1996, p. x).

Conclusion

This chapter has focused on the metaphors used to describe and guide communication design for the Web. It argues that we should stop using the term Web *page* because the *page* has ceased to be relevant as a dominant metaphor, and that the evolutionary trend in Web communication is moving toward the creation of *screen environments* that have more affinity with cinema, computer games and virtual reality than with the pages of a book. It also issues a call to those of us involved in new media communication to explore and develop new metaphors, new conceptual models, and a new vocabulary for describing and guiding creative work and critical examination of Web communication.

In considering the issue of the metaphorical framework used to engage the Web, let us ask ourselves why Web metaphors warrant academic attention. Is it because metaphors help to shape the way we think? Since communication design for the Web has already begun to exceed the confines of the page, let us begin to change the language we use to describe our experiences. Many communication design professionals have already moved beyond the page as their conceptual model for Web site design and development, and some have already abandoned the term *Web page* entirely. For those of us in the academy for whom new media communication is the subject of our research and teaching, the extent to which our conceptual models keep pace with current practice is of vital importance. Certainly there are those among us who have registered the changes and who are teaching and writing about new directions in communication design for digital media. It is with this fact in mind that the call is issued for our discourse commu-

nity to formally acknowledge the changes in practice by letting go of the metaphor of the page, and developing new terminology, new models, new metaphors.

The purpose of this essay is to guide and support the professional obligations we have as educators, critics, and scholars. As educators, we owe it to our students to provide them with a range of useful conceptual models that will help them become effective communicators in new media. As critics, we owe it to our audience to possess a keen understanding of the medium, which ought to be reflected in the language we use to describe it. And finally, as communication scholars, we owe it to our discipline to regularly re-examine our assumptions and the language we use, even when the issue is something as seemingly simple and innocuous as the term Web *page*.

Notes

Portions of this manuscript appeared in my unpublished doctoral dissertation (2000), Medium of the Future, Stories of the Past: The Web, Remediation and Regional Heritage, written under the guidance and direction of S. Michael Halloran at Rensselaer Polytechnic Institute, Troy, New York.

1. Rhizome, founded in 1996 and affiliated with the New Museum in 2003, is "dedicated to the creation, presentation, preservation, and critique of emerging artistic practices that engage technology." (http://rhizome.org/)

References

Berners-Lee, T (1991, August 6). WorldWideWeb: Summary. Message originally posted to alt.hypertext. Retrieved Nov. 22, 2008, from http://www.w3.org/People/Berners-Lee/1991/08/art-6487.txt

Bolter, J., & Grusin, R. (1999). *Remediation: Understanding new media*. Cambridge, MA: MIT Press.

Cerf, V. (1996). Foreword. In M. Stefik, *Internet dreams: Archetypes, myths, and metaphors* (pp. ix-x). Cambridge, MA: MIT Press.

Coyne, P. (2009, May/June). Editor's column. *Communication Arts, 51*(2), 8-11.

Coyne, P. (2010, April/March). Editor's column. *Communication Arts, 52*(1), 8-13.

Crowley, D., & Heyer, P. (1999). *Communication in history: Technology, culture and society*. New York: Addison Wesley Longman, Inc.

Jenkins, H. (2006). *Convergence culture: Where old and new media collide*. New York: University Press.

Johnson, S. (1997). *Interface culture: How new technology transforms the way we create and communicate*. New York: Basic Books.

Kay, A. (1990). User interface: A personal view. In B. Laurel (Ed.), *The art of human-computer interface design*. Reading, MA: Addison-Wesley.

Lakoff, G., & Johnson, M. (1980). *Metaphors we live by*. Chicago: University of Chicago Press.

Manovich, L. (2001). *The language of new media*. Cambridge, MA: MIT Press.

Martin, M. (2009, July 3). Pocket universe ups the astronomy ante. *The unofficial Apple weblog*. Retrieved May 6, 2010, from http://www.tuaw.com/2009/07/03/pocket-universe-ups-the-astronomy-app-ante

Martinec, R., & van Leeuwen, T. (2009). *The language of new media design: Theory and practice*. New York: Routledge.

Mast, G., & Kawin, B (2008). *A short history of the movies* (10th ed.). New York: Pearson Education, Inc.

Mitchell, W. J. (1995). *City of bits: Space, place, and the infobahn*. Cambridge, MA: MIT Press.

Morrissey, B. (2010, March 22). Digital gets physical. *Adweek*. Retrieved May 6, 2010, from http://www.adweek.com/aw/content_display/news/digital/e3id96098b1ed5efecd1e2d76ba98890d4c

The next move by urbandaddy iPhone app. (2010). Retrieved March 28, 2010, from http://www.commarts.com/interactive/cai10/urbandaddyiphoneapp.html

Nielsen, J. (1997). *How users read on the web*. Retrieved October. 25, 2008, from http://www.useit.com/alertbox/9710a.html

Peri, C. (2010, Spring). Augmented reality for the iPhone: Combining the real world with virtual reality. *iPhone Life*, 2(2), 40-42.

Stefik, M. (1997). *Internet dreams: Archetypes, myth, and metaphors*. Cambridge, MA: MIT Press.

Tribe, M. (2001). Foreword. In L. Manovich, *The language of new media* (pp. x-xiii). Cambridge, MA: MIT Press.

2009 PGA championship iPhone app. (2010). Retrieved March 28, 2010, from http://www.commarts.com/interactive/cai10/2009PGAiphoneapp.html

Whittle, D. B. (1997). *Cyberspace: The human dimension*. New York: W.H. Freeman and Company.

Chapter Two

Something New, Something Old, Something Borrowed
Web Pages and Visual Culture

Susanna Paasonen

Web aesthetics are a central, yet surprisingly little-researched field of contemporary visual culture. Addressing the visual aspects of Web interfaces in relation to discussions on digital imaging, as shaped by mid-1990s debates on digital photography, this chapter aims to sketch out some central features of their visual rhetoric. More specifically, it situates Web sites into the traditions of graphic arts and design spanning from the comics and print graphics to photography, cinematography, and various forms of digital imaging, and connects them to established genres of visual interpretation (such as home media, journalism, or visual arts). Doing so, the chapter argues for the importance of a contextual understanding of Web aesthetics and their visual rhetoric that accounts for the development of the Web as a visual medium in the context of media history.

Web aesthetics are a central, yet surprisingly little-researched field of contemporary visual culture. Scholars investigating the cultural implications and aesthetics of digital imaging have largely focused on digital photography, special effects, computer games, computer animation, and, in the 1990s, CD-ROMs. With the exception of usability studies and design, the Internet has been studied largely in terms of textual communication and linguistic features in fields such as media and communication studies. It is fair to claim that the intermedial and multimodal aspects of Web content have not been a major preoccupation in studies of either visual culture or Internet research (Pauwels, 2005). This is noteworthy given that

the Web has become an increasingly visual medium since the launch of the first graphic Web browsers in the early 1990s, and that the cultural visibility and importance of the Web as an information and communication medium has since increased considerably.

This chapter considers the visual aspects of Web interfaces in relation to discussions on digital imaging, as shaped by mid-1990s debates on digital photography, in an attempt to sketch out some central features of their visual rhetoric. In what follows, I consider Web pages in the framework of visual media culture that is histories of and visual practices that precede and run parallel to the development of Web interfaces and cut across the history of media technology. While Web design is a young profession and Web aesthetics have only a brief history, they appear less novel when considered in the context of visual practices spanning from print graphics and cartoons to animation, digital imaging, photography, cinematography, and television. The chapter begins with a general discussion of Web site visuality and considers the ways in which it connects (or fails to connect) to debates regarding the meanings and definitions of the analog and the digital (or, "old" and "new" media), which have tended to dominate discussions on digitization and visual imaging for well over a decade. Situating Web sites into the traditions of graphic arts and existing genres of visual interpretation, I argue for the importance of a contextual understanding of Web aesthetics and their visual rhetoric that accounts for the development of the Web as a visual medium and its connections to media history.

Novel Visual Forms

Since the 1990s, Web pages have been characterized by the use of rectangular graphic elements (tables, frames, menus, fields, bars) that repeat the overall form of the computer screen. While site design has since adopted softer shapes (such as rounded corners), rectangular shapes and fields still largely dominate the visual structure of Web interfaces. Other visual characteristics have included animation (banners, Flash, animated GIFs, Java applets), the use of background colors and wallpapers to structure the page and to separate different parts and elements from one another, as well as the wide use of photographs, graphics, icons, and combinations of these. Although Web pages have historically relied mostly on text, they have become more graphic: pages flicker and twinkle with animation and motion effects, and they attract users' attention with colors, graphic shapes, and visual

elements of all kinds. On individual pages, text, image, and ornament have often become difficult to tell apart.

Media theorist Siegfried Zielinski (1999, p. 291) has nevertheless considered the combinations of image, sound, text, and movement on Web sites as aesthetical reduction in which other modes of expression are subjected to the grammatical and mathematical order of text. This argument for the primacy of the textual in Web site design certainly has some ground in a historical perspective, given that the majority of Internet uses have been textual in nature (e-mail remains the most popular of uses, chat or database searches are primarily textual, and blogs and on-line magazines rely largely on the written word). The case is, however, much less certain today than in the late 1990s. As the World Wide Web and its graphic interfaces have been conceptually conflated with the Internet at large in discourses both popular and academic (the Internet being the overall term for a global system of millions of interconnected networks-based packet switching, and the WWW being merely one of its many parts, in addition to file sharing, e-mail, chat, or on-line gaming), the boundaries of the textual and the visual are increasingly blurry when considering the aesthetic aspects of the medium. Furthermore, as forms of visual expression have diversified and grown more elaborate over the years, it is increasingly more difficult to argue for the dominance of the textual in site layout.

The expressive possibilities and accessibility of the Web have facilitated the transformation of the Internet to a ubiquitous communication and entertainment medium. The Internet was strongly privatized and commercialized in the early to mid-1990s, and "user-friendly" graphic interfaces were developed in order to attract wider groups of users as well as commercial interests of advertisers, retailers, and various content and service providers. The first Web browser with a graphic user interface was the little-known Erwise in 1992. ViolaWWW launched in 1991, started gradually supporting graphics, and the beta version of Mosaic was introduced in the spring of 1993. The graphic interface of Mosaic (and its "offspring," Netscape Navigator, Mozilla, and Firefox, as well as competing browsers such as Microsoft Explorer, Safari, Opera, or Chrome) enabled the use of colors, hypertext links, and basic text layout (for example, aligning text left or right, or adjusting font size and color). In Bolter and Grusin's (1999) terms, this graphic turn opened the Web up for various "remediations." Bolter and Grusin addressed the inter-connections between different media, their aesthetics, contents, representational conventions, and user experiences through the notion of remediation: newer media are compared to previous ones, explained and understood through them; newer technologies are used in older media; representational conventions of

older media appear in newer ones and vice versa. It is through such a dialogue that new media are given form and that they become situated in broader discourses concerning media and culture (Tichi, 1991, pp. 3-7).

Bolter and Grusin (1999, p. 208) suggest that "the ultimate ambition of the Web designer seems to be to integrate and absorb all other media." In their phrasing, the Web becomes something of a gargantuan meta-medium that threatens to devour other media, while the Web designer becomes the intentional agent of such a takeover. If the Web is seen in this vein as the "ultimate medium" that integrates functions and aesthetics of all other media into its browser interfaces, it becomes difficult to account for media specificity in terms of technological basis, expressive possibilities, or cultures of production and usage. Rather than absorbing all other media, the Web borrows from them, adopting familiar visual practices, communicational functions, and representational forms that become transformed into something different in the process. Web visuality is a form of *bricolage* in which visual elements are borrowed, appropriated, and combined in novel ways. All of this results in its own idiosyncrasies.

Graphic Web interfaces enabled diverse remediation from dictionaries to photographs, newspapers, magazines, advertising, and marketing messages. During the latter part of the 1990s, graphic design was established as a central framework for Web page creation as graphic designers started working on the new platform and Web design was established as a specific skill and profession (Kotamraju, 1999). According to Bolter and Grusin (1999, pp. 198-199), graphic designers brought "to the Web their obsession with visual perfection" and a need to "control the placement and color of every pixel on the user's screen." While it may not be entirely correct to identify design expertise as visual obsession, such orientation toward designed layouts and coordinated color and style schemes was certainly in clear contrast to previous text-based online cultures of experts and hackers. In these, user friendliness or visual pleasures were rather marginal objects of concern (Abbate, 1999, pp. 195-200; Winston, 1998, p. 333; Bolter & Grusin, 1999, pp. 197-200).

The introduction of graphic design principles to Web interfaces transformed ways of thinking about layout, usability, and expressive potential of the medium. It should nevertheless be noted that the skill, definition, or even the term "Web design" did not come into being overnight. As Kotamraju (1999) pointed out, site-design skills tended to be articulated in highly ambiguous terms in the mid-1990s and the term itself was not broadly used before 1997. All in all, site design expertise encompasses a considerably more fluid and broad set of skills than those con-

cerning the visual (or graphic design). If Web design is understood as "the technical process of making Web sites," then its areas of expertise include coding (as with HTML, XHTML, XML, CSS, or JavaScript), the creation of graphics, as well as the incorporation of media elements such as video, sound, or chat on the site (Kotamraju, 2002, p. 5). The profession of graphic design was slow to adapt to Web design and tended to look down on both the possibilities of the Web as a design platform and on design professionals working in the field (Kotamraju, 2002, pp. 7, 10-11). Kotamraju explains graphic designers' initial reluctance toward Web design through the juxtaposition of art and code: graphic designers emphasized their art and skill over the technical mastery of code or the aesthetic limitations set by HTML. In order to become Web designers, they needed to overcome this chasm and learn new skills (Kotamraju, 2002, pp. 11-12). This transition was also facilitated by the fact that the expressive possibilities of the medium widened as Dynamic HTML (DHTML) enabled interactive and animated page designs. As browser version upgrades started to support more features and functions, the technical horizons of possibility setting limits to that which could be visually achieved were continuously broadening.

The aesthetics of site design depend on the capacities of browsers to support file formats, plug-ins, and scripts. Transformations in these have been rapid, given the brief history of the Web as a medium. Newer browser versions also tend to efface memories of previous applications. Kotamraju (1999) has identified this as "time compression" characteristic to the Internet in general and ways of figuring Web design as a profession in particular: "Digital technology permits the evidence of modifications to be written over, erased, replaced, and forgotten with ease, speed, and low cost" (p. 467). Rapid changes in technology influence ways of remembering and forgetting experiences and histories of the Web as a medium. The Web designers Kotamraju interviewed had problems remembering the impact of technical changes that had occurred only a few months ago (Kotamraju, 1999, p. 468; see also Paasonen, 2005, pp. 8-9).

The same goes for memories of using the medium. For example, downloading and using the 1997 version of Netscape 4.0 today makes evident the transformations that have occurred in browser interface design, the possible solutions and experiences that it enables, as well as its potential experience of usage. Although the development from one browser version and upgrade to another seems smooth, going back makes evident the differences in both usability and the overall aesthetic environment. Thinking of Web site design in a historical perspective means acknowledging both the historicity and contingency of the medium (as well as the

tendency to forget its history), and its connections to media culture and contemporary media landscape. Discussions concerning the visual aspects of site design are, by necessity, also ones involving technical solutions, hardware, and software development.

Netscape started to support frames, software plug-ins, animated GIFs, and Java applets in its 2.0 version of 1996. The enabling of sound, animation, and Web cameras also meant that the Web began to remediate video, television, animation, surveillance cameras, radio, and the telephone—gradually, and to varying degrees. Videos and movies began to open up in small "players" (either in separate windows or within the page); users could access home videos, television news, concert videos, film trailers and "teasers," or experimental video art if they were so inclined. In the late 1990s, Web cameras became something of a phenomenon with "camgirls" running their own cameras, porn producers launching their own services, and cameras recording the weather in cities around the world for the interested to observe (see Senft, 2008). With their mosaic, static yet jerky stream of images, Web cameras remediated the "witnessing function" of surveillance cameras by appearing to witness mundane events automatically, independent of visible human intervention or geographical distance, and repeated the objective format of surveillance cameras (some Web cameras eventually provided users with the possibility of choosing angle and focus). Web cameras also involved some of the accessibility and instantaneity of live television. These connections were heightened by the similarity of the television and computer screen (Manovich, 1995a), which created some unity on the level of viewing experience.

Web cameras were popular particularly in the mid- and late-1990s that also saw the rise of reality television focusing on mundane events and so-called ordinary people performing in front of the cameras (O'Riordan, 2002, pp. 53-54). The attraction of Web cameras has been associated with an illusion of transparency, independent of whether they depicted things taking place in urban space, a private apartment, or the cage of a pet rodent (Bolter & Grusin, 1999, pp. 203-208). The "stream" of Web cam images tended to be a far cry from 24 images per second (as used in cinema, for example). The image might refresh every minute or five minutes, or even every hour; the image quality was grainy, and there was generally no sound. Rather than simply or directly repeating the functions and aesthetics of surveillance cameras or television, however, Web cameras gave rise to a particular visual form that was often accompanied by textual communications with the audience (Senft, 2008, pp. 4-5). Web cameras have largely given way to more expli-

citly interactive communication practices, such as Skype or instant messaging (IM), using cameras together with sound and text.

Web interfaces have undergone considerable transformations during the past 15 years to the degree that the medium has basically reinvented itself. Broadband connections and increasing hardware performance have enabled wider use of video, larger image files, multimedia, and elaborate visual interfaces. Content familiar from other media has been shifted to and shaped by online platforms, which have, for their part, been invested with some degree of hype (that was partially disturbed, but hardly effaced by the burst of the dot.com bubble in 2000). In the course of the 1990s, the Internet came to stand for new media in journalism, advertising, and research alike, while the Web came gradually to stand for the Internet. As representative of new and digital media, the Web and its possibilities were largely defined against older and analog media, such as print or television. In such juxtapositions, the analog "stands for the traditional mechanical and photochemical processes in production and reproduction; digital stands for electronics and the future" (Zielinski, 1999, p. 273). While binary conceptualizations such as new and old, digital and analog, are obviously one effective means of structuring and categorizing the field of media, they come with some analytical limitations.

In studies of visual culture in the 1990s, digital images were associated with a cultural crisis concerning the truth-value of photographic imaging as well as a crisis of "faith" in photographic images as records of that in a particular time and space. No such debates really occurred in the context of digital sound or hypertext (Lister, 1995; Elsaesser, 1998). Drawing heavily on studies of photography and cinema, this discourse (also referred to as "post-photography") worked to frame digitization as a metaphor for a cultural crisis. Rather than referring to any particular technology, digitization became a framework for discussing transformations in the production, distribution, and consumption of media, the status of the visual, as well as the relationships of visual representation, realism, and reality (Elsaesser, 1998).

Images to Trust

Images published on the Web are generally characterized by relatively low resolution. According to the standard, browsers display image files as 72 pixels (or "dots") per inch, while the resolution for print images is at least 300 dpi. Low resolution makes files relatively small in size and quicker to download. Whether the file in question is a digital photograph, drawing, or a graphic element (ball, orna-

mental stripe, or a text saved as an image file), it is in all likelihood a GIF, JPEG, BMP, or PNG file with a resolution of 72 dpi. As digital files, they consist of series of zeros and ones, the order of which can be altered with algorithms, and their appearance and size is open to virtually endless alteration.

Categorizing such image files as "photographs," "drawings," or "graphics" is a question of aesthetic categorization. These categorizations have no basis on the materiality of the images (since they are all electronic files), or the means of generating them (with a camera, by hand, or by computer), but on frameworks of interpretation. Photorealism can be achieved by generating images with software or by merging photographs with graphics of drawings. The perennially popular software application PhotoShop provides various filters for modifying photographs toward more graphic appearance, for example, with brush or pencil strokes, fresco, pallet knife, mezzotint, or mosaic filters. The ensuing images can be printed on canvas in resemblance of an oil painting, while photorealistic graphics can be printed on photo paper in order to maximize the desired visual effect.

With digitization, the boundaries between production and post-production, shooting and editing have become blurred in photography and cinematography alike. Digitization has blurred conventional definitions of the photographic, given that things seen in photographs have not necessarily been generated with a camera (or let alone on film). Since the early 1990s, the so-called post-photographic turn inspired debates over the loss of proof-value of photographic images, as theorized within semiotics. More precisely, digital imaging was seen to mark a break from the tradition of explaining the functions of photographs through Peirce's concepts of the icon and the index. According to Peirce and Hoopes (1991, pp. 181-183), icon is a sign that stands for its referent through likeness. Icons are representative, as in the classic example of passport photographs. Index is a trace, a sign created by the presence of the signified (like footprints in the snow, or a photograph caught on film). Elsaesser (1998, p. 207) points out that "the indexicality of the trace is so bound up with the iconicity of the likeness that it has, in some ways, confused these categories." Indexicality has been the basis of the status of photographs as evidence, marks and imprints, as images that record that which has taken place. As Barthes (1983) rather poetically put it, the

> "photograph always carries its referent with itself, both affected by the same amorous or funeral immobility, at the very heart of the moving world: they have been glued together, limb by limb, like the condemned man and the corpse in certain tortures: or even like those pairs of fish (sharks, I think, according to Michelet) which navigate in convoy, as though united by an eternal coitus" (pp. 5-6).

Mitchell (1998) makes the point more prosaically: "Photographs seem to bond image to referent with superglue" (p. 28). If traditional photographs denote physical reality and refer indexically to that which has been, this is not the case with digital photographs. For Mitchell (1998), the difference between digital and traditional photography "is grounded in fundamental physical characteristics that have logical and cultural consequences" (p. 4). Mitchell identifies the blurring of the categories of mechanically produced and hand-made images as one of the most important consequences. Traditional photographs result from the mechanic movement of the camera's shutter and photochemical processes involving film, chemicals, and photographic paper. Since digital images have far less certain origins, they oscillate between visual art, graphics, and photorealism (Mitchell 1998, p. 60). Critiquing Mitchell's views, Manovich (1995b) is particularly dubious of his basic distinction between mechanical and digital photography, in which the former is seen as direct and truthful, and the latter, due to its internal mutability, as disturbing and questioning the relations of the signifier and the signified.

Mechanically produced photographs have been manipulated and retouched throughout their history. While merging several images, editing out elements, or adding new ones has been made easier by digital imaging technologies, this does not mean that such practices are novel as such. Crossing the binary division of old and new, analogical and digital media technology, Manovich suggests rephrasing the question as one concerning two paradigms of visual culture: the one realistic, and the other connected to collage and montage that breaks up the spatiotemporal unity of the image. In Manovich's view, there has never been a single dominant way of reading photography, and realistic photography has been only one tradition among many. Mitchell's study of post-photography, originally published as early as 1992, can be critiqued for foregrounding abstract reflections on the ontological status of photography while paying far less attention to the diverse uses of photographs, or the social and cultural conventions of making sense of them. Ways of understanding images as photorealistic (as truthful or lacking in truth-value) are underpinned by cultural codes and contexts of usage. Generalized arguments over the status and meaning of images based on their technological origins cannot account for their travels across different publishing platforms.

Paradigms for Reading Pictures

Visual practices do not follow any neat techno-conceptual divisions of the analog and the digital. As digital images are printed out as photographs and stored in al-

bums, or when photographs are scanned and altered, ontological and epistemological questions concerning their truthfulness tend not to be ones of primary concern. In other words, the post-photographic crisis discourse seems to have a random connection to the practices and experiences involving digital images. With Web visuals, it can be claimed that image manipulation and modification are more the norm than the exception. Most images are altered in some ways before uploading—be this in terms of size, color balance, hue, file format, resolution, or cropping—without such modification challenging their status as photographic images. Claiming that all images published on the Web would be interpreted through the same semiotic codes since they are digital image files with the same resolution is obviously too weak an argument to be bothered with. Holiday snapshots published in blogs or photo-sharing sites (the framework of amateur photography), news pictures in online newspapers (the framework of journalism), images in online art galleries (the framework of visual art), home pages of institutions (the framework of promotion and public relations), or e-shopping sites (the framework of advertising and commerce) belong to obviously different visual regimes. For example, in journalism, photographs are assumed to be authentic, non-manipulated (unless stated otherwise), and taken in the time and place stated in the caption (see Mitchell, 1998, pp. 218–222). Journalistic images illustrate new items and bear witness to current events, whereas in the visual arts, fictitiousness and photorealism tend to be understood as aesthetic categories that shape ways of interpreting images. Addressing, reworking and playing with these codes may well be the main focus of artistic work.

Amateur photography (so-called "family snaps" and, to a far lesser degree, amateur video) has been one central arena of visual remediation from the personal home pages of the 1990s to contemporary social networking and photo-sharing sites. Independent of their technologies of production, personal photographs present visual proximity in the sense of functioning as records of everyday life, as a visual memory produced by and for one's self, friends, and family. This set of images relies on indexicality and iconicity in terms of the people, events, and places depicted while also relying on an assumed textual innocence of amateur photography (Zimmermann, 1995, pp. xi–xii; Citron, 1999, p. 17; Kuhn, 1995, pp. 16-20, 42). Defined against its hierarchical opposite—the professional—an amateur photographer or a hobbyist Web site designer is assumed to operate simpler versions of technical equipment and software and to work for the purpose of pleasure on his or her leisure (Zimmermann, 1995, p. 1). While the relation of the sign and the referent, and the ability of media representations to convey reality have been

widely questioned in discussions on digital imaging and post-photography, "the photographs we take ourselves are meant to tell the truth in a way which we would no longer expect of any publicly placed picture" (Slater, 1995, p. 145). Personal photographs used in blogs, personal home pages, social networking profiles, or personal ads carry historically formed codes of amateur photography that set limits to the play of the sign, the signifier, and the signified.

Assumptions concerning image manipulation or visual authenticity are clearly redrawn on commercial and promotional Web sites. Here, images are hardly assumed to be "direct" in the sense of conveying any particular realness. Product displays with coordinated colors and matching backgrounds, images of happily smiling model customers or friendly employees can by all means be read as indexical signs of things depicted. Considering the standard practice of image manipulation, this is far from certain and hardly the most central of issues when investigating their meaning. Furthermore, this uncertainty spans from Web pages to printed and electronic ("analog") publicity texts and advertisements created by PR and advertising agencies. Ways of looking at advertisements are structured by viewers' awareness of the fact that these images aim to influence them: to produce positive associations, to gain recipients' trust, interest, and ultimately a will to purchase. These appealing displays are in all likelihood read less as traces of reality than as representations standing in for and substituting reality—as texts that aim to produce a certain framing or impression of reality.

Such examples of personal and promotional photography, their adjoining codes and conventions of interpretation, make visible some of the problems inherent in generalized overviews on digital imaging as marking a cultural crisis. Furthermore, both promotional and personal (amateur) practices make evident the centrality of commercial cultures in digital imaging and visual culture. As Slater (1995) and Zimmermann (1995), among others, have pointed out, the history of so-called home media is a commercial one involving cameras, film, developing services, as well as guidebooks and special interest magazines providing amateur photographers with representational guidelines and aesthetic norms. With the Web, products and services catering to the hobbyist site designer have spanned from scanners and digital cameras to image manipulation software, guidebooks, site templates, hosting services, personalized domain names, and a range of publishing platforms.

Histories of the Graphic

The roots of digital imaging, computer technology, and information networks all lie in U.S. military experiments and interests. The relations of military institutions and those developing computer technology have often been symbiotic (Manovich, 1995a; Darley 1991). The first drum scanners for digitizing images were built in the 1950s. According to Darley, until the late 1960s it was possible to identify two paradigms within digital imaging: engineering (with a technical focus) and modernism (focusing on experimental art), and the two often collaborated closely together. Funding for experimental projects combining engineering and artist practices was gradually cut as the entertainment industry and the media started to show increasing interest in digital imaging in the 1980s. With commercial exploration and application, visual experimentation shifted from the paradigm of modernist aesthetics to that of graphic design. According to Darley (1991), the nowadays widely used term *computer graphics* was only launched once the paradigm of graphic design took over, and as the possibilities of digital imaging were increasingly applied to commercial ends (as in television shows, advertising, music videos, or cinema). With computer graphics, graphic design became the key framework for discussing, conceptualizing, and developing technologies and skills related to digital imaging.

The framework of graphic design has been crucial for research and product development in digital imaging, and remains so in the context of Web design (after all, the Web is all about graphic interfaces, often created by designers). Web graphics refers to the overall page design and layout in which visual, textual, and variously animated elements are mixed together to structural and thematic solutions, to color schemes, and to the site's overall design functions and hyperlinks (see Kotamraju, 2002). As design elements, photographs are only one visual element among many others. This broader visual entity provides them with a new interpretative framework: not only the individual images but, far more centrally, the page and site design provides users with interpretative guidelines. Manovich (1995b) has addressed such use of photographs as *graphic elements among others* in the tradition of commercial photography and advertising. In advertising, the boundary—as well as differences—between images created by hand or by technical means are fundamentally blurred as photographs are merged with text, graphic elements, and other visual elements into an assemblage comprising a new graphic entity. Such use of images, whether digital or analog, is based on the principles of collage (which Mitchell associates exclusively with digital imaging). For Manovich,

there is in fact no such thing as "digital photography" but merely a tradition and continuum of *the graphic* that encompasses photography, graphics, and analog and digital imaging technologies. Rather than pondering the crisis of photography related to digital imaging, Manovich's suggestions point to a conceptual and theoretical shift toward analysis of graphic cultures cutting through various visual technologies and aesthetics, and disturbing any clear divisions between analog and digital technologies. Animated GIFs provide one possible example of such histories and their reverberations within Web graphics.

In addition to singular still images, Web sites feature a range of moving images from video to animated icons and banners, Shockwave and Flash animations. Small, looping and often flashing, animated GIFs were the precursor to moving Web visuals. Initially used on all kinds of sites, animated GIFS became, in the course of the late 1990s, markers of amateurism that have been most generally used on personal home pages (and, more recently, in personal profiles on some social networking sites). Mailboxes opening and closing, stars twinkling, skulls winking, smileys, atoms, flames, and various moving objects from rotating disco balls to tornados or hourglasses have been used in sites hosted in different parts of the world. While simple to make, animated GIFs tend to be downloaded from online galleries similarly to wallpapers or icons. Small and quick to load, they are used similarly to icons and clip art files—for attracting attention to the page's features (it tends to be common knowledge that a mailbox implies the possibility of sending e-mail, or that a man with a shovel implies the site is under construction), or for livening up otherwise static and text-based pages. Applets, small programs created with Java and supported by browsers since 1996, have been used especially for creating diverse motion effects in still images.

In terms of their visual style, animated GIFs resemble short comic strips, cartoons, clip art files, three-dimensional logos, and text elements created with computer graphics. Considered in the context of visual culture, these animations connect to the traditions of animated film and moving graphics. In his study of animation film, Klein (1998) discusses a continuum of *graphic narratives* developed since the 18th century, including cartoons and illustrations of late 19th-century newspapers, 20th-century traditions of caricature and visual narration, as well as animated film. Muybridge's animal and human motion studies conducted since 1877 have been generally seen as precursors to cinematography, whereas according to Klein (1998), his contemporaries saw them as graphic narratives similar to optical gadgets and innovations of the time, such as zoetropes, thaumatropes, or phenakistoscopes. These devices used drawings in order to create an illusion of

movement and relied on visual simplification, surface, rhythm, repetition, and line in doing so. Considered in this framework, animation is much less a sub-genre of cinema (based on techniques of photography) than a form of graphic narrative. Images for optical gadgets and animation film were made by well-established draftsmen and illustrators for whom these new "platforms" were parallel, rather than representative of any paradigmatic shifts in visual representation (Klein, 1998, pp. 3-7, pp. 12-14; Huhtamo, 1997, pp. 82-84; Huhtamo, 2000).

Cinematography and photography are explicitly connected to the graphic already in terms of etymology. All three terms derive from the Greek word *graphikos*, concerning painting or drawing. The graphic continuum both precedes and exceeds the cinema. Like previous graphic innovations and gadgets, Thomas Alva Edison's early mutoscope pictures were based on repetition, looping images, and scenes. As cinema developed both aesthetically and technically, it became predominantly narrative in form. As Manovich (1995c, p.x) puts it, "Everything which characterized moving pictures before the twentieth century—the manual construction of images, loop actions, the discrete nature of space and movement—all of this was delegated to cinema's bastard relative, its supplement, its shadow—animation" (p. x). Unlike cinema, animation (this bastard relative) continued to heighten and underline its artificiality and excess.

Online animations have not been predominantly occupied with narrative but connect more to the tradition of graphic narratives and their attractions of motion, transformation, and repetition. Cartoon characters and their characteristic gestures, such as Felix the Cat pacing back and forth lost in his thoughts, Snoopy sleeping on his doghouse, or Calvin and Hobbes wildly dancing, were easy to appropriate as animated GIFs. Like mutoscope films, phenacistoscope disks or zoetrope images, these animations loop and resemble animated cartoons that regularly involve characters defying gravity and metamorphosing in shape and form (Klein, 1998, pp. 22-23; also Huhtamo, 2000, p. 139; Huhtamo, 1997, pp. 85-86). With Flash, animations have become increasingly graphic in the sense of foregrounding shapes, colors, patterns, their two-dimensional transformations, and collage over any "cinematic" or photorealistic effects.

More Than Film

In 1999, the book *Website Graphics Now! Best of Global Site Design* addressed the (then novel) techniques of JavaScript, Flash, and Shockwave animation. Its preface stated that "what works for the movies, will work on the Web ... Tell a good story

and we will listen. Make it look good and we will keep our eyes on it. And make it work well, so we don't switch off before the Happy Ending" (Spiekermann, 1999, p. 5). In other words, the preface framed cinema as the penultimate goal of Web design and a criterion of rich content. The formulation may seem odd in retrospect, given its emphasis on narrative and Hollywood aesthetics in the context of Web site design that has since developed into increasingly graphic direction in terms of visual display. Cinema, along with television, was the dominant medium of the 20th century that novel media have challenged, complemented, and converged with. Given this—as well as the convention of interpreting photorealism as conveying the real (Manovich, 1995b)—it is hardly surprising that the increasing use of moving image and audio online has been identified by some as technical and aesthetic "perfection."

Since 1999, the increase in broadband connections and developments in computer and browser performance has certainly meant that Web interfaces are becoming increasingly visual and multimedia, but hardly cinematic. Rather, the development of site design points to a need to depart from cinema as a dominant framework for thinking about moving-image culture—let alone visual culture—and to redefine it more broadly in terms of the graphic. The abovementioned book has certainly not been the only instance of cinema being introduced as an aesthetic norm or template for making sense of visual culture. The discipline of cinema studies has tended to dominate ways of narrating the history of optical gadgets. Consequently, they have been defined as "pre-cinematic" and pinned down in a specific technological and aesthetic history, rather than investigated in historical context as developments and practices independent of, although preceding or parallel to, the development of cinema as a cultural form (Huhtamo, 2000). Similarly, online animations from Flash to machinima, or various forms of streaming media, point out the necessity of studying multimodal and intermedial contexts and connections without reducing the variety of visual practices to notion of "the cinematic."

The "graphic continuum" approach for thinking about visual content online ties together the traditions of photography, painting, and graphics often understood as clearly separate or even opposing paradigms and fields of practice. Divisions have been made, for example, between the expressive paradigm of visual arts and the (photo)realistic or photographic mode of representation (Elsaesser, 1998, p. 205; Hollander, 1991). The graphic continuum cuts through media history; it heightens the ties between various technical applications and their visual attractions, and considers continuity and variation without resorting to assumptions of

automatic or fundamental rupture caused by the introduction of new technologies. Whereas scholars addressing the "crisis of the photographic," such as Mitchell (1998), have focused on the differences between the indexical, mechanically recorded photographs and digital (graphic) imaging, Manovich has aimed to recontextualize both forms of imaging as belonging to the category of the graphic. Such an approach seems fitting to considerations of Web site design in a historical context of visual practices. Seeing the field of the visual as structured by the graphic provides an alternative point of departure for thinking about site design. Rather than returning to notions of photorealism (and the adjunct debates concerning truth-value in digital imaging, as waged since the mid-1990s), visual practices online need to be seen as fundamentally hybrid, multimodal, and as incorporating visual elements into new kinds of graphic assemblages. Such a perceptual shift also necessitates thinking beyond the juxtaposition of the analog and the digital (or old and new media). Instead, the visual aspects of Web site design need to be considered in the framework of not just graphic design but equally that of a graphic continuum from print media to illustrations, animation, and collage.

It's Not All the Same

The visual rhetoric of Web design involves intermedial and media historical connections, generic conventions, and codes of interpretation. Web sites are a central component of contemporary visual culture, and their intermedial connections go several ways. These involve, for example, aesthetic affinities between Web graphics, flyers, and other forms of contemporary consumer graphics, or the use of menus, tables, and forms in book layout, television, or cinema. In the early 2000s, several television channels in my native country of Finland introduced popular TV chats shown after the end of actual programming. Following the format of online chat, participants send SMS messages that appear on the screen (that becomes transformed into a televisual chat room) while occasional hosts or guests appear in a separate window next to the text field. Initially building on the aesthetic novelty of TV chat, such programming has since become standard. Remediations between Web and television concern not only the structure and feel of the interface but also uses of language and forms of communication—and these, of course, are difficult to tell apart.

Considering intermedial connections in a broader cultural context, it should be noted that popular media are fundamentally intermedial: the same visual materials are distributed on film, television, and gaming as on online platforms or in

print media. As Lehtonen (2001) has argued, digitization of media culture increases such intermediacy, the recycling and marketing of media contents, stories, and characters from one platform to another. All this necessitates accounting for the visual rhetoric of Web sites as something resulting from the circulation of visual elements across the field of media, and as involving bricolage through which these elements are transformed and set in new (technical, aesthetic, and interpretative) frameworks while still remaining recognizable themselves.

This chapter has investigated the visual aspects of Web design in relation to debates concerning the status and meaning of photographic imaging technologies, paradigms for interpreting images, as well as the possibilities of conceptualizing the history of visual technologies as one involving a continuum of the graphic. In an aim to situate Web graphics in the context of visual culture, I have addressed various representational forms and traditions side by side without discussing their specific origins and by highlighting their tendency to intertwine in terms of practices of media production, usage, and modes of interpretation. This approach may, however, risk blocking media specificities and technological transformations from view—or even creating a falsely smooth narrative of progress from one medium or distribution platform to another. While not one medium or the visual practices related to it can be reduced to any other, neither should a medium be explained through or in terms of another (as has occasionally been the case with the uses of cinema as template for understanding other visual media). In other words, considerations of Web visuals in the framework of the graphic continuum need not lead to aesthetic, technological, or historical reduction of Web aesthetics to visual conventions already introduced and circulated in other media. Rather, I see historical frames of interpretation as essential for a contextual understanding of how media develop, how they are made use of, and how they become situated within broader media culture.

The skill and profession of Web design is a recent one. As Kotamraju's studies (1999; 2002) point out, it came into being gradually after the launch of the graphic browsers and has functioned as an umbrella term for a variety of skills and tasks. Web design has not been the sole proprietary of graphic designers, and the field of site design is by definition broader than one concerning graphics. The introduction of templates and dynamic HTML shaped the Web radically as a visual environment in their emphasis on coordinated colors and the overall centrality of visual styles. Graphic interfaces are more explicitly about graphic design than they were a decade ago, but parallel to this development there exists a broad range of visual styles, genres, and practices ranging from hobbyist photo-sharing sites to

visual art forums, modding (such as the modification of graphic game characters, settings, or objects), or amateur, semi-amateur and professional pornography delivered in virtually endless styles and formats. Although the Web has become an increasingly commercial and designed environment, it accommodates a diversity of visual practices that call for contextual approaches that do not block the surrounding media culture, its histories, institutions, or economies from view.

References

Abbate, J. (1999). *Inventing the Internet*. Cambridge, MA, and London: MIT Press.

Barthes, R. (1983). *Camera Lucida: Reflections on photography*. Richard Howard (trans.), from *La chambre claire* (1980). New York: Hill and Wang.

Bolter, J. D., & Grusin, R. (1999). *Remediation: Understanding new media*. Cambridge, MA, and London: MIT Press.

Citron, M. (1999). *Home movies and other necessary fictions*. Minneapolis: University of Minnesota Press.

Darley, A. (1991). Big screen little screen: The archaeology of technology. *Ten-8*, 2(2), 78-87.

Elsaesser, T. (1998). Digital cinema: Delivery, time, event. In T. Elsaesser, & K. Hoffman (Eds.), *Cinema futures: Cain, cabel or cable? The screen arts in the digital age (pp. 201-222)*. Amsterdam: Amsterdam University Press.

Hollander, A. (1991). *Moving pictures*. Cambridge, MA, and London: Harvard University Press.

Huhtamo, E. (1997). *Elävän kuvan arkeologia*. (Archeology of the Moving Image). Jyväskylä: YLE.

Huhtamo, E. (2000). Esielokuvasta elävän kuvan arkeologiaan: pohdintoja eräästä murroksesta audiovisuaalisen kulttuurin tutkimuksessa (From Pre-Cinema to the Archeology of the Moving Image). In A. Koivunen, S. Paasonen, & M. Pajala (Eds.), *Populaarin lumo--mediat ja arki* (The Lure of the Popular--Media and Everyday Life) (pp. 132-146). Turku: University of Turku.

Klein, N. M. (1993/1998). *7 Minutes: The life and death of the American animated cartoon*. London and New York: Verso.

Kotamraju, N. P. (1999). The birth of Web design skills: Making the present history. *American Behavioral Scientist* 43(3), 464-474.

Kotamraju, N. P. (2002). Keeping up: Web design skill and the reinvented worker. *Information, Communication & Society*, 5(1), 1-26.

Kuhn, A. (1995). *Family secrets: Acts of memory and imagination*. London and New York: Verso.

Lehtonen, M. (2001). On no man's land. Theses on intermediality. *Nordicom Review* 22(1), 71-84.

Lister, M. (Ed.) (1995). *The Photographic image in digital culture*. London: Routledge.

Manovich, L. (1995a). An archeology of a computer screen. Retrieved October 15, 2008, from http://www.manovich.net/TEXT/digital_nature.html.

Manovich, L. (1995b). The paradoxes of digital photography. Retrieved October 15, 2008, from http://www.manovich.net/TEXT/digital_photo.html.

Manovich, L. (1995c). What is digital cinema? Retrieved October 15, 2008 from http://www.manovich. net/TEXT/digital-cinema.html.

Mitchell, W. J. (1992/1998). *The reconfigured eye: Visual truth in the post-photographic era.* Cambridge, MA, and London: MIT Press.

O'Riordan, K. (2002). Windows on the Web: The female body and the Web camera. In M. Consalvo, & S. Paasonen (Eds.), *Women and everyday uses of the Internet: agency and identity* (pp. 44-61). New York: Peter Lang.

Paasonen, S. (2005). Net years, pioneers, and flat perspectives: Temporality and Internet research. In M. Consalvo, & M. Allen (Eds.). *Internet Research Annual, Volume 2* (pp. 4-14). New York: Peter Lang.

Peirce, C. S., & Hoopes, J. (1991). *Peirce on signs: Writings on semiotic* Chapel Hill, NC: University of North Carolina Press.

Senft, T. M. (2008). *CamGirls: Celebrity and community in the age of social networks.* New York: Peter Lang.

Slater, D. (1995). Domestic photography in digital culture. In M. Lister (Ed.) *The photographic image in digital culture* (pp. 129-146). London: Routledge.

Spiekermann, E. (1999). Learning from Hollywood. In Mediamatic (Ed.), *Website graphics now: The best of global site design* (p. 5). Amsterdam: BIS Publishers.

Tichi, C. (1991). *Electronic hearth: Creating an American television culture.* New York and Oxford: Oxford University Press.

Winston, B. (1998). *Media technology and society. A history: From the telegraph to the Internet.* London: Routledge.

Zielinski, S. (1999). *Audiovisions: Cinema and television as entr'actes in history.* Amsterdam: Amsterdam University Press.

Zimmermann, P. R. (1995). *Reel families: A social history of amateur film.* Bloomington and Indianapolis: Indiana University Press.

Chapter Three

An Elemental Approach to Web Site Visuals

Valerie V. Peterson

Visuals of Web sites can be assessed screen by screen, and across connections or "threads" made to other screens. To assess the visuals of Web sites, both aspects of interfaces should be considered. This essay describes existing approaches to Web site visuals and argues for the comparative virtues of a rhetorical approach. It begins with a discussion of the rhetorical criticism of visual communication and reveals problems with traditional rhetorical means of analysis. An alternative "elemental" rhetorical schema for the analysis of visuals is offered, and its usefulness for critical practice of Web site visuals is outlined. Finally, a sample analysis is provided to show how such assessments might be done and to suggest what helpful insights they might provide.

To spin is to twist, and also to make thread. Communicating on the World Wide Web (hereafter called the Web) is related to both meanings. On the one hand, because the Web is a communication medium with its own peculiar possibilities and constraints, verbal and visual information on it is "twisted." The Web reminds those who engage it critically of the spurious distinction between form and content and the relative (but not arbitrary) natures of meaning and truth. Twisting also suggests the tropes (turns) of rhetoric and also the "spin" of media; both are concerned with design elements of communication and their persuasive impact on audiences.

On the other hand, because the Web is a system of connections, messages follow pathways (or "threads") of transmission. Words and images are sent to and from select audiences via screens that are connected to other screens (and the software behind them). These connections, like those of a spider's web or the knots in a hammock, mean that the impact of a word, image, message, screen, or Web site is related to the way its web connections have been threaded or "spun."

Consequently, it is also important to consider the ways connections have (or have not been) designed to lead users to other parts of the Web, with all their ensuing possibilities.

To assess the visuals of Web sites, both "twisting" and "threading" elements of spin should be considered. Initially, assessment of Web site visuals is most associated with the "twist" of communication and can be done screen by screen. On each screen, evaluators can assess the "twist" or suasory impact of visual elements. Exploring connections or "threads" made to other screens expands the possibilities for Web site assessment by opening analysis to the logic and flow of chains of connection themselves. Using these methods, visual assessment may contribute to a more comprehensive understanding of Web sites and their impact.

In the following pages, existing approaches to Web site visuals are described and an argument is made for the comparative virtues of a rhetorical approach. Next, a discussion of the rhetorical criticism of visual communication reveals problems with traditional rhetorical means of analysis. Then, an elemental rhetorical schema for the analysis of visuals is offered and its usefulness for critical practice outlined, especially with regard to Web site visuals. Finally, the value of this elemental approach to visual communication is illustrated by an exemplar Web site visual analysis and assessment.

Existing Approaches to Web Site Visuals

Public and private institutions have gone online hoping to cut costs, expand markets, and encourage various economies and communities. They have built Web sites in order to maintain and improve their reach, image, sales, and/or standing. Individuals have also increasingly turned to Web sites as avenues through which they may conduct business and personal communications. For these and other reasons, well-designed Web sites are growing increasingly important. Books, Web sites, scholarship, and businesses that specialize in Web design proliferate. Despite all of the commentary and literature on Web sites and Web visuals, however, much of it still suffers from at least one of three problems: absence of focus on audiences, an excess of technical jargon, and a focus on practical tactics of Web design over more general visual aesthetics.

How-to approaches to Web design can lead to an absence of focus on audiences. Books and Web sites concerned with teaching people how to create and maintain Web pages are addressed to those who do the designing; they are not as focused on the end user. Books such as *Creative HTML Design* (Weinman &

Weinman, 1998), *Paper Prototyping* (Snyder, 2003), *Building the Service-Based Library Web Site* (Garlock & Pointek, 1996), *Creating Killer Web Sites* (Siegel, 1997), *Cybrarian's Manual 2* (Ensor, 2000), *Web Design Tools and Techniques* (Kentie, 2002), *Building a Web Site for Dummies* (Crowder, 2004), and *The Non-Designer's Web Book: An Easy Guide to Creating, Designing, and Posting Your Own Web Site* (Williams & Tollett, 2006) are good examples of such texts. These books devote a majority of space to matters of construction: networks, means of network connections, HTML and other programming languages, etc., but less space discussing matters related to end users and their experiences of the site. When end users are discussed, their experience with sites is often discussed generally, e.g., "Users can get lost or frustrated looking for what they need. The means of obtaining basic information should be obvious" (Garlock & Pointek, 1996, p. 50).

Technical jargon is a problem related to lack of audience focus and can lead to one-way communication about Web sites and Web visuals, especially in more advanced texts. Computer terminology from programming and graphic arts makes it difficult for people who are not at least partly fluent in these languages to understand or share observations and advice (e.g., Lopuck, 1996). This is not only true of many how-to style texts, but also of scholarship about the Web and how people use it. Additionally, scholarship imports other specialized vocabularies (of psychology, perception, etc.), which can further complicate the communication of ideas and assessments (e.g., Forsythe, Grose & Ratner, 1998). Technical jargon privileges Web page literatures and the people who use them regularly, leaving many newer programmers and even more end users without equivalent means to comment upon what they experience.

The third problem with Web site and Web visual literatures is their emphasis on practice and tactics over praxis and visual aesthetics. Instead of explaining or asserting principles or theories behind elements of Web site design, many literatures concentrate on Web design ideas that may be approximated or borrowed wholesale. *Secrets of Successful Web Sites* (Siegel, 1997) *Elements of Web Design* (DiNucci, Giudice, & Stiles, 1997), *Color Harmony for the Web* (Boyle, 2001), and *1,000 Graphic Elements: Details for Distinctive Designs* (Harvey, 2004) offer this sort of direction. While they suggest color schemes, the modeling of other Web sites, and a variety of techniques of Web site design and construction, they say less about how and why these schemes, sites, and techniques are relevant to and might variously affect different audiences.

These problems suggest rhetoric as a solution. Because rhetoric is concerned with audiences and their experiences, recognizes the importance of shared vocabu-

laries, and is at home with theory and aesthetics as well as with practical applications, it could be a useful place to turn for help with the analysis of Web site visuals.

Rhetoric and Visual Communication

Visuals can be persuasive in various ways. Scholarship on visual communication often tries to explain how this works. Theorists and critics of art and media (e.g., painting, film, and television), for example, have developed sophisticated vocabularies of description and aesthetics as a way to account for visual effects (e.g., Mettalinos, 1996; Zettl, 1999). As the kind, number, and complexity of man-made images to which people are exposed increases, so too do the number and kinds of studies devoted to visuals and their impact. The recent appearance of books, journals, and conferences concerned primarily with visual communication and its social significance reflects the visual realities of modern life (e.g., Evans & Hall, 1999; Lester, 2000; vanLeewen & Jewitt, 2001; Smith, Moriarty, Barbatsis & Kennedy, 2005; Jamieson, 2007; *Visual Communication Journal*, first volume published by Sage Publications, February 2002; the Biennial Kern Conference on Visual Communication and Technology (since 2002), Viscom conferences since the 1990s, etc.).

Rhetorical scholars in the United States have traditionally been concerned with persuasion in speech and language but their attention to visuals in the past 10 years or so has increased substantially. Those who first ventured into the world of visual rhetoric often discussed the use of images "painted" with words (e.g., Kaplan, 1990), explained how visuals complemented words and texts (e.g., Morello, 1992), and/or applied traditional, language-centered vocabularies of rhetorical theory to the images at issue (e.g., Olson, 1987, 1990).

Recently, however, rhetorical scholars have tried to approach visual communication as "ocularcentric rhetoric" (Gronbeck, 1998). Ocularcentric rhetoric recognizes visuals as part of a visual system of relations in which power is exerted and negotiated. This system of relations or "scopic regime" is seen as political and grounded in a vision-based epistemology (Gronbeck, 1998). These scholars may be taking their cue from different but related fields of study where vocabularies of rhetoric have been used to explain visual practices of and in various media (see, for example, Burgin's extensive discussion of figures of speech in "Art, Common Sense, and Photography," 1997). Rhetorical scholarship and theory based on ocularcentric rhetoric takes visual communication as a primary concern and treats it

as a unique phenomenon (e.g., Birdsell & Groarke, 1996; Blair, Jeppeson & Pucci, 1991; Edwards & Winkler, 1997; Foss, 1982, 1986, 1987, 1988, 1993, 1994; Foss & Kanengeiter, 1992; Hariman & Lucaites, 2001, 2002, 2003; Jamieson, 1992; Hill & Helmers, 2004; Lake & Pickering, 1998; Lancioni, 1996; Medhurst & De-Sousa, 1981; Rosenfield, 1989; Scott, 1994; Twigg, 1992).

Some years ago, an essay was published describing a schema for the rhetorical criticism of visual elements (Peterson, 2001). The value of this schema comes from its starting point. Instead of beginning the task of visual criticism by identifying *the image,* this schema begins the critical task by assessing visual *elements.* This shift in approach avoids many of the pitfalls of earlier approaches and lends itself well to the analysis of Web site visuals. Rather than replicate all the arguments made in that essay, this essay will briefly identify pitfalls of earlier approaches and explain why the elemental schema is better suited to analysis of certain kinds of visuals.

Traditional Rhetorical Approaches to Visual Communication

In traditional rhetorical approaches to visual communication, judgments of the aesthetic quality and effectiveness of visuals are made in terms of the *function* communicated by an *image* (e.g., Foss, 1994). The process of assessment moves from identification of the function of an image, to an assessment of the fulfillment of that function by the image, and finally to an evaluation of the legitimacy of the function. Problems with traditional rhetorical approaches to visuals include giving undue precedence to visual images, circularity, separating function from aesthetics, and reliance on modernist assumptions about intentionality, authorship, and identity that may not work with postmodern media.

Starting the critical process with visual images overlooks the complexities of perception. To put it more precisely, by giving undue precedence to images, traditional rhetorical approaches to visuals participate one too many times in the process of interpretation. This error occurs because vision is taken as a simple matter of image-identification and not as a complex physiological process (where image-identification may result). As eye-movement studies have shown, viewers can't focus visual attention on everything in the visual field at once, so certain things are selected to look at (Ornstein, 1972). Light, which varies with environment, is registered by photoreceptors and processed by retinas and nerve fibers. A large amount of information processing is done at the eye level, more than in the brain,

and "even the eye filters out information" (Hanson, 1987, p. 39). "[T]he brain processes individual properties such as colors, textures, the edges of objects, light and shadow, and motion separately and brings them together into an image" (A. A. Berger, 1998, p. 15). Physical variables (e.g., blood sugar level), previous pathways of neuronal firings in the brain (e.g., memory), and other factors all affect the seeing of images. How the brain pieces together images is still "something of a mystery" (p. 15), but what is known is that images appear (are "made out") *late in the process of visual perception*, already affected by our environment, our physiology, what we know, and what we believe (J. Berger, 1972, p. 8).

Circularity is the consequence of putting the (interpretive) cart before the (perceptual) horse. Traditional rhetorical approaches to visuals see visuals as *images*. But images are already the result of the cognitive machinery of particular viewers (interpretations) and are thereby shaped by those viewers' perceptions, knowledge, and beliefs. The first part of the process (the seeing and interpreting of the image itself) is not discussed or defended, though it sets up all further analysis. Self-fulfilling critical prophecy is often the result. By not venturing to account for the first part of the process of seeing, traditional critics are left with a "critical looking glass where they find what they expect to find and see what they can't help but see" (Peterson, 2001, p. 22).

Traditional approaches to visual communication also inappropriately separate function from aesthetics. Foss (1994), for example, argues "what makes aesthetic perspectives on evaluation unsatisfactory for application in a rhetorical realm is that their aim is to identify artistic merit or aesthetic excellence; they are not concerned, as are rhetorical critics, with the influence of images on audiences and the way images are constructed to affect such influence" (p. 214). Like other false dichotomies, this distinction misses the way the two realms overlap and the ways vocabularies of fine and graphic arts may be used for the purposes of visual analysis. It also misses the role beauty plays in assessments of excellence.

Finally, traditional approaches to visual communication are often based on modernist assumptions. Modernity understands visuals as organic wholes and assumes that images and/or their creators have more or less identifiable, real, and socially sharable purposes. Modernist assumptions also include the privileging of function/content over form/style and seeing style primarily as a means to understanding artists and artistic purposes (Sarup, 1993, pp. 129-148). In contrast, postmodern theories of communication reject the totalizing idea of "reason" for the multiple reality of reasons (for more on this, see "Dispatch Concerning the Confusion of Reason" in Lyotard, 1984). The assessment and critique of visuals

that are mass-produced, fragmented, polymorphous (shape-shifting), polyvocal (many-voiced), or highly stylized would benefit from this different sort of approach. So, too, would the assessment and critique of visuals without explicit or identifiable authors or purposes, and visuals with multiple authors or purposes. Postmodern characteristics, like the ones just mentioned, are typical of Web site visuals, which is why their assessment suggests a different, elemental approach.

An Elemental Approach

In contrast to traditional rhetorical approaches to visual communication, an elemental approach (Peterson, 2001) is better suited to the assessment of Web site visuals. This schema differs from traditional approaches by putting the discussion of *elements* of visuals *before* any discussion of *images,* signs, texts, or contexts. It is preferable for a number of reasons.

First, sensory input is often understood in similar ways, even by different people. Unlike images, symbols, or texts, which are larger and more complex phenomena, visual elements are immediate to the visual encounter and require less interpretation. For example, it is easier for two people to agree on what is "red" than it is for them to agree on what counts as "democracy" or "obscenity." The elemental approach exposes that part of the perceptual process where viewers first make sense of visual elements *before* putting them together into larger wholes (e.g., "seeing a series of small intricate shapes in a line" rather than "seeing a toolbar"). Using the elemental approach, Web designers could get a clearer idea of how users initially react to Web visuals not only by asking users about these elements or testing their responses to them, but also by listening to or even hiring critical "elemental" viewers who are attentive to and able to account for their initial perceptions in order to assist designers in seeing how users might initially experience Web sites. Designers could then make changes to sites based on their findings.

Second, because people sense the physical world in different ways, differences in initial perceptions of visual elements could be identified and addressed, and perceptual sub-groups could be identified. For example, one Web user or group of Web users/critical viewers might see a thick blue line separating a monitor in half while another might see a thin blue line, and still another might see two different "fields" of visual stimuli. Learning about differences of perception in different users or sub-groups of users would be an advantage to Web designers who could tailor the elements they use to target the audiences they hope to reach.

Third, beginning analysis of visuals with visual elements takes advantage of already existing and useful vocabularies of visual assessment. It starts with basics of description and also broadens analytical resources to include terms from fine arts and performing arts, and television, film, and video production. It opens the door to descriptive terminology from textbooks of applied media aesthetics such as Zettl's *Sight Sound Motion: Applied Media Aesthetics* (1999) and potentially useful vocabularies from treatments of different but related electronic media, for example, Metallinos' *Television Aesthetics: Perceptual, Cognitive, and Compositional Bases* (1996).

Analyses of Web sites would begin with assessments of visual elements such as light, line, shape, shading, perspective, direction, proportion, scale, texture, hue, saturation, edge, balance, cut, frame, shot, angle, speed, etc. Web users and designers could then assess the suasory aspects of visual elements, that is, how elements shape perception and persuade particular ways of acting, thinking, and being. These assessments could be made in aesthetic and/or functional terms (e.g., bright light leads users to this section and encourages them to interact here or bright light is cheerful, bright light suggests truth). Because perception comes first in visual encounters, so, too, would the use of ocular (sight-related) terms and theories. Once elements are assessed, questions about them might include: "Where do shapes and colors initially direct the eye?" "How much visual stimulus constitutes visual overload for the intended audience?" "How do colors of visuals affect the moods of viewers?" and "How do composition, balance, and other elements of visuals influence user perception and response?" Use of other-than-ocular theories for further interpretation and assessment would come only after identifying and assessing the initial impact of visual elements.

Of course, more specialized vocabularies of visual elements drawn from art, production, theater, and other sources would not, at first, be easy to apply. Most people are so familiar with looking for and at *images* that they may be less skilled in identifying and assessing visual *elements*. Some practice in the method of analysis would be required. Also, vocabularies of visual elements are not exact, nor are they transparent. Even if people do agree, in general or in specific contexts, about what qualifies as thick or thin, red or green, a triangle or a square, they might not agree about borderline cases (e.g., is that blue-green or green-blue?). In such instances, Web users and designers could justify their "read" of the site with evidence from the screen itself. For example, a user might say, "That shape is difficult for me to see because it is small," and could point to the shape at issue on the screen. The designer of that screen may not see the shape as "small" at all, but may also have

better eyesight. Perceptions of size are often related to the quality of eyesight, which often deteriorates with age. In this case, older critical viewers could help identify difficulties such as these, and help designers reconsider the size of text or images used on Web sites targeted to older audiences.

Assessment would be somewhat complicated by a number of factors that influence the quality of Web access individuals might have. These factors include variations in computer type, computer speed, monitor size, monitor quality, and software parameters. Another factor would be differences in advertisements targeted to particular users that might appear on the screen (which themselves use "elemental" tactics of communication). All of these factors could change the appearance of screens and alter the way users might interact with those screens. Fortunately, if research and analysis are conducted from users' perspectives, the visual elements approach would discover these differences of quality and comment on how they participate in (e.g., enhance, interfere with, are irrelevant to, make ironic) the communicative process.

Eventually, visual elements would require assessment in light of their contexts, but this should be done only *after* their initial identification. As Gombrich (1994, 1999) notes, visual elements have no meaning in and of themselves just as words have no meaning outside of a particular utterance. Designers and users might disagree about the way visual elements should be read within the larger contexts (e.g., does red mean "danger" or "exciting" in this context?), but some general schemes do exist to guide interpretation. Osgood, Suci, and Tannenbaum (1957), for instance, chart the relative positive or negative impact of sights with findings such as "bright" and "light" denote friendly and "dark" denotes hostile. Zettl (1999) identifies various psychological and emotional effects of lighting and color. For example, he describes below-eye lighting as disorienting and suggestive of the unusual, ghostly, and frightening (p. 29). Within particular generic and formulaic contexts, (e.g., a film or video clip playing on the screen) such schema might prove useful in the critical reading of Web site visuals.

Postponing considerations of context, avoiding simple distinctions between function and aesthetics, and using visual elements as starting points of Web site assessment fits a postmodern sensibility. The inductive and non-totalizing nature of the visual element schema fits such an understanding by deferring the determination of the function of visual images until after visual elements are noted and assessed. Postmodernism in the visual arts is also characterized by, among other things, a shift in emphasis from content to form/style and frequent references to

fragmentation and pastiche (Sarup, 1993). This fits with both the elemental approach to visuals and the realities of computer-mediated communication.

Five or so years ago, when this essay was first conceived, one Web design manual, *Web Style Guide: Basic Design Principles for Creating Web Sites* (Lynch & Horton, 1999), came close to accomplishing an elemental approach to Web site visuals. "This is not an HTML manual," write Lynch and Horton, "nor is it a book on graphic design" (ix). While the authors primarily addressed Web designers, their work could also be read and understood by users. They offered "basic design principles that you can use to make your content as easy to understand as possible" (ix). A focus on aesthetic principles and a concern for audiences is reflected in the organizational scheme of the book (topical, by user concern) and also in the style of writing. In chapters such as "Page Design," "Typography," "Editorial Style," and "Web Graphics," the authors consistently attended to needs and concerns of users. They drew terminology from technical sources such as graphic design (e.g., "Times New Roman," "dithering," and "gutters") and also used terms from more basic artistic vocabularies (e.g., "proportion," "consistency," and "contrast"). In doing so, they offered a good approximation of a Web site manual concerned primarily with visual elements.

In the intervening years, more resources have appeared that speak to elemental and user-oriented concerns. Books such as *Designing Web Usability* (Nielsen, 2000), *Don't Make Me Think: A Common Sense Approach to Web Usability* (Krug, 2006), and *Research-Based Web Design & Usability Guidelines* (U.S. Department of Health and Human Services, 2006) are just a few examples of resources with a more audience-centered approach and a more elemental way of engaging Web site visuals. The proliferation of such resources confirms not only the value of this approach for Web site designers but also the value of using this approach to assess Web sites designed by others.

Assessing Web visuals using visual elements instead of larger complexes at least potentially expands critical possibility. Unlike images, signs, or texts, which are more subject to both individual reader interpretations and cultural master narratives, visual elements offer sensory (experiential, embodied) starting points and a firmer (though not solid or indisputable) basis for assessment. This shift in starting point does not eliminate interpretation and associated difficulties. But it does give users and designers a common territory from which to approach matters of perceptual difference and design. It also offers a wide critical vocabulary from which to draw. To assess visual communication, we need to consider how visual

elements communicate (or fail to communicate) meaning to the people who see and make sense of them.

The discussion above suggests the value of the elemental approach to Web site visuals but does not fully illustrate how an analysis using such an approach would be conducted. The following is an example of how such an analysis would be done. The analysis reflects reactions that a Web user had to the Amazon.com Web site in 2002. Though the analysis was conducted years ago, this matters little to the value of the example. The visual content of Web sites is constantly replaced and updated, and any analysis of a popular Web site with an active design team behind it will soon be dated. What does not shift is the method of analysis used for the analysis itself and the way it helps designers and sponsors better appreciate and understand end users' visual experiences.

Assessment of Web Site Visuals: The Amazon.com Web Page

Amazon.com is the largest bookstore in the world, and a virtual bookstore. It claims to have the Earth's biggest selection of books, music, magazines, and videos, and it also carries a wide array of other products. Because Amazon.com has no relation to brick and mortar storefronts, its Web site and the ways potential customers might interact with it are especially important to its continued success. Because Amazon.com is a big business and a familiar and reputable name to many people, the experience of its opening screen (home page) makes a useful exemplar for the analysis of visual elements.

The Amazon.com home page has changed over time as the site has grown and changed. Beyond this, different computers will "draw" somewhat different versions of the Amazon.com opening screen for reasons related to the user's connection, browser, browser preference settings, past searching/purchasing habits (if any), and other factors. Some computers will call up the text and visuals more slowly and in notable stages, while others will call them up so quickly that no time-lagged "sketching in" of the screen's surface is noticeable. Also, some computer monitors or software programs will "cut off" various parts of the visuals and text on the screen, requiring users to actively navigate their screens for fuller viewing, while other (larger) monitors and/or software packages will show the site more fully. Because Amazon.com uses a good deal of Web advertising, visuals will also vary depending on what advertisements are scheduled to appear and/or what information might already have been gathered about users from traceable search

habits. Each visit to the site yields different advertisements, and these constitute a large part of the Web visuals.

These realities of Web communication do not undermine analysis of the Amazon.com Web site, or any other Web site, from the perspective of visual elements, they recommend it. End users' experiences of different screens may be taken as indicative of the experiences of others who share their characteristics as users. Findings may then be compared across computers and users, and similarities and differences identified. Designers would then be encouraged to consider not only visually static matters of the home page, but also audience-relevant matters such as the average speed and quality of users' computers and software. For example, because the user's computer and software were very old and slow when the example elemental analysis of the Amazon.com Web site was conducted, and because the user was not a regular Internet user or shopper, she effectively represents the subgroup of less-computer-wired people (e.g., poorer, less media-literate people) and how they would experience the Web site.

The analysis of the Amazon.com Web site that follows is brief, but illustrates the spirit if not the practice of an elemental approach to Web site visuals. A visual depiction of the home page is not included, not just because finding and securing an image of the 2002 home page would be difficult, but because the visual experience of Web sites is a fluid and temporal process as much as a spatial process. Much of how the user "took in" the visuals had to do with how the visuals went about "drawing up" on her screen. To reduce this experience to the end resulting "image" of the home page would be to "pre-interpret" the Web site and reduce the visual experience to much less than what it was.

Encountering the Screen

After typing in the Amazon.com Web address and hitting "enter," the user's computer begins to draw in the site's first screen. Little chunks of text and shape begin to appear in random order. Top middle, upper left-hand corner, middle top, right top, left to right across the top, down along the right side. Her eye is teased by the appearance of shape and color where there was none before in various places on the screen, and a new appearance is usually perceived before much assessment of the last appearance can be made. Such "popping up" of lines and shapes is exciting but also somewhat overwhelming. She is tempted to look away.

Once the appearances have stopped, the user tries to make sense of the jumble of material. If she were to try to identify "bits" of information in front of her, there

would be quite a few. There is text in all quadrants of the screen—both individual words and short phrases—and initially, there seems to be little order to it. Looking a bit longer reveals a variety of sizes, fonts, and lengths of writing piled up across the top, and a loosely defined three-column vertical arrangement below. The third column on the right seems thinner than the other two and she notices that her computer screen is cutting off the right-hand part of the screen. She is not happy to be missing out on some of the material and briefly wonders what she is missing.

Long, horizontal rectangles are the dominant shape (12 to 18 of them) and these may have a somewhat stabilizing or calming effect. There are also occasional small circles (four to five of them) at various places. There is little color on the screen; most of it is white. The user's eye is drawn to what colors there are, including the relatively saturated and varied shades across the top of the screen (appearing as rectangular shapes with words in each). She also notices a particularly photo-realistic brightly striped hat that appears to sit atop one of the rectangles (that she then notices contains the text "Apparel & Accessories").

Next, the user's eyes begin to pick out and try to make sense of a few more small but recognizable images. As she makes them out, she looks around for text to explain their presence on the screen. These images include a stylized man on a kind of scooter, a stylized shopping cart, a graphic of a day calendar, a picture of a camcorder, and a picture of a magazine with a large flower on the cover.

Finally, the user's eyes become accustomed to the jumble and she begins searching for text that will help her with whatever next step she is interested in taking. This is no simple matter because there is an array of buttons she might click on and each one sends her to a different place.

Assessment

To begin, visual elements suggested systemic problems. There are two possible conclusions from this that could be drawn. The first is that the user needs a new computer. The second is that the designers of the Amazon.com Web site might want to accommodate their less ideally computer-outfitted customer. One way to do this would be to reduce the horizontal material on the screen so it would be less likely to outstretch small monitors. Such accommodation would save less outfitted users from missing important material, the irritation of having to navigate back and forth, and/or the unhappy or frustrated feeling of missing out on the gestalt of the screen.

Another way to accommodate users of "weak" computers is to simplify the screen (especially the first screen) of Web sites (e.g., the Google search screen). Putting less/simpler material on the opening page means it would take less time for that material to appear. Because the user was in the habit of attending to all new and unfamiliar visual cues, and because she was using a slow computer with a slow Internet connection, this part of the Amazon.com visit was so stimulating and busy an event that she found herself using a good amount of perceptual energy to little constructive end. While some users, perhaps more experienced users and/or users "brought up" on the Internet, may be able to "tune out" of this sort of thing, others might be less able to avoid its impact and get overloaded or turned off by it.

Visual elements also suggested problems with design. Once the appearances (or "popping-up" of material) stopped, the user perceived a jumble of material. There were no fields delimited by line or background color, and there were so many "bits" of information in view (clusters of letters, various shapes, small identi-fiable images) that it was difficult to attach relative weight or importance to them without visually attending to them each in turn. This might be a strategy of atten-tion-getting on the part of the page designer, but could backfire for users who might be overwhelmed and back away from the site. Such complexity could be contrasted with what Sullivan (2001) calls "safe visual rhetoric on the web." In a Web design course, Sullivan identified safe visual rhetoric on the Web as having no more than two colors and two fonts, with page widths of 535 pixels or less, text in tables, headings, bibliographic information, and a back link for navigation (p. 104).

During the user's initial Amazon.com encounter, other design issues also pre-sented themselves. All over the screen there were multiple varieties of font, and a predominance of little words, that upon closer inspection she identified as a multi-tude of pitches, requests, questions, "sign ins," "free stuff," "click here's," etc. Only the colorful rectangles at the top (what we call "tabs" to mimic tabs in a notebook) suggested they might be a priority. But even these were surrounded by distracting elements, such as the shopping cart and the figure of the man on the scooter. The existence of the lone hat image atop the "Apparel & Accessories" tab lent what seemed to her a sloppy "leaving your things lying about the house" look. Also, there were two places where a new user could sign up to receive "personalized rec-ommendations," one written out long hand below the tabs with text that a user could click on, and another designed as a button and labeled. Such repetition could be seen as strategic—one more chance to reach the user, or as redundant—

unnecessarily complicating the Web site and adding confusion. The apparent over-fullness of the screen, in her perception, suggested the latter.

Subsequent visits to the same Web site featured various advertisements. In some cases, these advertisements contained flashing elements in bright or contrasting colors. This flashing effect is highly attractive to the eye (which is one reason why advertisers use it) but adds even more complexity and confusion to an already busy site. The potential for this sort of element to attract potential buyers is initially strong but may be outweighed by its simultaneous potential to turn people off and add visual insult to visual injury.

In a fuller analysis of the Amazon.com Web site, critical attention would be paid not only to the initial screen, but also to other screens and the quality and quantity of "threads" connecting screens to other screens. Those other screens would be assessed in much the same way as the initial screen. Additionally, those other screens also would be assessed by the ways they are (or are not) connected to other screens (e.g., Do you reach the new screen by button? Do you reach it by underlined text? Is the gateway to the new screen clearly marked and understandable to a new or returning user? Is there more than one way to get to a new screen from a previous screen? Is it easy to navigate back and forth from screen to screen without getting lost or encountering a "glitch" in the software?).

If users were (or could become) accustomed to the jarring "drawing up" and resultant jumbled appearance of the Amazon.com Web site, they might be able to use it more effectively. In the instance just discussed, the onus of adaptation rested squarely on the user. This would also be true for other new or occasional users with similarly slow equipment and software. People such as these, interested in what Amazon.com might have to offer, would simply have to deal with the unpleasant, perhaps hostile, visual complexities of the screen. Eventually, familiarity with the look of design elements and their placement might make navigation of the Web site easier, and successful purchases might provide incentive for further interaction with and adaptation to the interface by the user, but they would not address underlying problems of the site itself.

Analysis of the visual elements of the Amazon.com Web site suggests that computer-literate, well-equipped and well-connected regular users probably are the sorts of users most often anticipated and targeted by Web site designers. Web site designers, themselves, often use faster, better-than-average computers in their own workplace and may mistakenly attribute such computer "wiredness" to intended audiences. If Amazon.com is interested in attracting new users, however,

Web designers may want to consider the needs of other users, and rethink some of their practices and strategies regarding less well-wired audiences.

Conclusion

The Web is an important context in which to assess visual communication. Taking a systematic approach to Web site visuals that assesses both the "spin" of screens and the "threads" connecting screens to other screens is an important and useful kind of visual rhetorical criticism. Most existing approaches to Web sites and Web visuals express little concern about audiences, traffic heavily in jargon, and privilege tactical pragmatics over praxis and aesthetics. Traditional rhetorical approaches to visual communication also fall short of the task of assessing Web site visuals because they focus on images and their functions. The elemental approach to Web site visuals offers a useful analytical perspective and rich vocabularies of description and assessment from which to draw. With this perspective and vocabulary, critics, Web designers, and users can assess the quality of their encounters with various Web sites and more effectively share those assessments with others.

References

Berger, A. A. (1998). *Seeing is believing: An introduction to visual communication* (2nd ed.). Mountain View, CA: Mayfield.

Berger, J. (1972). *Ways of seeing*. London: British Broadcasting Company and Penguin Books.

Birdsell, D. S., & Groarke, L. (Eds.). (1996). Toward a theory of visual argument. *Argument and Advocacy*, 33(1-2), 1-10.

Blair, C., Jeppeson, M. S., & Pucci, Jr., E. (1991). Public memorializing in postmodernity: The Vietnam Veterans Memorial as prototype. *Quarterly Journal of Speech*, 71, 204-217.

Boyle, C. (2001). *Color harmony for the Web: A guide for creating great color schemes on-line*. Gloucester, MA: Rockport Publishers.

Burgin, V. (1997). Art, common sense and photography. In J. Evans (Ed.), *The camera essays* (pp. 74-85). London: Rivers Oram Press.

Crowder, D. A. (2004). *Building a Web site for dummies*. Hoboken, NJ: Wiley Press.

DiNucci, D., Giudice, M., & Stiles, L. (1997). *Elements of Web design*. Berkeley, CA: Peachpit Press.

Edwards, J. L., & Winkler, C. K. (1997). Representative form and the visual ideograph: The Iwo Jima Image in Editorial Cartoons. *Quarterly Journal of Speech* 83(3), 289-310.

Ensor, P. (2000). (Ed.). *The cybrarian's manual 2*. Chicago, IL: American Library Association.

Evans, J., & Hall, S. (Eds.). (1999). *Visual culture: The reader*. Thousand Oaks, CA: Sage.

Forsythe, C., Grose, E., & Ratner, J. (Eds.). (1998). *Human factors and web development*. Mahwah, NJ: Lawrence Erlbaum Associates.

Foss, S. K. (1982). Rhetoric and the visual image: A resource unit. *Communication Education*, 31, 55-66.

Foss, S. K. (1986). Ambiguity as persuasion: The Vietnam Veterans Memorial. *Communication Quarterly*, 34, 326-340.

Foss, S. K. (1987). Body art: Insanity as communication. *Central States Speech Journal*, 38, 122-131.

Foss, S. K. (1988). Judy Chicago's The Dinner Party: Empowering women's voice in visual art. In B. Bate & A. Taylor (Eds.), *Women communicating: Studies of women's talk* (pp. 9-26). Norwood, NJ: Ablex.

Foss, S. K. (1993). The construction of appeal in visual images: A hypothesis. In D. Zarefsky (Ed.), *Rhetorical movement: Essays in honor of Leland M. Griffin* (pp. 210-224). Evanston, IL: Northwestern University Press.

Foss, S. K. (1994). A rhetorical scheme for the evaluation of visual imagery. *Communication Studies*, 45, 213-224.

Foss, S. K., & Kanengieter, M. R. (1992). Visual communication in the basic course. *Communication Education*, 41(3), 312-323.

Garlock, K. L., & Pointek, S. (1996). *Building the service-based library Web site: A step-by-step guide to design and options*. Chicago, IL: American Library Association.

Gombrich, E. H. (1994). *Meditations on a hobby horse and other essays on the theory of art*. New York: Phaidon.

Gombrich, E. H. (1999). *The image and the eye*. New York: Phaidon.

Gronbeck, B. (1998, November). Three rhetorics of the seen. Paper presented at the National Communication Association convention, New York.

Hanson, J. (1987). *Understanding video*. Newbury Park, CA: Sage.

Hariman, R., & Lucaites, J. L. (2001). Dissent and emotional management in a liberal-democratic society: The Kent State iconic photograph. *Rhetoric Society Quarterly*, 31(3), 5-31.

Hariman, R., & Lucaites, J. L. (2002). Performing civic identity: The iconic photograph of the flag raising on Iwo Jima. *Quarterly Journal of Speech*, 88(4), 363-392.

Hariman, R. & Lucaites, J. L. (2003). Public identity and collective memory in U.S. iconic photography: The image of accidental napalm. *Critical Studies in Media Communication*, 20(1), 35-66.

Harvey, W. (2004). *1,000 graphic elements: Details for distinctive designs*. Beverly, MA: Rockport.

Hill, C. A., & Helmers, M. (Eds.). (2004). Defining Visual Rhetorics. Mahwah, NJ: Lawrence Erlbaum Associates.

Jamieson, H. (2007). *Visual communication: More than meets the eye*. Bristol, UK: Intellect.

Jamieson, K. H. (1992). *Dirty politics: Deception, distraction, and democracy*. New York: Oxford University Press.

Kaplan, S. J. (1990). Visual metaphors in the representation of communication technology. *Critical Studies in Mass Communication*, 7, 37-47.

Kentie, P. (2002). *Web design tools and techniques* (2nd ed.). Berkeley, CA: Peachpit Press.

Krug, S. (2006). *Don't make me think: A common sense approach to Web usability* (2nd ed.). Berkeley, CA: New Riders.

Kostelnick, C., & Hassett, M. (2003). *Shaping information: The rhetoric of visual conventions*. Carbondale: Southern Illinois University.

Lake, R. A., & Pickering, B. A. (1998). Argumentation, the visual, and the possibility of refutation: An exploration. *Argumentation*, 12, 79-93.

Lancioni J. (1996). The rhetoric of the frame: Revisioning archival photographs in the Civil War. *Western Journal of Communication*, 60, 397-414

Lester, P. M. (2000). *Visual communication: Images with messages* (2nd ed.). Belmont, CA: Wadsworth.

Lopuck, L. (1996). *Designing multimedia: A visual guide to multimedia and online graphic design*. Berkeley, CA: Peachpit Press.

Lynch, P. J., & Horton, S. (1999). *Web style guide: Basic design principles for creating Web sites.* New Haven, CT: Yale University Press.

Lyotard, J. F. (1984). *The postmodern condition*. Manchester: Manchester University Press.

Medhurst, M. J., & DeSousa, M. A. (1981). Political cartoons as rhetorical form: A taxonomy of graphic discourse. *Communication Monographs*, 48(3), 197-236.

Mettalinos, N. (1996). *Television aesthetics: Perceptual, cognitive, and compositional bases*. Mahwah, NJ: Lawrence Erlbaum Associates.

Morello, J. T. (1992). The "look" and language of clash: Visual structuring of argument in the 1988 Bush-Dukakis debates. *Southern Speech Communication Journal*, 57, 205-218.

Nielsen, J. (2000). *Designing Web usability*. Indianapolis, IN: New Riders.

Olson, L. C. (1987). Ben Franklin. *Quarterly Journal of Speech*, 73, 18-42.

Olson, L. C. (1990). Benjamin Franklin's commemorative medal Libertas Americana: A study in rhetorical iconology. *Quarterly Journal of Speech*, 76, 23-45.

Ornstein, R. E. (1972). *The psychology of consciousness*. San Francisco: W. H. Freeman.

Osgood, C. E., Suci, G. J., & Tannenbaum, P. H. (1957). *The measurement of meaning*. Urbana: University of Illinois Press.

Peterson, V. V. (2001). The rhetorical criticism of visual elements: An alternative to Foss's schema. *Southern Communication Journal*, 67, 19-32.

Rosenfield, L. W. (1989). Central Park and the celebration of civic virtue. In T. W. Benson (Ed.), *American rhetoric: Context and criticism* (pp. 221-266). Carbondale: Southern Illinois University Press.

Sarup, M. (1993). *An introductory guide to post-structuralism and postmodernism* (2nd ed.). Athens: University of Georgia Press.

Scott, L. M. (1994). Images in advertising: The need for a theory of visual rhetoric. *Journal of Consumer Research*, 21, 252-273.

Siegel, D. (1997). *Creating killer Web sites: The art of third-generation site design* (2nd ed.). Indianapolis, IN: Hayden Books.

Siegel, D. (1997). *Secrets of successful Web sites: Project management on the World-wide Web.* Indianapolis, IN: Hayden Books.

Smith, K., Moriarty, S., Barbatsis, G., & Kenney, K. (Eds.). (2005). *Handbook of visual communication: Theory, methods, and media.* Mahwah, NJ: Lawrence Erlbaum Associates.

Snyder, C. (2003). *Paper prototyping: The fast and easy way to design and refine user interfaces.* New York: Morgan Kaufman Publishers.

Sullivan, P. (2001). Practicing safe visual rhetoric on the World Wide Web. *Computers and Composition* [H. W. Wilson—EDUC], 18(2), 103-121.

Twigg, R. (1992). Aestheticizing the home: Textual strategies of taste, self-identity, and bourgeois hegemony in America's "Gilded Age." *Text and Performance Quarterly, 12,* 1-20.

vanLeewen, T. & Jewitt, C. (Eds.). (2001). *Handbook of visual analysis.* London: Sage.

U. S. Department of Health and Human Services (2006). *Research-based web design & usability guidelines* (version 2). Washington, D.C.: U.S. Dept. of Health and Human Services: U.S. General Services Administration.

Visual Communication and Social Change: Rhetorics and Technologies Conference, April 3-6, 2003, Rochester Institute of Technology.

Weinman, L., & Weinman, W. (1998). *Creative HTML design.* Indianapolis, IN: New Riders Publishing.

Williams, R. & Tollett, J. (2006). *The non-designer's Web book: An easy guide to creating, designing, and posting your own Web site* (3rd ed.). Berkeley, CA: Peachpit Press.

Zettl, H. (1999). *Sight, sound, motion: Applied media aesthetics* (3rd ed.). Belmont, CA: Wadsworth.

Chapter Four

Thinking Visually
Heuristics for Web Site Analysis and Design

Craig Baehr

A user's interpretation of a Web page goes beyond recognizing conventions of style, page layout, and stunning graphic design. Users think visually, act instinctively, but also develop different interactive strategies based on their experiences with Web sites. Understanding the perceptual and cognitive processes in how users process and interpret visual and spatial configurations of content can inform our heuristics in evaluating and producing highly usable Web sites. This chapter examines research on user perception, visual thinking, Web development, and eye-tracking studies. It discusses how our visual instincts affect recognition of visual hierarchies, as well as our problem orientation, concept formation, and overall understanding of Web site content. Considering these factors, the chapter proposes a series of heuristics which can be used in Web site analysis and design.

The great virtue of vision is that it is not only a highly articulate medium, but that its universe offers inexhaustibly rich information about the objects and events of the outer world.
–Rudolf Arnheim, Visual Thinking, 1969, p. 18

The perception of the Web as a three-dimensional visual space is perhaps extrapolated from the physicality of the printed book. For those of us educated in print-based environments, we held a book, turning its pages in succession while attempting to visualize what the author was trying to convey. Today, when reading in Web-based environments, we can interact with the visual using browser and customized Web interfaces to navigate text, images, and other forms of visual media.

The nature of digital-based environments requires us to think quite differently in how we navigate, conceptualize, and comprehend new information.

Saco (2002) conceives three aspects of the three-dimensional nature of Web spaces: the physical, the social, and the cognitive (p. 5). Physically, monitors display millions of pixels on our screens to form text and images transmitted across tremendous distances from other computers. Socially, the Web is a social space where we interact with others through e-mail, instant messaging, chat rooms, social networking sites, and other forms of synchronous and asynchronous means of communication. Cognitively, our minds organize and interpret a multitude of elements in our visual field all at once. We interact with visual information using navigation toolbars, clickable objects, and hyperlinks to browse through the many layers of a Web site. While much literature on visual design for Web sites has established the importance of page layout, graphic clarity, visual contrast, and typography, it has largely neglected the cognitive aspect or how readers think both visually and spatially in Web-based environments.

As readers, we respond in similar ways to verbal information presented visually in much the same way we respond to visual stimuli in our environment, as suggested by both Gestalt theory and visual thinking (Koffka, 1935; Arnheim, 1969; Johnson-Sheehan & Baehr, 2001). These approaches suggest that designers should "visualize future paths in their texts, anticipating the experiences that users may have or want" (Johnson-Sheehan & Baehr, 2001, p. 24).

Designers must realize the user's interpretation of a Web page goes beyond the perception of individual visual objects, extending to their spatial configurations on the page. Some examples of this include layering graphics, drop-down menus, floating windows, and objects, all of which are often used in Web navigation and advertising. Kohler (1947) suggests that "all sensory facts do appear in one space, the space in which also the visual objects and visual self are located" (p. 215). While some of these traditional approaches have applied concepts of visual thinking primarily to art and graphic design, this chapter extends their application to Web-based environments in how users think and interact with visual content in Web sites.

Visual Theory and Visual-spatial Origins

Visual thinking has its foundations in Gestalt theory, developed by Max Wertheimer, Kurt Koffka and Wolfgang Kohler in the 1910s and 1920s from the field of psychology. From their research on perception, they developed the idea that

humans perceive information as conceptual wholes rather than just individual parts. Gestalt theory argues that humans actively classify and organize objects in their visual field based on a need to apply order to comprehend the whole. Based on the concepts of grouping and relationship of objects in the same visual field, individuals impose order on these objects in an attempt to perceive them as wholes (Koffka, 1935). Gestalt theorists argue that wholeness is not merely a sum of individual parts, but rather "a whole effect" or the "dynamic interrelation" of each part (Behrens, 2001).

For example, as readers, we attempt to perceive any text as a whole in an attempt to understand the relationship between given sentences, paragraphs, graphics, headers, layers, document divisions, and other visual elements. In Web sites, users examine hyperlinks, graphics, icons, shaded areas, and text chunks to understand the arrangement, structure, and function of the whole site. Conceptualizing the whole does not eliminate the distinction between parts but rather helps us to better understand more about each part in relation to the whole.

Gestalt theory also focuses on the importance of the intrinsic relationship between individual visual objects and how these relationships govern perception (Koffka, 1935). In other words, we perceive cognitive relationships between elements as a result of them being in a similar context or visual field. Gestalt theory argues that imposing order on a set of objects helps to create meaning based on causal connections readers assign between objects rather than memorized patterns (Koffka, 1935). Similarly, our actions are based on previous experience of observing and learning similar patterns or groupings. For example, in printed texts we learn to navigate based on fixed conventions such as using tables of contents, indices, headers, and page numbers, whereas in Web sites we must learn the unique structure and use visual tools such as navigation menus, browser controls, scrollbars, hyperlinks, and other elements to direct our reading responses and actions.

Research in the visual arts began integrating Gestalt theory during the middle part of the 20th century, partly in an attempt to provide "scientific validation of age-old principles of composition and page layout" (Behrens, 2001, p. 5). One example is the concept of figure-ground contrast, which is frequently cited in visual design texts (Kostelnick & Roberts, 1998; Williams & Tollett, 2006). Koffka (1935) states: "The figure depends for its characteristics on the ground on which it appears. The ground serves as a framework in which the figure is suspended and thereby determines the figure" (p. 184). In viewing a picture or piece of work with a variety of colors, we perceive the dynamic figure-ground relation of colors as opposed to individual colors; in reverse figure-ground contrast, we perceive the

whole based on the spaces between individual swatches (Behrens, 2001). We forcibly impose order on a myriad of colors in an attempt to construct meaning in a painting; similarly, as readers, we use like strategies in an attempt to interpret and conceptually group visual and textual content. Color theory, negative space, visual contrast, layering, and grid-based layouts are all examples of methods used in print-based design that build on the notion of figure-ground.

Kostelnick and Roberts (1998) argue that part of comprehending the whole is examining the textual, graphical, and spatial elements and forming concepts about their relationships. Their cognate strategies include perception and Gestalt theory as design guides. Williams and Tollett (2006) present a set of design principles that relate to Gestalt theory, advocating the use of alignment, proximity, repetition, and contrast. What these connections suggest is that many design theories make connections between user perception and design, which can be extended to inform our understanding of how users interact similarly with visual content on the Web.

Thinking Visually

Users think visually before they articulate verbally and act on their perceptions (Arnheim, 1969). For example, in Web environments, we fixate on icons, animations, search interfaces, and navigational toolbars to solve problems, make meaning, navigate, and plan searches. We examine contextual clues, familiar shapes, design metaphors, icons, and verbal-visual pairs to better understand complex relationships between visual information and textual content found in Web sites. Arnheim (1969) asserts quite simply that "visual perception is visual thinking" and suggests the essential perceptual acts include "such operations as active exploration, selection, grasping of essentials, simplification, abstraction, analysis and synthesis, completion, correction, comparison, problem solving, as well as combining, separating, putting in context" (pp. 13-14).

Visual thinking occurs during our perceptual acts as we interact with Web content. We closely examine objects, arrangements, groups, layers, and layouts, and make meaning based on our unique experiences. In turn, our actions are guided by our perception in deciding what to click or focus on next.

Arnheim (1969) conceived specific visual thinking principles to form the basis of his ideas on visual thinking. These principles are *vision is selective, fixation solves a problem, there is discernment in depth, shapes are concepts, and we complete the incomplete.* These principles explain the essential elements of visual thinking,

which include our tendency to focus on distinct visual objects, identify their problem-solving function, examine their context, conceptualize the meaning of visual objects, and perceive how they contribute to a complete whole. These visual thinking principles form the basis of our behaviors and perceptual acts in browsing and searching in Web-based environments.

Building on visual thinking research, Barry (1997) introduced the notion of a visual intelligence, which encompasses "critical perceptual awareness" that includes "a holistic integration of skilled verbal and visual reasoning, from an understanding of how the elements that compose meaning in images can be manipulated to distort reality, to the utilization of the visual in abstract thought" (p. 6). Her approach underscores the importance that context, meaning, and relation play in shaping our perspective and perception of visual information. Schriver (1997) suggests the importance of visual thinking and also emotion in how users comprehend the meaning and uses of visual information. She stresses there is a "dynamic interplay between cognition and affect during interpretation" of visual information by users (p. 207). Her approach considers how thought and feeling affect our understanding and our sense of perspective. For example, the emotional response to specific colors and visual imagery based on user experience, culture, background, or other factors plays an important role in the overall impression. Collectively, these approaches highlight the important roles that perception and cognition play in our complex understanding of visual information.

Visual Instincts and Perception

While visual thinking and visual intelligence might suggest we have natural reactions to visual elements and form concepts and meaning about what we see on a screen, our visual instincts are not static but evolve based on our exposure and experiences with visual information. How our instincts guide our actions and our overall perspective or concept of a Web site involves understanding how each of its parts relate and how it functions as a whole. From a macro view, Web site content is a complex collection of layered elements in a single space. Tufte (1997) calls such a collection a visual confection. Visual clutter, lack of context, and inconsistencies in layout or style all affect our perception or impression of a Web site. Barry (1997) argues, "As we become more and more dependent on the visual for sending and receiving information, we will inevitably become more adept at quickly reading the affective and cognitive aspects of the messages" (p. 6).

Our natural visual instincts cause us to focus on elements that are visually distinct or interesting on a screen, but our individual experiences affect our overall perspective. One example is the use of advertising banners and interactive objects on Web sites, which feature messages on how to lose weight fast, win a free vacation, or obtain a quick approval on a home loan. The first time these advertising banners are seen, our perception of them is that they are novel and maybe even interesting. Many of these ads contain animation and are designed to be visually interactive. However, after continuous exposure to similar banners, we develop instinctive responses to avoid them unless they are relevant to our browsing. Arnheim (1969) suggests that repetitious and predictable visual stimuli are eventually ignored by readers. As such, our perspective toward similar visuals may change when we encounter them on other Web sites.

Another example deals with the overuse of visual elements on a site, which can often overload the visual senses. Most Web sites are composed of multiple toolbars, banners, interactive objects, and embedded hyperlinks that provide many more visual elements than we can deal with all at once and which compete for our attention. Some sites have so much visual clutter that they force users to find the "skip intro link" or "close" button before they can even begin the task of searching the site. In turn, this interferes with the information-seeking process and contributes to considerable confusion for users with respect to the navigation, layout, organization, and usability of a site. Our visual instincts develop from these experiences and guide our future actions, which might include avoiding troublesome sites in favor of more visually coherent ones.

Another issue that affects our perceptual instincts deals with context, which drives both our comprehension and interaction with a Web site. Baehr and Logie (2005) argue that the unique visual characteristics of Web environments place "textual content in new and different visual and spatial contexts, which requires us to consider how readers perceive information beyond traditional concepts" (p. 1). Since there are no fixed conventions with regard to structure, layout, navigation, or usability for Web sites, as there are for printed books, users are left to their visual instincts and past experiences to help them comprehend the content of a new Web site. Horn (1998) suggests that users see unities in a new visual landscape, which are context dependent, and these unities help them understand the whole. Typically, most users will understand the function and meaning of given visual shapes and objects if they are used in familiar ways or if they are explained within the given context. In less familiar surroundings, users rely on contextual clues to help them perceive the meaning, function, and use of visuals. For example, designs

that shift the location, placement, order, or style of objects from one page to the next may likely cause user confusion. Web sites that go through frequent redesign can frustrate experienced readers who have to continually learn the new layout, design, and basic functionality. Such rapid changes in context distract users and keep their focus away from the site content as they attempt to discern the basic meaning and function of the site.

Use of visual shapes, symbols, and icons is also highly context dependent. Two frequent design problems include the overuse of visuals and their placement in unfamiliar contexts. Arnheim (1969) uses the term visual noise to describe the overuse of objects, symbols, shapes, shading, boxes, and lines, which might seem gratuitous and interfere with our ability to make sense of the visual space. In regard to context, using the same style declarations for both standard text and navigational links may confuse readers, causing them to click on the wrong item. Confusion about meaning and function might also arise if icons are used without accompanying text, i.e., using only an icon of an airplane in a site that sells airline tickets. Users will likely associate multiple meanings to that shape, such as schedules, booking a flight, types of planes, frequent flyer program, or something unknown. Our instincts evolve from our experiences and perceptual interaction with visual content, and context plays an essential role in their development.

Visual Hierarchies

Users tend to focus on elements that change in their environment or visual field and respond to more visually distinct elements. When something changes in the visual field, is in motion, highlighted, shifted, or superimposed on another, the eye is drawn to select that element over other static elements (Arnheim, 1969). As elements in the visual field change, users must make sense of the new configuration, suggesting a cognitive component to this perceptual process. Users also tend to focus on new information. When we first encounter a specific Web page, all of the information presented on the screen seems new and our "vision imposes a conceptual order on the material it records" (Arnheim, 1969, p. 22). Extending on this notion, Lynch and Horton (2001) suggest that visual information should follow a visual hierarchy, in which more important elements are emphasized for readers (p. 81). Otherwise, we as readers tend to respond first to animations, mouseovers, or visuals with greater figure-ground contrast in the same way we might first notice boldfaced headers on a page of text. Eye-tracking studies and other research have found that users focus first on photos, then brief descriptions, and

finally on article text, which indicate users have specific hierarchical preferences in what they focus on when browsing Web site content (DeVigal, 2005). Some heuristics that can be used in designing and evaluating visual content, which incorporate this approach, include the following:

Visual contrast. Use good color contrast, mouseover effects, and other styling techniques to make textual and graphic elements more visually distinct to readers.

Visual emphasis. Use shading, directional arrows, lines, or shapes to group search tools or navigation menus for added visual emphasis.

Placement. Place visual elements in consistent and predictable locations throughout a page or site.

Style consistency. Develop consistent visual styles for titles, headers, and navigation links to signal importance (Baehr, 2007).

There are also some problems with selective vision and perception, which can complicate our predictions of how users react to visual content. Users can experience visual overload when confronted with too many elements on a single screen or page. This may cause frustration and cause users to seek out more visually coherent sites for the same information or products. Another problem is that our visual instincts may be trained to ignore repeated or predictable visual stimuli (Arnheim, 1969). Experienced users can learn to overcome their initial instincts to click on an animated visual if they learn that it fails to serve a useful purpose (Baehr, 2007). Usability testing may provide a good source of information on user preferences for a specific site or product. It is also important for designers to be selective in the use of visual emphasis and design choices to maximize usability and to minimize search time for users.

Problem Orientation

Confronted with an unfamiliar situation, our eyes tend to focus on elements that help us ascertain or solve problems (Johnson-Sheehan & Baehr, 2001). Horton (1994) suggests we should "design the document to answer questions the reader will ask" (p. 51). Usability testing of Web sites often involves task-based scenarios, which focus on learning how accurately users perform tasks and solve specific problems with Web content. In a sense, Horton suggests designing user-centered content that responds to specific problems or information needs users might have. Arnheim's (1969) visual thinking principle *fixation solves a problem* suggests that whatever the purpose or problem, users will tend to focus or fixate on elements in the visual field that they believe will help solve a specific problem. In a Web page,

we do this when our eyes scan the page for elements or objects that we can use to plan our pathways through content. During the Web-searching process, users seek hyperlinks or navigation tools they believe will eventually lead to relevant information. Eye-tracking research can be helpful in determining how users interact with Web content and solve problems using navigation tools, search boxes, headers, site maps, and other visual objects. Some heuristics that can be used to help users focus and solve problems in Web sites include the following:

Tool variety. Provide a variety of navigation tools such as menus, toolbars, site maps, hyperlinks, and search tools to accommodate for different problem-solving strategies (Baehr, 2007).

Alternative text. When using visually based tools, such as image maps or icons, provide textual equivalents for users to help them understand their use or function.

Visual context. Use visual cues to help users quickly find and comprehend tools to solve problems. Highlight information pathways for readers by using descriptive headers, visual contrast, site maps, and indices.

One issue to consider is that a user's focal point is small, and the more screen elements Web users encounter, the greater the potential is for confusion and usability problems. Visual clutter, such as splash screens and animated objects with no purpose, can interfere with the problem-solving process. Providing the proper textual equivalents for some visual content not only helps maximize usability, but accessibility as well, particularly for users with specific disabilities or visual impairments (Baehr, 2007, p. 166). And as Horton (1994) suggests, designers should focus on creating content that anticipates users' needs and assists them in solving information problems with a variety of useful tools and methods.

Concept Formation and Relational Discernment

In the attempt to interpret and analyze visual information, we seek out familiar and consistent shapes in the visual field to form basic concepts and meaning about their function. Arnheim (1969) states, "Perception consists in fitting the stimulus material with templates of relatively simple shape, which I call visual concepts or visual categories" (p. 27). Concept formation is one of the perceptual acts involved in visual thinking (Arnheim, 1969). Users rely on past experiences with shapes they encounter to help understand new and unfamiliar ones. Web sites use a wide range of recognizable shapes, including keyword search boxes, expanding navigation menus, shopping carts, and play and rewind buttons. Shapes can be icons,

boxes, circles, shaded regions, tables, and even negative space around an object. The use of consistent and familiar shapes in Web pages allows readers to quickly analyze them to understand something about their function or use in a particular context. Familiar shapes can also be used in site maps and headers to illustrate the site's structure or hierarchy so readers can compare top-level information with specific content, visually. In this way, site maps can illustrate important spatial relationships between individual pages in different levels of a site.

The relational aspect involves understanding how visual grouping and pairing can help emphasize the shared characteristics between visual elements on a page. When we focus on a specific object, the background details often become blurred, or less significant, and conversely, when focusing on the background, specific details of the object become unfocused (Arnheim, 1969). Similar to the Gestalt principle of figure-ground, we either focus on the figure (specific object) or on the ground (overall background) when examining visuals (Kostelnick & Roberts, 1998). With a more complex visual, such as a Web page, users can choose to focus on specific content, i.e., paragraph, graphic, icon, button, etc., but become less aware of the contextual information surrounding that specific object, such as the page layout grid, placement of navigation tools, visual template, and background imagery. Conversely, while trying to focus on the overall page layout and interface as a whole, specific objects may become unfocused. In other words, users discern meaning from the various layers of content in creating a holistic understanding of visual content. Some heuristics that consider the conceptual and relational aspects of visual content include the following (Baehr, 2007):

Familiar shapes. Use conventional or easily recognizable shapes and icons to assist users in understanding their meaning within a given context.

Visual-textual pairs. Pair visuals with text descriptors for shapes and graphics used in unfamiliar contexts to help users associate the correct meaning of these objects.

Visual grouping. Use shading, rules, boxes, and other grouping techniques to visually signify and illustrate related content.

Context cues. Provide contextual information, such as headers, consistent graphics, and icons on pages throughout a site to help users identify content groups and how each relates to the overall site purpose.

Relational cues. Use text tags, toolbars, icons, headers, colors, nested navigation menus, indices, and repeated hyperlinks to illustrate how visual and textual content relate.

Some relational and context problems that deal with visual content are commonly found in Web sites and contribute to a number of usability problems. Placing shapes in unfamiliar contexts can confuse users as to their meaning and function within a site. Visual noise, or the overuse of visual elements, can also interfere with the user's ability to make sense of the whole visual space. And with few contextual clues, readers can become frustrated in their search for information in visually complex sites. Sites with navigation links that change location or style from one page to the next can also confuse users. Such rapid changes in overall layout or design keep users focused on discerning the overall organization, rather than on the specific content they seek. Conversely, a site that provides mostly contextual information, but little content, will have a similar effect on users. Many of these usability problems can be addressed by using visual content in a context that is familiar or in one that clearly indicates its use and function.

Conceiving the Whole through Structure and Interface

When viewing a new Web site, users form initial impressions about the overall purpose, function, and structure of information found. Our perceptual interaction with the site is iterative, in that we constantly revise our impressions based on our perception and experiences with that site. Similar to the Gestalt concept of completing partially obstructed shapes, here "the cognitive feat involved in such a process consists in rejecting the wholeness of a shape that presents itself and in reinterpreting it instead as a part of a larger and structurally better whole" (Arnheim, 1969, p. 34). Users base their initial impression of a Web site on the navigation tools, graphics, contextual clues, and other visual information, and through subsequent navigation and exploration that impression evolves. Through the acts of trial and error, browsing, searching, and following new information pathways, users gradually form a more accurate impression through continual shaping and re-evaluating the concept of the whole. This process of conceiving the whole is the essence of thinking visually.

Site structure and interface design are two essential elements of Web site development. The site structure communicates the overall arrangement of content, pages, and other elements in a site, including how they interrelate and are linked together. The site interface provides the visual interactive field that allows users to search and browse the site's content. Together, they help present a Web site as a whole or complete entity to users. Rosenfeld and Morville (2002) advocate the

importance of information (or site) architecture as part of the work of designing Web sites. They argue the importance of developing "logical structures that help us find answers and complete tasks" (p. 3). The spatial arrangements of these structures are usually demonstrated to users through site maps, indices, or navigational toolbars, which suggest a logical arrangement of content to users (Kostelnick & Roberts, 1998). Developing a site structure involves the tasks of organizing content, integrating contextual clues, and planning information pathways for readers. Information architecture uses these concepts and involves structuring content associatively rather than in a linear manner, like a printed text. Rosenfeld and Morville (2002) argue that this type of structural grouping of related items "supports an associative learning process that may enable the user to make new connections and reach better conclusions" whether the information is arranged hierarchically, hypertextually, or by topic, task or audience (p. 59).

Whereas site architecture involves discerning the various content layers and pages, the interface design involves layering of visuals, graphics, icons, text chunks, interactive menus, search fields, and spatial arrangement. Initially, users analyze the various visual, spatial, and textual elements to discern audience, purpose, context, and function of the site. In essence, they are trying to learn the language of the interface. Interface design focuses on the visual tools and concepts used to help the reader navigate and comprehend content in three-dimensional Web environments, including hyperlinks and other visual objects. The interface acts as a switchboard that allows users to navigate spatially through a site's structure. This interface is composed of various user controls, hyperlinks, and interactive objects that allow users to customize the visual quality, arrangement of content, media, and style of textual content. Johnson (1997) suggests a connection between the spatial and the semantic, and argues "the interface is a way of seeing the whole" (p. 238). Visual information, whether presented in print or on a screen, is perceived as having multiple layers that comprise the whole. Depth perception, perspective, and figure-ground contrast are all elements that suggest users perceive visual information in three-dimensions, or perhaps more.

Site structures and interface designs can build on established or recognized design conventions to assist users in comprehending the site layout. But in reality, many site designs require a higher degree of customization than a downloadable template, out-of-the-box Web solution or set of design conventions can offer. A deeper understanding of the perceptual acts associated with visual thinking is required to develop highly usable sites. Considering the issues of visual focus and how users form visual hierarchies can be useful in helping users visually compre-

hend the structure and layout of a site. Addressing the need for users to solve problems and providing tools and helpful cues can improve their searching and browsing experiences. And providing the appropriate visual context that demonstrates how site function and content relate can be a powerful way of communicating visually to users.

Conclusion

Heuristics for Web site analysis and design require a more complex understanding of user perception and thought. Users think visually, act instinctively, but also develop different interactive strategies based on their experiences with Web sites. Our understanding of Web sites involves how we think both visually and spatially in solving problems, interacting, and forming concepts about how visual and textual content relate in a site. As technology evolves, the standards and conventions that govern Web site development will as well. As users encounter new and unique Web environments, they rely on visual thinking to help them learn new tools and methods of interaction. One thing developers can do to ensure successful interaction between user and site is to consider the important role user perception plays. While our initial assumptions of digital content may have early roots in books and their print-based conventions, they have evolved considerably, and the way we think about designing and understanding content in the digital medium will change. Developing more adaptive models and heuristics for analyzing Web sites can ensure greater usability and accessibility of site content. Once we begin to apply heuristics that consider these approaches in our Web designs, our sites will begin to meet the visual and spatial thinking needs of users.

References

Arnheim, R. (1969). *Visual thinking*. Berkeley: University of California Press.

Baehr, C. (2007). *Web development: A visual-spatial approach*. Columbus: Pearson Prentice Hall.

Baehr, C., & Logie J. (2005). The need for new ways of thinking. *Technical Communication Quarterly*, 14 (1), 1-5.

Barry, A. M. S. (1997). *Visual intelligence*. Albany: State University of New York Press.

Behrens, R. (2001). Art, design and Gestalt theory. *Leonardo on-line*. Retrieved March 1, 2002, from http://mitpress2.mit.edu/e-journals/Leonardo/isast/articles/behrens.html

DeVigal, A. (2005). Putting eyetrack study to good use. Stanford-Poynter Project Eye Tracking Online News. Retrieved May 18, 2006, from http://www.poynterestra.org/et/i.htm.

Horn, R. (1998). *Visual language: Global communication for the 21st century*. Bainbridge Island: MacroVU, Inc.

Horton, W. (1994). *Designing and writing online documentation*. (2nd ed.). New York: John Wiley & Sons, Inc.

Johnson-Sheehan, R., & Baehr, C. (2001). Visual-spatial thinking in hypertexts. *Technical Communication*, 48 (1), 22-30.

Johnson, S. (1997). *Interface culture*. San Francisco: HarperCollins Publishers, Inc.

Koffka, K. (1935). *Principles of Gestalt psychology*. New York: Harcourt.

Kohler, W. (1947). *Gestalt psychology*. New York: Liveright Publishing Corporation.

Kostelnick, C., & Roberts, D. (1998). *Designing visual language*. Boston: Allyn and Bacon.

Lynch, P., & Horton, S. (2001). *Web style guide*. (2nd ed.) New Haven, CT: Yale University Press.

Rosenfeld, L., & Morville, P. (2002). *Information architecture for the World Wide Web*. (2nd ed.). Sebastopol, CA: O'Reilly and Associates.

Saco, D. (2002). *Cybering democracy*. Minneapolis: University of Minnesota Press.

Schriver, K. (1997). *Dynamics in document design*. New York: John Wiley and Sons, Inc.

Tufte, E. (1997). *Visual explanations*. Cheshire, CT: Graphics Press.

Williams R., & Tollett J. (2006). *The non-designer's Web book*. (3rd ed.). Berkeley, CA: Peachpit Press.

Chapter Five

Using Eye Tracking to See How Viewers Process Visual Information in Cyberspace

Sheree Josephson

How the brain processes visual images in cyberspace is a relatively unexplored research question. Without a "cerebrascope" (Grabinger, 1989) to gaze into the brain as it processes visual information, we can't know exactly what is going on as viewers navigate this digital visual landscape. To help solve this problem, eye-movement apparatuses can record eye-fixation location, duration, and scanpath information to help make the "invisible" cognitive processes visible. The technology used to gather this information involves a video camera with an infrared light that shines into the subject's eyes, allowing the system to track exactly what the individual is looking at. The subject, however, is generally unaware of the tracking equipment, fostering a natural viewing environment. This paper argues that eye-movement research is well suited to analyzing how visual information is processed in cyberspace in the absence of a "cerebrascope" and provides details on how data are collected and subsequently analyzed.

How the brain processes the vast universe of visual and verbal information in cyberspace is a relatively unexplored research question. Without a "cerebrascope" (Grabinger, 1989) or an imaging system to gaze directly into the brain as the eyes take in the imagery of the Internet, we can't know exactly what is going on as viewers navigate through this visual and verbal landscape. But we do have relatively easy-to-use and inexpensive eye-tracking apparatuses to help us see what is happening as Internet users process digital data. These apparatuses allow us to record

the location and duration of individual eye fixations and to follow the path the eyes take as they travel through cyberspace.

More than 25 years ago, Levy-Schoen (1983) explained the importance and relevance of eye-tracking research in a way that is still pertinent today:

> Since oculomotor activity (eye movement) is an overt behavior that is accessible to record-ing and measurement, it opens a door to the scientist interested in the organization of perceptual and cognitive processing. To the extent that eye movements are reliable corre-lates of the sequential centering of attention, we can observe and analyze them in order to understand how thinking goes on (p. 66).

In other words, eye-movement data can help make the "invisible" perceptual and cognitive processes "visible."

Eye movements, which largely go unnoticed in everyday experience, are neces-sary for a physiological reason. Detailed visual information can only be obtained through the fovea, the small central area of the retina that has the highest number of photoreceptors (Noton & Stark, 1971a). Eye movements (combined with head and body movements) are necessary to take in information in the real world or the Web world.

To direct the fovea toward the area of interest (AOI) in the visual scene, the eyes alternate between fixations, when they are aimed at a fixed point, and rapid movements called saccades. Fixations typically last between 200 and 500 millise-conds, and 1 to 5 degrees of the visual angle of view is processed (Yarbus, 1967). Fixations are separated by rapid, jerky movements, or saccades, during which the eyes' focus changes to a new location. Saccades are exceedingly quick and occupy only about 10 percent of the total time spent viewing information. Saccades rarely move the eyes more than 15 degrees of visual angle (Yarbus, 1967). During a fixa-tion, only a small area of the available visual information is selected at any time for intensive processing essential to perception of detail. Levy-Schoen (1983) points out that this may have the functional value of protecting the central processors in the brain from overload. At the next instant, a new part of the available visual in-formation can be selected for further intake and processing.

These fixations, which occur on average from two to five times every second, are physiological indicators of attention that can be directly linked to cognitive processing without having to devise a "cerebrascope." Specifically, attention is linked to visual fixation (Daffner et al., 1992) and visual fixation is linked to cog-nitive processing (Just & Carpenter, 1980; Rayner, 1978).

The majority of work regarding visual fixation can be summarized as investigation of one of three propositions (Fisher et al., 1983). First, fixations accumulate in locations judged to contain high semantic or visual information. Second, fixations are responsible for perception and are generally considered to be a reflection of the individual's cognitive strategy. Third, the fixation sequence allows for the encoding of the information in the brain and subsequent reconstruction of the images in memory.

Buswell (1935) was among the earliest researchers to claim that fixations accumulate in locations judged to contain high semantic or visual information. In his 1935 study, he showed that people's faces and hands are the most fixated areas of pictures regardless of what else is shown. He claimed that areas receiving the greatest number of fixations are the areas of greatest interest to the viewers. Other eye-movement researchers, namely Yarbus (1967), found a high concentration of fixations to the relatively few areas of a picture deemed to be highly informational. For example, when subjects were asked to determine approximate ages of the people shown, they directed their fixations to the faces of the human figures, since faces offer the best age clues.

An example of a study that links visual fixation to perception and subsequently to cognition is one by Ditchburn (1973). His work helped to show that the eyes fixate on those items currently being processed in the brain. He set up a target consisting of a line of print and had subjects view it. He found that, starting from the center, each letter could be read in turn by deciding to pay attention to it. Then, at a certain distance from the center, it suddenly became impossible to read the next letter. Similarly, with a Necker cube, it was found that if the corner was placed fairly near the center of the fovea, the alternations of position could be induced by deciding to direct attention to the corner. However, when the corner was too far from the foveal center, attention could not reach it, and no alternations were observed. Mackworth (1976) uses the term "useful field of view" (p. 307) to define the area around the fovea from which information can be effectively processed.

Fixation sequence is believed to correspond to the sequence of processing. The order in which information gets processed may reveal something about the task. Yarbus (1967) reported that when subjects were given different instructions before a three-minute viewing of a picture, different fixation patterns on the visual emerged. Nodine, Carmody and Kundel (1976) also found different patterns, depending on the task. Some researchers (Noton & Stark, 1971c; Josephson & Holmes, 2002) believe the fixation sequence also allows for the encoding and sub-

sequent reconstruction or recognition of the image in memory. Despite the fact that the sequence of fixations is largely unpredictable before viewing begins, there is evidence that when subjects are asked to recognize a picture they have seen before, the re-creation of the scanpath used to initially view the picture becomes a critical component in the recognition process.

Eye-movement Studies on the Web

While eye tracking as a research methodology has been around for decades, it has been used only in the last decade to examine the eye movements of viewers as they take in visual imagery on the Internet. However, in recent years due to the technological advancements and affordability of eye-tracking equipment, more and more researchers are using eye-movement research to measure what is happening as the eye moves through the Web's digital landscape. Information designers in the fields of media and marketing are probably the primary users of these apparatuses, which are the next best thing to a "cerebrascope."

In one of the early studies applying eye-tracking research to the Web, researchers at the Poynter Institute and Stanford University (2000) teamed to track the eye movements of 67 news users in Chicago and St. Petersburg, Fla., as they read news using their own bookmarks, and clicking and scrolling in as natural a fashion as possible. Researchers found that the eyes of many subjects were attracted to text first when a screen full of Web news was called up. This finding was contrary to the belief that viewers are likely to look at graphics and photographs first. The eyes of these online news readers fixated on the photos and graphics, but sometimes not until they returned to the first page after clicking away to a full article. In the analysis of advertising messages on the news Web sites, Poynter-Stanford researchers found that 45 percent of all banner ads were fixated but for only an average of one second. However, they concluded that this is probably sufficient time for the Web users to perceive the message.

In an eye-tracking study centered on banner advertisements on the Web, Josephson (2004) interestingly came up with similar results. In this study, 44% of Web viewers looked at banner ads, and those Web surfers who fixated on a banner did so for an average of 1.21 seconds. Location was found to be the strongest variable in determining whether viewers looked at banner ads and how long they looked at them, with animation playing little or no significant role in whether viewers fixated on banner ads or how long they looked. Banner ads on the top of the page were much more likely to be viewed than those placed on the bottom.

In a study in which participants searched for specific targets, Grier (2004) concluded that neither motion nor position dominated target detection or gaze behavior. Regarding animation specifically, Faraday and Sutcliffe (1999) cautioned that it can have detrimental effects if it not used correctly on the Internet. They concluded that "unconstrained use of multimedia results in user interfaces that confuse users and make it harder for them to understand the information" (p. 458). After testing four designs of animation in Web pages, they suggested that information designers use "contact points" (p. 458), which integrate the text and visual streams, to facilitate the processing of visual information on the Web.

Using Internet portal pages as visual stimuli, Josephson and Holmes (2002) tested the scanpath theory of visual perception (Noton & Stark, 1971b, 1971c). As defined by Noton and Stark, scanpaths are repetitive sequences of fixations and saccades that occur upon re-exposure to a visual stimulus. Josephson and Holmes reasoned that since Internet users are exposed to repeated visual displays on Web portals, they provide ideal stimuli to test this theory. In this study, eye-movement data were recorded for subjects' repeated viewings of three portal pages over three sessions, and the resemblance of eye-path sequences was compared using a string-edit technique. While the results were not definitive, a statistically significant main effect for cross-viewing comparisons was found, reflecting a linear trend in which eye paths for the same subject became more alike over time.

Using this same data analysis technique to compare scanpaths, Josephson and Holmes (2004) sought to determine whether there are any age differences that manifest in visual search for information on Web pages. They found preliminary evidence that older adults who are avid Internet users are able to rapidly and accurately find information, while the visual search of children who have never known a world without the Web is almost as fast and accurate as that of teenagers or adults. In a study that same year on age differences, Grahame, Laberge and Scialfa (2004) measured eye movements during visual search of Web pages to determine age-related differences in performance as a function of link size, link number, link location, and clutter. They found that increased link size from 10 to 12 point improved performance, whereas increased clutter and number of links hampered search, especially for older adults.

Other researchers have used eye-movement measurement to study Web page viewing. Bing et al. (2004) looked at various determinants of Web page viewing behavior and found that it is driven by the gender of the subjects, the order of the Web pages being viewed, and the interaction between Web site types and the order of the pages being viewed. Goldberg et al. (2002) used eye tracking to test the

performance of subjects in completing several tasks on a Web portal page. Their research demonstrated that there were more regular horizontal eye movements than vertical eye movements between different segments of a portal page, that the headers in a portal were not usually visited before the body, and that searches did not become more directed as a screen sequence increased. Eye tracking has also been used to study numerous components on Web pages, including click-down menus (Byrne et al., 1999), computer interfaces (Goldberg & Kotval, 1998, 1999; Goldberg, 2000), and color of links (Halverson & Hornof, 2004).

While eye-tracking studies have been increasingly used by scholars in the last decade to study how information is processed in cyberspace, it is by no means a widely used methodology to evaluate Internet imagery. Also it is difficult to assess how frequently the research method is being used in industry because many of the findings are proprietary. However, as evidenced by the emergence in 2000 of an ACM (Association for Computing Machinery) conference devoted to eye-movement research—ETRA: Eye racking Research & Applications Symposium—there is an increased interest in this methodology by both scholars and industry.

Why Eye Tracking Hasn't Been Widely Used

If eye-movement data can provide such a highly reliable and high-tech way of looking at how visual information is processed on the Web, why aren't even more researchers using it as a research methodology? There may be a number of reasons for this.

First and foremost, some critics claim that eye-movement data are unnecessary for studying Web sites because the behavioral results of Web page exposure—hits or click-through rates—are right there in the log for any Web publisher to see. True, hits can show whether particular pages on the Internet are viewed, and click-through rates can show whether a particular item on a Web page is noticed. However, only eye-movement data can show what happened when a viewer looked at a page and what happened in between the clicks. Only eye-movement data can help explain what is happening in the brain as the eyes take in visual imagery on the Internet—and why.

Second, when dealing with computers in general and the Web in particular, the technical features involved in displaying the information generally receive more attention than the human factors involved in processing the displayed visual information. In a statement made more than 20 years ago that is still applicable today, Galitz (1985) noted that as a result of technology receiving greater atten-

tion than usability, screen design research has failed to adequately reflect human perceptual and processing capabilities. Galitz would likely agree that visual communication scholars and human factors researchers need to use eye tracking to better understand how people process the visual information found on Web pages.

Third, many designers of visual and verbal images in cyberspace have simply operated under the assumption that what works in print will work on the Web and that the analog and digital visual information will be viewed in similar fashion. That this is not always the case is illustrated with an exploratory eye-tracking study of typography, the basic element to visual and verbal communication on the Web. Josephson (2008) found that the readability of the sans serif typeface Verdana, designed specifically to be read on a computer screen, was better than it was for two typefaces originally designed for print—specifically Times New Roman and Arial. Subjects experienced fewer regressions or backward eye movements when reading text displayed in Verdana. They also expressed a strong preference for Verdana onscreen.

Finally, a fourth reason is that until recently, sophisticated equipment such as that used to track the eyes' travel in the Web environment has been expensive to acquire, complex to operate, and has gathered data that were difficult to analyze. However, as Duchowski (2002) points out, the years 1970 to 1998 were marked by significant improvements in eye-tracking systems, facilitating accurate and easily obtained measurements, and improvements have continued to be made in the last 10 years. Despite the fact that eye trackers have been "bolstered by advancements in computational power, richness of graphical displays, and robustness of interactive styles" (p. 455), numerous researchers are probably still intimated by the apparatuses and overwhelmed by the data-rich analysis required to make meaningful findings beyond simply what was viewed and how long it was fixated.

As refinements continue to be made in eye-tracking technology—both in hardware and software—we will likely see eye movements more commonly measured as a means of analyzing visual imagery on the Internet. A number of eye-tracking companies such as Applied Science Laboratories (ASL), tobbi technology, seeingmachines, EyeLink, Arrington Research, eyetools, and ISCAN, Inc., are marketing the systems and software. A number of individuals have also made their own eye-tracking apparatuses.

Eye-tracking Technology to Study the Web

Typical of eye-tracking systems is the RK-426PC Pupil/Corneal Reflection Tracking System designed by ISCAN, Inc. (ISCAN, 1998), of Burlington, Mass. Even though this system is 10 years old, it operates according to the same principles as the newer technology. It requires a video camera that aims an infrared light source into the subject's eyes to track exactly what that individual is looking at (see Figure 1). A PC- card-sized, real-time digital image processor then is able to automatically track the center of a subject's pupil and reflection from the corneal surface.

Like most systems, this one allows for a fairly natural viewing environment. Subjects can freely move their heads and hands as they navigate through the Web. That is because this system overcomes a number of obstacles, such as head movements. By tracking both pupil and corneal reflection, changes in the subject's gaze may be discriminated from movements of the subject's head. A natural viewing environment is also possible because the system can operate in widely changing lighting levels. This system is also flexible in that it accommodates a wide subject population, including those who wear eye glasses or contacts, or those who have droopy eyelids or heavy eyelashes. Finally, when a subject blinks, the information is accounted for and eliminated.

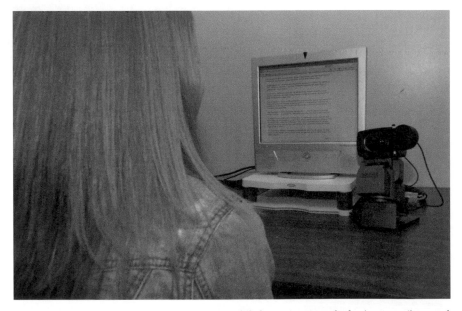

Figure 1: A subject looks at a computer screen while her eyes are tracked using a pupil-corneal reflection tracking system developed by ISCAN, Inc.

Before data can be collected, the system must be calibrated. Calibration is accomplished by correlating the pupil positions with an eye excursion over a known visual angle. The calibration procedure involves instructing the subject to fixate on five (or nine) targets, one at a time. The targets are generally positioned in the center, the upper left, the lower left, and lower right portions of the subject's field of view. After calibration, these correlating factors are used to compute the point-of-regard for subsequent eye movements.

Three kinds of data are recorded by the system: fixation chronology, fixation time, and fixation number. Fixation chronology is a hierarchal mapping that shows what the viewer looked at first, second, third, etc. Fixation time is the amount of time recorded in milliseconds that a viewer looks at specific elements. Fixation number is the total number of times a viewer fixates on various elements.

This information is recorded in two forms: on videotape with the fixation points and ensuing scanpath superimposed on top of the video in real time, and in a computer program that allows the data to be later analyzed in a number of different formats. The data recorded by the computer program allow the results to be displayed both numerically and pictorially. The numerical display consists of a list showing each fixation, its starting time and duration in seconds (see Figure 2). The pictorial display consists of a scanpath display and a raindrop fixation display. The scanpath shows the path the eye followed as it traveled across the information on the Web page (see Figure 3). Raindrop fixations are so called because the size of the fixation dot increases in size with the length of the fixation (see Figure 4). For ease of presentation and analysis, this information can be superimposed over the image that was viewed by a subject by doing a screen capture. The subject's points of regard and scanpath are displayed graphically over the captured computer screen (see Figure 6).

The computer program allows for analysis of fixation on different areas of the Web page, also known as areas of interest (AOI). By establishing boundaries around certain elements, researchers can determine whether viewers looked at certain items, for how long and in what order (see Figure 5). Bar graphs and pie charts show the total fixation time and the percentage of the total time that was spent looking at those particular items (see Figures 7). A "time line" style fixation chronology may be generated showing which elements were viewed and in what order (see Figure 8). Thus, a number of different visual representations can be created to illustrate the numerical results of the eye-tracking system.

Eye-tracking Analysis Methods

Once the data have been collected, a number of different analyses can be performed. The major eye-tracking analysis methods can be divided into four main categories: (1) measures of processing that primarily use the fixation number, location and duration data, (2) measures of search that rely on basic scanpath and saccade data, (3) measures of scanpaths that compare their complexity, regularity, and similarity, and (4) other measures. All of these eye-tracking analysis methods can be computed by using variations of the fixation chronology, fixation duration, and fixation location data described above.

Measures of Processing

Number of Fixations. In a visual search, the number of fixations is related to the number of components that the user processes before locating the target, but not necessarily the depth of required processing (Goldberg & Kotval, 1999, p. 643). However, once the searcher finds what he or she is interested in, the number of fixations indicates the amount of interest in a visual area. Mackworth and Morandi (1967) made comparisons between visual fixations on, and verbal estimates of, the relative importance of regions within photographs. For example, these researchers found that the regions rated highly for informativeness produced the highest fixation frequency.

Location of Fixations. Fixations indicate one's spatial focus of attention over time. The eyes naturally fixate on areas that are surprising, salient, or important through experience (Loftus & Mackworth, 1978).

Fixation Duration. Viviani (1990) found that the minimum processing duration during a fixation is 100 to 150 milliseconds with the average length of a typical fixation at 250 to 300 milliseconds. Yarbus (1967) agreed that fixation durations are in the same range. Buswell (1935) found that more difficult processing produced longer fixation durations. Mackworth (1976) noted that higher display densities produced fixations durations that were 50 to 100 milliseconds longer than those fixations on lower density displays. Longer fixations imply the user is spending more time interpreting or relating the visual representation to internalized representation of the visual data.

```
* List of Fixations Data Display *

Subject:                                    Date:  2-20-03
Description:  NONE                          Sample Rate:  60 Hz

    Fix #         P-O-R H         P-O-R V         FixStart        FixTime

      1             261             260            0.683           0.400
      2             339             337            1.217           0.633
      3             194             324            2.000           1.017
      4             253             296            3.050           0.267
      5             169             355            3.517           0.117
      6             157             370            3.633           0.117
      7             177             451            3.933           0.933
      8             346             216            5.033           1.533
      9             324             278            6.683           0.583
     10             376             184            7.383           1.733
     11             230             219            9.250           0.217
     12             311             227            9.617           0.867
     13             238             142           10.600           0.750
     14             234             219           11.467           0.583
     15             339             341           12.183           0.450
     16             319             419           12.783           0.833
     17             231             320           14.150           0.117
     18             142             346           14.367           0.100
     19             125             153           14.633           0.100
```

Figure 2: A numerical display shows the horizontal and vertical coordinate or point of regard (P-O-R) for each fixation, the time the fixation started, and the fixation's duration.

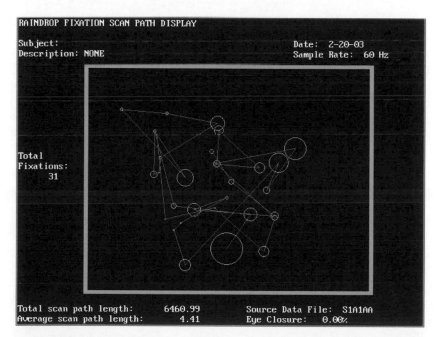

Figure 3: This raindrop fixation scanpath shows the path the eye followed as it moved across the Web site. The size of the fixation circle is proportionate to the length of the fixation.

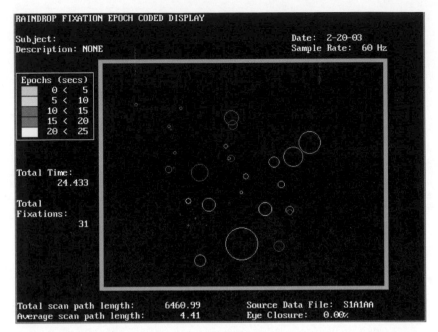

Figure 4: The raindrop fixation epoch-coded display assigns the fixations to epochs based on time. The size of the circle is proportionate to the length of the fixation. This table also lists total time, total fixations, and total scanpath length.

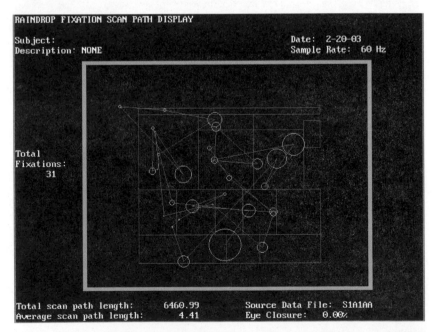

Figure 5: In order to perform the string-edit analysis to compare scanpaths, areas of interest have to be defined on the Web site, in this case Altoids.com. The participant's scanpath is superimposed.

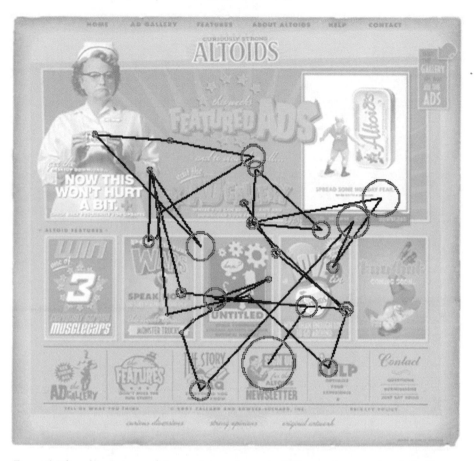

Figure 6: The subject's scanpath is superimposed over the Web page that was viewed, in this case Altoids.com. The last fixation (bottom center) was on the "sign up" link since the participant was told to locate this.

Cumulative Fixation Time. The total amount of fixation time on an area of interest (AOI) is generally interpreted as the amount of interest a viewer has in that particular visual element. It is also interpreted as the amount of time spent processing the information. Latimer (1988) suggests making a cumulative fixation time (CFT) plot, which is a topographical representation of the cumulative fixation times made by a subject while inspecting a stimulus. "Such plots can also be cumulative across stimuli and/or subjects" (p. 438). To plot a CFT, a computer program reads a text file of x-y coordinates and fixation times, and then (1) converts the x-y coordinates to row and column coordinates, (2) accumulates the fixation times for each location, and (3) prints out truncated 't' values in their screen locations (p. 438). Methods and computer programs exist to depict the CFT in a three-dimensional graph.

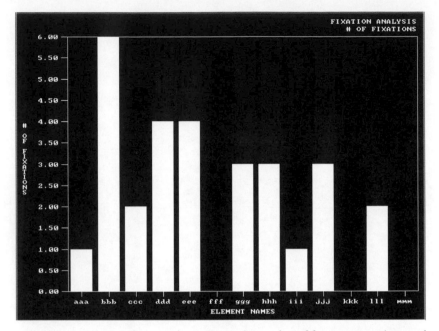

Figure 7: Bar charts can be created to compare the number of fixations on each area of interest on the Web page.

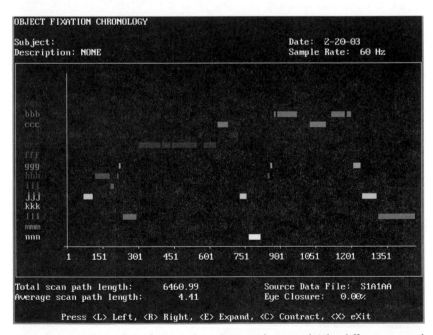

Figure 8: A timeline of the fixation chronology can be created. The different areas of interest are represented by different colors.

Analysis of Visual Clusters. Clusters are "heavy concentrations of fixations and fixation time (attention) on particular areas of a screen and stimuli. If a CFT distribution can be partitioned into such clusters in some relatively objective manner, an experimenter should be able to point to such clusters and assert that stimuli or stimulus parts located under them have received significant attention by a subject or subjects" (Latimer, 1988, p. 445). "The mean of a cluster in a CFT distribution is assumed to be the central point of an area of the screen, a stimulus or a stimulus region for which the fixations within the cluster were intended" (Latimer, 1988, p. 445). Latimer proposes using the 'k' means cluster methodology for analysis of eye-fixation location. According to this approach, each object or location is given three descriptors (triple): its row coordinate, its column coordinate and its 't' value. Then Latimer uses the three-dimensional representations to estimate the location and number of clusters. The initial cluster means are noted. Once the initial estimates are settled, the remaining triples ('t' values together with their row and column coordinates) are now considered in random order for membership within each cluster. "The criterion of membership is the Euclidean distance from each cluster mean, where each randomly chosen triple is allocated to its nearest cluster. After a triple has been allocated, the new mean row and column coordinates and total 't' value are computed from the triples already in the cluster and the new triple. The process of random assignment of triples continues until all triples in the CFT distribution have been allocated and the final mean positions ascertained" (Latimer, 1988, p. 445).

Heat Maps. A heat map is a graphical representation of how a number of visitors behaved on a Web page. Heat maps typically use different colors to chart eye-movement activity, with red denoting the greatest activity, followed by orange, green, and blue. Lighter shades represent lesser activity. Sections of the Web page with no activity would be displayed with no color overlay or with some eye-tracking systems in black. Basically, the eye-tracking system computes how many individuals look at a specific pixel on the computer screen, computes the percentage, and colors it with the shade associated with that percentage (Hernandez, 2007).

On-target Fixations. The number of fixations on the designated area of interest (AOI) can be determined by counting the number of fixations on the AOI. The ratio of the number of fixations on the AOI or target can be determined by counting the number of fixations on the AOI, then dividing by all fixations.

Measures of Search

Scanpath Length. Scanpath length is computed by summing the distance (in pixels) between gazepoint (earlier described as fixation location) samples. For information search tasks, the ideal scanpath is "a straight line to the target, with a relatively short fixation duration on the target" (Goldberg & Kotval, 1999, p. 635). Shorter scanpaths seem to indicate that the information is well-organized, and the information is easy to find. Lengthy scanpaths indicate less efficient scanning behavior but do not distinguish between search and information-processing times.

Scanpath Duration. "Scanpath duration is more related to processing complexity than to visual search efficiency, as much more relative time is spent in fixations than in saccades. Using 60 Hertz gazepoint samples, the number of samples is directly proportional to the temporal duration of each scanpath, or Scanpath Duration = n x 16.67 ms, where n = number of samples in the scanpath. However, using fixations, the scanpath duration must sum fixations with saccade durations" (Goldberg & Kotval, 1999, p. 638).

Convex Hull Area. The area covered by a scanpath is also important to an analysis of visual search. Goldberg and Kotval (1999) propose an algorithm to construct convex hulls and hull area in order to minimize the effect an outlying gazepoint sample would have if the area of a scanpath were simply computed by drawing a circle around the scanpath. Using the convex hull area in conjunction with the length of the scanpath, Goldberg and Kotval are able to determine whether a lengthy search covered a large or localized area on a display.

Spatial Density. "Coverage of an interface due to search and processing may be captured by the spatial distribution of gazepoint samples. Evenly spread samples throughout the display indicate extensive search with an inefficient path, whereas targeted samples in a small area reflect direct and efficient search" (Goldberg & Kotval, 1999, p. 640). The amount of spatial density can be computed by dividing the visual stimulus into grid areas representing the physical screen area or specific screen objects and counting how many of these grids received at least one fixation. The spatial density index is equal to the number of cells containing at least one sample, divided by the total number of grid cells.

Transition Matrix. A transition matrix expresses the frequency of eye-movement transitions between AOIs (Ponsoda, Scott, & Findlay, 1995). This measurement considers both search area and movement over time. Also known as link analysis (Jones, Milton, & Fitts, 1949), frequent transitions from one region of a display to another indicates inefficient scanning with extensive search. Goldberg and Kotval (1999) determine it by dividing the number of active transition cells (those containing at least one transition) by the total number of cells. According to their formula, a large index value indicates a dispersed, lengthy and wandering scanpath, while smaller values point to more directed and efficient search. When a limited and small number of AOIs are used, Josephson and Holmes (2008) simply count the number of transitions between areas of interest.

Number of Saccades. The number of saccades in a scanpath indicates the amount of search, with more saccades implying greater amount of search. The number of saccades equals the number of fixations minus one.

Saccadic Amplitude. Saccadic amplitude is defined as the distance covered by a saccade. The average saccadic amplitude is computed by summing the distances between consecutive fixations, dividing this by the number of fixations minus one.

Measures of Scanpaths

Scanpath Regularity. "Measures of scanpath complexity and regularity, considering integrated error or deviation from a regular cycle, can indicate variance" (Goldberg & Kotval, 1999, p. 643). "Many potential measures of scanpath complexity are possible, once cyclic scanning behavior is identified" (p. 643.)

Markov Analysis. A Markov process is a stochastic model predicting the probability that the viewer's eyes will move from one visual element to another. This means that when the eye is fixated in a particular position, there are many possibilities where the next fixation will occur, but some locations are more probable than others. A common assumption regarding scanpaths is that they can be described by a first-order Markov process—that is, each eye fixation only depends on the previous one. Two other first-order stochastic possibilities underlie visual scanning: reversibility and stationarity. Reversibility means that saccades from element A to B occur as often as saccades from B to A (Ellis & Smith, 1985), while stationarity

predicts that the scanpaths of viewers exposed repeatedly to the same visual stimuli remain constant across exposures. Ellis and Smith (1985) suggested that scanpaths can be generated by completely random, stratified random, or statistically dependent stochastic processes. A completely random process assumes that each element of a visual has an equal probability of being focused on during each fixation. A stratified random process assumes that the probabilities of visual elements being fixated reflect the attentional attractiveness of those elements, but they do not depend on previous fixations. The statistically dependent stochastic process specifies that the position of a fixation depends on previous fixations. Rayner (1995) and Stark and Ellis (1981) believe it is unlikely that saccades from one fixation point to another are either completely random or stratified random processes and look toward statistically dependent stochastic processes as explanation, meaning that current location of fixation is the strongest predictor of the subsequent fixation.

String-edit Analysis. The string-edit method is a technique that measures resemblances between eye-path sequences by means of a simple metric based on the insertions, deletions, and substitutions required to transform one sequence into another. Abbott and Hrycak (1990) noted several advantages of string-edit methods for studying event sequences and outline several difficulties with Markovian sequence models. First, and foremost, they argued the sequence-generating process may have a longer history than the immediate past typically used in Markov analysis. Second, Markov models don't address the question of whether there is a typical eye-path sequence. Abbott and Hrycak (1990) argued that the direct testing of the Markov model—in terms of actual resemblance between generated and observed sequences—requires a technique for assessing similarity between sequences, categorizing sequences, and identifying typical sequences for individuals or between individuals. String-edit analysis affords all of these techniques.

The first step in comparing eye-path sequences using the string-edit technique is to define a sequence alphabet for the stimulus. This is accomplished by assigning each defined target area an alphabetic code. The second step is to define the eye-path sequence for each subject's viewing of the stimulus material by recording the sequence of fixations by the defined target area within which the fixation occurred (called "target tracing" by Salvucci and Anderson [2001]). For example, a viewing beginning with a single fixation in area "A" followed by three fixations in area "C," would generate a sequence beginning "ACCC...".

Next, optimal matching analysis (OMA) is used to compare the coded sequences. OMA is a generic string-edit tool for sequence comparison (Holmes, 1997), when each sequence is represented by well-defined elements drawn from a relatively small sequence alphabet. OMA produces a numerical index—the Levenshtein distance—of the similarity between any two sequences, computed as the smallest possible cost of elementary operations of insertion, substitution, and deletion of units required to align or transform one sequence into another (Sankoff & Kruskal, 1983; Abbott & Forrest, 1986). Similar sequences will, when compared, have smaller dissimilarity indexes; very different sequences will have larger dissimilarity indexes.

In their application of the string-edit method, Brandt and Stark (1997) set equal substitution costs for all pairs of sequence elements or AOIs. Josephson and Holmes (2002) based the substitution values on a measure of distance. The contribution to the Levenshtein distance by the length of the compared eye-path sequences (defined by the number of fixations in each) is an issue that has to be considered in OMA. To adjust for the role of sequence length in shaping the total cost of alignment, Josephson and Holmes (2002) determined the inter-sequence distance by dividing the raw sum alignment cost by the length of the longer sequence in the sequence pair. This makes the distance relative to length and comparable across pairs of varying lengths.

Next, WinPhaser software (Holmes, 1996) is used to generate a sequence distance matrix of distance indexes for each possible pair of sequences for each stimulus. WinPhaser's OMA package uses a dynamic programming algorithm by Andrew Abbott. UCINET software (Borgetti, Everett, & Freeman, 1992) is then used to perform non-metric multidimensional scaling and hierarchical cluster analysis on the distance matrices. Scaling arranges the sequences in n-dimensional space such that the spatial arrangement approximates the distances between sequences; cluster analysis helps to define "neighborhoods" of similar cases within that n-dimensional space.

Other Measures

Backtrack. "A backtrack can be described by any saccadic motion that deviates more than 90 degrees in angle from its immediately preceding saccade. These acute angles indicate rapid changes in direction, due to changes in goals and mismatch between users' expectation and the observed interface layout" (Goldberg & Kotval, 1999, p. 643).

On-target: All-target Fixations. The on-target: all-target fixations "can be defined by counting the number of fixations falling within a designated AOI or target, then dividing by all the fixations. This is a content-dependent efficiency measure of search, with smaller ratios indicating lower efficiency" (Goldberg & Kotval, 1999, p. 643).

Post-target Fixations. "The number of post-target fixations or fixations on other areas, following capture of the target, can indicate the target's meaningfulness to a user" (Goldberg & Kotval, 1999, p. 643).

Conclusion

As the World Wide Web becomes ubiquitous in professional, personal, and cultural spaces, it is becoming increasingly important to determine the effectiveness and efficiency of Web-based communication. The Web is no longer a place of pure research or technical interest. It has become a space where we work, learn, communicate, and play. Thus, it is imperative that we are able to understand how this digital landscape is perceived and processed. One of the most effective ways to accomplish this is to watch the movement of the eye using the next best thing to a "cerebrascope"—an eye tracker.

This apparatus records the eyes' fixation location, the duration of that fixation, the number of fixations, and the fixation chronology or scanpath. From these relatively simple eye-movement measures, a number of different analyses can be performed, including (1) measures of processing that primarily use the fixation location, duration, and number data, (2) measures of search that rely on basic scanpath and saccade data, (3) measures of scanpaths that compare their complexity, regularity, and similarity, and (4) other miscellaneous measures. These four eye-tracking analysis methods can be used in a myriad of ways to gain insight into what is happening as the eyes travel through cyberspace. The argument that eye-tracking data is the next best thing to having a "cerebrascope" is supported by the fact that so much can be learned from the analysis of four fairly simple and straightforward forms of eye-tracking data.

References

Abbott, A., & Forrest, J. (1986). Optimal matching sequences for historical sequences. *Journal of Interdisciplinary History, 16,* 471-494.

Abbott, A., & Hrycak, A. (1990). Measuring resemblance in sequence data, *American Journal of Sociology*, 16, 144-185.

Bing, P., Hembrooke, H. A., Gay, G. K., Granka, L. A., Feusner, M. K., & Newman, J. K. (2004). The determinants of Web page viewing behavior: an eye-tracking study, *Proceedings of ETRA 2004: Eye Tracking Research & Applications Symposium* (pp.147-154). San Antonio, TX: ACM Press.

Borgetti, E. F., Everett, M., & Freeman, L. C. (1992). UCINET IV (Version 1.0) [computer software]. Columbia: Analytic Technologies.

Brandt, S. A., & Stark, L. W. (1997). Spontaneous eye movements during visual imagery reflect the content of the visual scene. *Journal of Cognitive Neuroscience*, 9, 27-38.

Buswell, G. T. (1935). *How people look at pictures*. Chicago: University of Chicago Press.

Byrne, M. D., Anderson, J. R., Douglass, S., & Matessa, M. (1999). Eye tracking the visual search of click-down menus. *Proceedings of the SIGCHI Conference on Human Factors in Computing Systems: The CHI Is the Limit* (pp. 402-409). Pittsburgh, PA: ACM Press.

Ditchburn R. W. (1973). *Eye-movements and visual perception*. London: Oxford University Press.

Daffner, K. R., Scinto, L. F. M., Weintraup, S., Guinessey, J. E., & Mesulam, M. M. (1992). Diminished curiosity in patients with probable Alzheimer's disease as measured by exploratory eye movements, *Neurology*, 42, 2.

Duchowski, A. T. (2002). A breadth-first survey of eye-tracking applications. *Behavior Research Methods, Instruments & Computers*, 34(4), 455-470.

Ellis, S. R., & Smith, J. D. (1985). Patterns of statistical dependency in visual scanning. In R. Groner, G. W. McConkie, & C. Menz (Eds.), *Eye movements and human information processing*, (pp. 221-238). Amsterdam: Elsevier Science Publishers BV.

Faraday, P., & Sutcliffe, A. (1999). Authoring animated Web pages using "contact points." *Proceedings of the SIGCHI Conference on Human Factors in Computing Systems: the CHI is the Limit* (pp. 458-465). Pittsburgh, PA: ACM Press.

Fisher, D. F., Karsh, R., Breitenbach, F., & Barnette, B.D. (1983). Eye movements and picture recognition: Contribution or embellishment. In R. Groner, C. Menz, D. F. Fisher, & R. Monty (Eds.), *Eye movements and psychological functions: international views* (pp. 193-210). Hillsdale, NJ: Lawrence Erlbaum Associates.

Galitz, W. O. (1985). *Handbook of screen format design*. Wellesley, MA: QED Information Sciences, Inc.

Goldberg, J. H. (2000). Eye movement-based interface evaluation: What can and cannot be assessed? *Proceedings of the IEA 2000/HFES 2000 Congress* (44th Annual Meeting of the Human Factors and Ergonomics Society) (pp. 6/625-6/628). Santa Monica, CA: HFES.

Goldberg, J. H., & Kotval, X. P. (1998). Eye movement-based evaluation of the computer interface. In S. K. Kumar (Ed.) *Advances in Occupational Ergonomics and Safety*, (pp. 529-532). Amsterdam: IOS Press.

Goldberg, J. H., & Kotval, X. P. (1999). Computer interface evaluation using eye movements: methods and constructs. *International Journal of Industrial Ergonomics*, 24, 631-645.

Goldberg, J. H., Stimson, M. J., Lewenstein, M., Scott, N., & Wichansky, A. M. (2002). *Proceedings of ETRA 2002: Eye Tracking Research & Applications Symposium* (pp. 51-58). New Orleans, LA: ACM Press.

Grabinger, R. S. (1989). Screen layout design: research in the overall appearance of the screen. *Computers in Human Behavior, 5*(3), 175-183.

Grahame, M., Laberge, J., & Scialfa, C. T. (2004). Age differences in search of Web pages: The effects of link size, link number, and clutter. *Human Factors, 46*(3), 385-398.

Grier, R. (2004). Visual attention and Web design. A. *Dissertation Abstracts International,* 65(07B) 3738.

Halverson, T., & Hornof, A. J. (2004). Link colors guide a search. *Proceedings of the Conference on Human Factors in Computing Systems* (pp. 1367-1370). Vienna, Austria: ACM Press.

Hernandez, T. (2007). Part V: Time and the heatmap. Retrieved February 3, 2009 from http://blog.eyetools.net/ eyetools_research/2007/09/but-whaat-does-1.html.

Holmes, M. E. (1996). WinPhaser user's manual (Version 1.0c) [computer software].

Holmes, M. E. (1997). Optimal matching analysis of negotiation phase sequences in simulated and authentic hostage negotiations. *Communication Reports, 10,* 1-8.

ISCAN, Inc. (1998, January). RK-726PCI Pupil/Corneal Reflection Tracking System PCI Card Version Operating Instructions. Rikki Razdan.

Jones, R. E., Milton, J. L., & Fitts, P. M. (1949). Eye fixations of aircraft pilots; IV: frequency, duration and sequence of fixations during routine instrument flight, US Air Force Technical Report 5975.

Josephson, S. (2008). Keeping your eyes on the screen: an eye-tracking study comparing sans serif and serif typefaces, *Visual Communication Quarterly, 5*(1-2), 67-79.

Josephson, S. (2004). Using eye tracking to study visual imagery on the Web. In K. Smith, G. Barbatsis, S. Moriarty, & K. Kenney (Eds.), *Handbook of Visual Communication: Theory, Methods, and Media* (pp. 63-80). Mahway, NJ: Lawrence Erlbaum Associates.

Josephson, S., & Holmes, M. E. (2002). Visual attention to repeated Internet images: testing the scanpath theory on the World Wide Web. *Proceedings of ETRA 2002: Eye Tracking & Research Applications Symposium* (pp. 43-49). New Orleans, LA: ACM Press.

Josephson, S., & Holmes, M. E. (2004). Age differences in visual search for information on Web pages. *Proceedings of ETRA 2004: Eye Tracking & Applications Symposium* (pp. 62). New Orleans, LA: ACM Press.

Josephson, S., & Holmes M. E. (2008). Cross-race recognition deficit and visual attention: Do they all look (at faces) alike? *Proceedings of ETRA 2008: Eye Tracking & Research Applications Symposium* (pp. 157-164). Savannah, GA: ACM Press.

Just, M. A., & Carpenter, P. A. (1980). A theory of reading: from eye fixations to comprehension. *Psychological Review,* 87(4), 329-354.

Latimer, C. R. (1988). Eye-movement data: cumulative fixation time and cluster analysis. *Behavior Research Methods, Instruments, & Computers,* 20(5), 437-470.

Levy-Schoen, A. (1983). Foreword. In R. Groner, C. Menz, D. F. Fisher, & R. A. Monty (Eds.), *Eye movement and psychological functions: international views.* (pp. 65-71). Hillsdale, NJ: Lawrence Erlbaum Associates.

Loftus, G. R., & Mackworth, N. H. (1978). Cognitive determinants of fixation location during picture viewing. *Journal of Experimental Psychology: Human Perception and Performance,* 4(4), 565-572.

Mackworth, N. H. (1976). Stimulus density limits the useful field of view. In R. A. Monty & J. W. Senders (Eds.), *Eye movements and psychological processes* (pp. 307-321). Hillsdale, NJ: Lawrence Erlbaum Associates.

Mackworth, N. H., & Morandi, A. J. (1967). The gaze selects informative details within pictures. *Perception & Psychophysics,* 2, 547-552.

Nodine, C. F., Carmody, D. P., & Kundel, H. L. (1976). Searching for NINA. In J. W. Wenders, D. F. Fisher, & R. A. Monty (Eds.), *Eye movements and the higher psychological functions* (pp. 241-258). Hillsdale, NJ: Lawrence Erlbaum Associates.

Noton, D., & Stark L. (1971a) *Eye* movements and visual perception. *Scientific American* 2240(6), 35-43.

Noton, D., & Stark, L. W. (1971b). Scanpaths in eye movements during pattern perception. *Science,* 171, 308-311.

Noton, D. & Stark, L. W. (1971c). Scanpaths in saccadic eye movements while viewing and recognizing patterns. *Vision Research,* 11, 929-942.

Ponsoda, V., Scott, D., & Findlay, J. M. (1995). A probability vector and transition matrix analysis of eye movements during visual search. *Acta Psycholgica,* 88, 167-185.

Poynter-Stanford Project (2000). Introductory highlights. Retrieved July 14, 2004, from http://www.poynterextra.org/et/l.htm.

Rayner, K. (1978). Eye movements in reading and information processing. *Psychological Bulletin,* 85(3), 618-660.

Rayner, K. (1995). Eye movements and cognitive processes in reading, visual search, and scene perception. In J. M. Findlay, R. Walker, & R. W. Kentridge (Eds.), *Eye movement research: Mechanisms, processes and applications* (pp. 3-22). Amersterdam: Elsevier Science Publishers BV.

Salvucci, D. D., & Anderson, J. R. (2001). Automated eye-movement protocol analysis. *Human-Computer Interaction,* 16, 39-86.

Sankoff, D., & Kruskal, J. B. (Eds.) (1983). *Time warps, string edits, and macromolecules: The theory and practice of sequence comparison.* Reading, MA: Addison-Wesley.

Stark, L. W., & Ellis, S. R. (1981). Scanpaths revisited: cognitive models direct active looking. In D. F. Fisher, R. A. Monty, & J. W. Senders (Eds.) *Eye movements: cognition and visual perception* (pp. 193-226). Hillsdale, NJ: Lawrence Erlbaum Associates.

Viviani, P. (1990). Eye movements and visual search: cognitive, perceptual and motor aspects. In E. Kowler (Ed.) *Eye movements and their role in cognitive processes* (pp. 353-393). Amsterdam: Elsevier Science.

Yarbus, A. (1967). *Eye movements and vision.* New York: Plenum

Chapter Six

Web Site Usability
Tips, Techniques, and Methods

Roxanne O'Connell

This chapter outlines various usability evaluation methods and provides readers with a set of best-practice guidelines to use in designing and testing Web sites for usability. Methods outlined are categorized for use in either designing Web sites or in conducting critical research and analysis of Web sites. Methods include creating user profiles and task scenarios, measuring strategic intent, evaluating navigation flows, load analysis, conducting expert reviews, heuristic evaluation, content analysis, affordance testing, paper prototyping, cognitive walk-throughs, card sorting, and formal usability studies using the "think-aloud" protocol. Emphasis is placed on visual analysis techniques of heuristic and expert reviews and affordance testing, levels of expertise required for execution, and appropriate use in the design life-cycle.

Usability is a hot issue in Web development. Since the mid-1990s millions of Web sites have launched, largely without any user testing, leaving the Webscape littered with confusing and unusable interfaces. Until now, the Web has been a rapidly growing frontier metropolis with no city planning, ordinances or zoning. The result is often bad or inadequate signage, traffic jams at every intersection, time wasted, mounting frustration, and an overall lack of enthusiasm for making the trip into town (O'Connell, 2005b).

Evaluating a Web site's usability serves two types of inquiry: (1) analysis of prototypes and functions throughout the design process, and (2) analysis of existing Web sites for improvement and/or socio-technical study. As one might expect, some evaluation methods are helpful in both cases while others are more suitable for either design or research.

Designing for Usability

Usability is ideally a design concern at the very inception of a Web project. It is part of the evaluation of every stage beginning with needs analysis and interface design straight through to development and deployment. Often, however, developers and business decision-makers postpone testing for usability until "there's something 'real' to test." This frequently leads to the following uncomfortable situation: a group of outsiders (the usability experts) deliver expensive bad news (the errors in design uncovered by the usability test) to unwilling clients (the business folks who needed the site up yesterday and the developers who now have egg on their faces)—a lose-lose scenario made more uncomfortable by the knowledge that, with a bit of planning, it could easily have been avoided.

Successful, usable Web projects follow this step-by-step process (see Table 1):

- Develop user profiles and task scenarios to plan and design the Web project;
- Design and test prototypes;
- Use the prototypes to create specifications, standards, and guidelines;
- Create the final test version of the Web site;
- Test the final version of the Web site; and
- Establish a process for continuous feedback and improvement.

Table 1: The 1-2-3s of Usability Testing

Phase	Activity	Test
Analysis	• Develop user profiles • Develop key task scenarios • Document user performance requirements	
Design	• Develop screen flow and navigation model • Create paper prototypes • Create high-fidelity prototypes • Create a design specification based on the prototypes, document standards, and guidelines	• Conduct usability testing on low-fidelity prototypes • Conduct usability testing on high-fidelity prototypes
Develop-ment	• Develop system/product using prototypes, specifications, standards, and guidelines	• Conduct ongoing heuristic evaluations • Conduct usability testing as soon as possible
Deploy-ment	• Survey users for feedback • Conduct field studies, evaluate actual use • Institute a process of continuous improvement by incorporating the appropriate usability evaluations for each site modification	• Treat minor modifications to the site as mini-iterations of the development life-cycle

O'Connell, R. (2005b). The 1-2-3s of usability testing. Mequoda Library. See also Ross et al., 2000.

For sites in the design process, it is critical to know where your Web project is in the design life-cycle (Mayhew, 1999).

Creating User Profiles and Task Scenarios

Before proceeding with any usability test, it helps to make sure that you have the basic information necessary to make the test worth doing. Even the most common evaluation methods—expert review and heuristic evaluations—are ineffectual unless you have one or more user profiles and a short list of the key tasks users should be able to complete. There are three cardinal questions that must be answered in order to design *anything*. If you started your Web project without getting sound, well-developed answers to these questions, you may have wasted precious time, money, and development resources building something that no one wants or can use. The questions are:

- Who are the users?
- What is it they want to do or know?
- What can you provide them so they can accomplish their goal?

Let's review each of these in depth.

Who Are the Users?

The fundamental rule regarding users is that the site is designed for them—not for you, not for your developer, not for your mother-in-law (unless she fits the profile of the user perfectly). You cannot design a usability test without a profile of the user or users. If you have more than one type of user, you must create two or more separate profiles and design separate tests with tasks important to each set of users.

Start by creating a user profile or "persona" (Cooper, 2004) for each major user type. For instance, a health care Web site might have two personas: health care professionals and patients. You might want to further refine the user populations if you believe there are accessibility issues related to any of them. For instance, "patients" could be an overly broad category. What are the demographic characteristics to which you must pay close attention? Age? Domain knowledge? Education? Income? Computer skill? Internet access and speed? Establish the thresholds for each of these characteristics and use this same profile when recruiting test partici-

pants. These profiles work even better if you give the *persona* a name, e.g. Dr. Joe, Helen, Carl.

We all tend to be self-referencing in the design stage, but we are not "the user." It helps to have a clearly defined, measurable profile on which the design team can focus. What is it they want to do or know?

Make no mistake—no matter how important your Web site is to you, if it isn't important for your users to use, they won't. Knowing your users' goals helps you understand why they are at your site, and what you need to give them to accomplish those goals. Frame user goals so that a task and a clear successful outcome are obvious:

Task: User Helen wants to receive e-mail updates on new treatments for breast cancer.

Notice that this framing of the goal does not specifically describe the manner in which Helen would sign up for the e-mail updates. At this particular Web site there may be multiple methods by which this user's goal could be achieved. Defining "how" the goal is achieved this early in the planning artificially hampers the designers and developers in finding usable and elegant tools and processes for the user.

The wording of the task can be the most difficult part of developing a user test. There are three rules for task creation:

- The task must be doable. All of the elements and tools need to be present and working. (Even in a paper prototype, the person playing the role of "computer" has to make everything "work." If needed elements are not present at the beginning of the test, the user and the "computer" can add them with paper, pencil, and glue.)
- The task must have success criteria. How do you know the task was completed?
- The task must not suggest the manner in which the task should be completed, i.e., do not tell user to "click on SEND button" as part of the task.

Most Web sites have at least three or four user goals. Some, like the original Google.com, have only one. The simplicity and elegance of the Google page are a testament to how clearly the design team understood their users' goal. They have consistently kept that goal foremost in the designs of subsequent products and maintain what is arguably the cleanest Web design ever made. Anything more would be, for them, superfluous—anything less, enigmatic.

What Do You Have to Provide Users So They Can Accomplish Their Goal?

The answer to this question is the basis for your content and interface design. It is important to keep in mind that the user isn't the only one with important goals. The Web site's owner or sponsoring organization also has goals. Successful Web sites have these sets of goals closely aligned. Once you have determined what users need, you also need to think about redundancy and information path/flow. Do you need to provide two or more locations or versions of that information for the same user need? Do you need to scaffold information for the user because there are dependent relationships between the items needed to meet user goals? (See Inan, 2002 and Spool, 2009, for more on customer centric design).

Align Your Strategic Intent with Your Users' Goals and Speak Their Language

It is at this point that important elements of your Web site must be established. The next set of questions should be asked, keeping the answers to the previous three questions in mind:

- What is the strategic intent of your Web site? Of each page (or template)?
- What is the language/voice that will be used for labeling and content?
- What are the appropriate speed/load constraints?

Strategic Intent

The strategic intent of a commercial Web site is the business goal. The strategic intent of an information Web site is its purpose. In either case, it involves what you want your users to do first when they arrive at your Web site. Each and every page of your Web site should have its own strategic intent as well, which is aligned with the overall strategic intent of the Web site. For most commercial Web sites, the primary strategic intent of the home page is for the user to tell you who he or she is. This logically feeds back into your first question—who is your user? The strategic intent of an *About Us* page is to communicate your identity and integrity to your users. This may be achieved by including your mission or your history or both.

Once you have identified the primary strategic intent of your page, determine if there are secondary and tertiary strategic intents. These might suggest more tasks or more options that you should consider including in your interface.

Language/Voice

You know who your users are. Do you know how they refer to the content of your proposed site? Is their language formal or informal? Is it specialized or general? What search keywords do users use to find what they are looking for? One excellent example of appropriate language and voice is CDBaby. The language is appropriate to both musicians and consumers of music and all interactive forms that allow for user labeling are easily editable and navigable.

A good way to determine user language is to visit some of the bulletin boards that discuss your Web site's topic. A content analysis of postings will yield a rich collection of terminology that you ignore at your peril. The language you use on your site is central to the issue of labeling. Have your team ask, "What would a user call this?"—not "What do the folks in this department call this?" or "What does the boss call this?" ... or worse "What catchy, made-up marketing word can we call this?" The only words that count at the end of the day are those that your intended users associate with what they are trying to find at your site (O'Connell, 2005a). Card sorting is an effective test method you can use if you want to validate or generate keywords for your labels and content. It is included in the "Other Usability Test Methods" section of this chapter.

Speed/Load

Why should we be concerned with site load speed? Won't broadband take care of this for us? Sure, if you live in an urban area in a western democracy. The vast majority of the world, however, still deals with dial-up speeds. Even the vast middle of the United States remains untouched by recent advances in broadband connection speed. In a global marketplace, whether it be of ideas or physical goods, it is prudent to consider the expense incurred by users who pay for every second they are online. If the content of your site is necessarily heavy, e.g., an entertainment site, users most likely expect to do a bit of waiting. On the other hand, if your content is information-oriented and there are other Web sites where the same information can be found, you risk losing users to the competition.

Summary

Usability testing is by far the most effective way to develop usable Web sites. Usability evaluation always costs something, either in time, money or both. If your testing budget is limited, the dollars and hours you spend early in the design cycle will be more effective and much of the design will be usable before any development dollars and hours are involved. Once development begins, it becomes much more expensive to incorporate changes. Companies who only test after the product has been developed may actually be looking for validation, not usability.

Analyzing for Usability

Usability testing is by far the most effective tool in developing usable Web sites, but it is also a useful way to analyze existing Web sites, either for design improvement or for socio-technical information. Usability analysis often utilizes the following methods: "live" site user testing, expert review, heuristic evaluation, content analysis, and affordance testing (see Table 2 on Page 136). Which of these methods, individually or collectively, are most appropriate depends greatly on what the researcher wants to learn.

Evaluating usability for incremental improvement not only uses tools created in the design phase but, in addition, leverages the user community. Amazon.com and Ebay.com are good examples of post-design usability evaluation. These companies are on a continuous improvement cycle. They use questionnaires and surveys based on "live" sites for remote testing—indirect methods that are limited in what they can reveal but they are useful for studying how end-users use a Web site, for tracking click streams, and for identifying users' preferred features. These instruments require large data samples and considerable experience to design and interpret.

Because these Web sites have users in the hundreds of millions, they can also create beta sites that expose a randomly selected group of real users to new features and task flows. The beta site needs to be fully functioning because real tasks and transactions are occurring. A short and specific rating survey might follow after the transaction to gather "ease of use" and customer experience data. However cost-effective and efficient surveys, questionnaires, and beta site feedback might appear, users' feedback about what they do at your Web site cannot always be taken strictly at face value. Actual user behavior, observed in user test labs, carries more weight than claims of what users think they do.

Discount methods like *heuristic evaluation* and *expert review* don't use real user subjects during the tests. These are both valid methods—providing you know what you are getting in terms of the results. A heuristic evaluation is an assessment of the usability of a design based on established design principles, or "heuristics." It relies on a handful of individuals, not necessarily users, going through your site to determine if it complies with a set of guidelines. This will often catch a number of logic and consistency errors. As the testers are using the same set of heuristics, there should be significant overlap in reported errors. However, guidelines about look and feel, even behavior, operate from the known. A heuristic evaluation is not a good predictor of user behavior. Will the user misinterpret a label? Will he or she find an alternative (unplanned) way to accomplish the task? A heuristic evaluation is not designed to answer those questions and so should not be the sole usability assessment tool.

An expert review is exactly what it sounds like. An expert in Web usability reviews your Web site and reports major problem areas. No two experts will find exactly the same list of problems and the overlap can be as little as 40 percent. You can improve the feedback from an expert review by providing a user profile and three to five critical tasks. Some experts have their own criteria they use to review a Web site—and that's a good start. But you want to make sure your expert has copies of your user profiles and a list of specific critical tasks before beginning. This will help the expert structure the examination of your site and weigh the severity of the errors encountered. A significant error in a remote, rarely used part of your site is not as important as a less significant error in a prominent, frequently used area—particularly if that error interferes with the user's ability to accomplish a critical task (Krug, 2005, 2009).

These two methods have become popular over the past few years as the number of experts in the field has grown. In heuristic evaluations, researchers use a set of guidelines created by a usability expert that outline best practices and cognitive norms based on user profiles and task scenarios. In expert reviews, trained usability experts "role play" the user. In both methods, researchers evaluate the frequency and severity of the problems or anomalies they encounter in order to determine which design flaws need to be addressed. Just as three-of-a-kind beats a pair, actual user testing beats both of these discount methods because nothing is as compelling as watching a real user struggle with a bad interface. However, any testing is better than no testing at all.

Content Analysis

Using content analysis to determine usability requires paying close attention to the first two design questions: "Who are the users?" and "What do they need to do or know?" Researcher and author Jared Spool (Spool, Perfetti, & Brittan, 2004) tells us that users are information hunters that are "most successful when they pick up a strong scent." His research reiterates a longstanding axiom about the Web— "Content is King!" Content refers not only to the information a site provides but also to the trigger words and images that tell a user they've hit pay dirt. As Spool explains, "Trigger words are the words or phrases that cause users to click. Scent is strongest when the page presents users with the right trigger words" (p. 25). When these trigger words and images are linked to extremely relevant information, using all the appropriate visual cues (see Affordance in the next section), the user enjoys the satisfaction of having achieved his or her goal. Researchers can use tools like Wordtracker™ to gauge the popularity of specific search terms. By counting how often those terms are used in a Web page's content and how often those words are linked, either as contextual links or as navigation, they can measure the page's ability to deliver on the "scent of information."

Another form of content analysis is measuring the *modality* of the content (Kress & Van Leeuwen, 1996). What percentage of the content is image and what percentage is text? Is the image or text information navigational, informational, or decorative? Decorative images and text are of little value in satisfying the user's needs. Navigational images and text are of more value but must consistently lead to the information being sought. Using a nine-cell grid (dividing the page into vertical and horizontal thirds) to analyze the visual to verbal ratio of a Web page does two things. First, if the user profile indicates that the user has a preference for "believing what they see" or *image modality,* the amount of imagery that is in each cell, particularly the amount of visual information, will indicate whether the page design affords users sufficient information in their preferred modality. If users have a preference for words, the quantity of verbal information in each cell will indicate the Web page's credibility with *verbal modality* users. The nine-cell grid also helps evaluators determine the *density* of the Web page as they are able to gauge what percentage of each cell is "full" of content. Users who prefer low-density environments often feel overwhelmed by high-density displays—too much information in too little space. *Modality* and *density* are often embedded in cultural aesthetic norms and are important considerations for user-targeted designs. Having these preferences articulated in the user profile helps designers and evaluators identify some of the less tangible aspects of usability.

The location of content displayed is also of critical importance. Information that falls "below the fold," a metaphor borrowed from the newspaper industry, is often invisible to users as information hunters unless there is a linked trigger word or image above the fold. Both Jakob Nielson's 2006 eye-tracking study and the Poynter Institute's series of reader studies indicate that users do not read content but rather scan it in either a Z-pattern or F-pattern (Quin & Adam, 2007). Both studies state that users stop more often on trigger words, especially when those trigger words are in a headline or a contextual link, confirming Spool's findings regarding the scent of information.

Affordance Testing

Affordance refers to the perceived and actual properties of a thing, primarily those fundamental properties that determine just how the thing could be used. A chair affords ("is for") support, and, therefore, affords sitting. Put another way, an object's perceived affordance is defined as something behaving in the manner indicated by the way it looks. Doorknobs turn, switches flip, and underlined colored text in a Web page should bring you somewhere when you click on it (O'Connell, 2005a; Norman, 1999).

An affordance test is essentially visual. It tests whether the sensory and arbitrary symbols that make up a Web page's content and navigation accurately convey information to the user. An excellent affordance test is to print a Web page in grayscale or on a black-and-white printer. Give some test users a yellow highlighter and ask them to highlight anything on which they think they could click. The first thing you will notice is that anything that is underlined will get highlighted. Those words that may or may not be colored but are not underlined will most likely not look like links to your test users because saturated colors on a grayscale printout all appear to be the same color. Headlines that are not linked might also get highlighted because they are different in size, weight, and location to the main content—all of which are possible visual cues to a desperate information seeker. Users may also highlight images that are not linked while overlooking images that are linked based solely on subtle cues like outlining, drop shadows, and 3-D effects.

Affordance is one of the primary areas that contribute to user goal satisfaction. Our visual sensory system has evolved to be effective in interpreting the Gestalt principles of similarity, proximity, and closure in order to determine what is a target and what is not. Because the visual cues of Web conventions such as underlining and 3-D button design in two-dimensional space are so well-established,

designers flirt with disregarding them at their peril. With the exception of words in sidebar or menu bar navigation where the bar itself declares its affordance, the following conventions should be followed:

- All linked text should be colored and underlined.
- Links that have been visited before should appear in a color different from unvisited links.
- Links and buttons should be used appropriately. Links bring you to another place—either another page or another spot on the current page. Buttons execute an action—clicking on one logs you in or out of a secured area, adds something to a shopping cart, makes a purchase, or submits data from a form.

Taking the underlining away, whatever the aesthetic rationale, makes the function of those links unusable—they lack affordance. Just changing the color is insufficient, as some users may have the inability to distinguish certain colors, e.g., red and green. Designers may protest, claiming that when the cursor is over the text the underlining appears or the cursor changes shape. This is the silliest of rationales as it implies that the user wants to play a game of hide 'n' seek with the links.

Another design disaster happens when an enthusiasm for Adobe Photoshop™ effects causes designers to create images for section headings that look like buttons. A good rule of thumb is if you are linking text to content, either on the same page or on a different page, use a clearly discernible link. If you want the user to complete an action, use a button. In either case, use a clear, unambiguous label placed in a logical location for the desired outcome. A "reset" button placed where the user might expect to click the "submit" button will cause all kinds of aggravation (O'Connell, 2005a; Spool, 2009).

One of the driving forces for designers is to create something that has never been done before or a look that is intriguingly unconventional. Unfortunately, with the exception of entertainment or game design, it is not at all important to a user to find out how to use a clever design. What is important to users is to get in, get the information they want and get out. For that reason, the sign of a good interface may very well be *less* user time spent on the high-level pages of your Web site and more time spent several levels down. Most users look for information in the following order:

1. Underlined blue links in the body copy. Because these links are embedded in the copy they have more credibility with the user.

2. Contextual navigation, left side first, right side next if it is clear that the navigation belongs to content and is not advertising related. (With the growing population of blog sites, the left-side/right-side convention is shifting. However, users are getting more sophisticated in avoiding the advertising areas of either side's navigation.)

3. Persistent or common navigation, if the labels are not too broad or vague. Persistent navigation refers to the navigation menu(s) that are common to every page. Variable or contextual navigation tends to show up in specific areas or sub-category pages.

4. Search fields, when there are no clear indications that the information users are looking for can be found on the page they are on (Spool et al., 1999).

User satisfaction with a Web site tends to track along this list. Steps 1 and 2 lead to higher levels of satisfaction. When you get to Step 4 users are ready to jump to a new site, particularly if the search results page is badly organized or uninformative.

Other Usability Testing Methods

Paper Prototype Testing

In the beginning of a project, creating and testing paper prototypes of your Web site can easily be the best investment of your time. Usability testing with paper prototypes has two excellent advantages: (1) There's no development cost. All you need is paper, sticky notes and various art supplies, someone to take notes, someone to play "computer," a facilitator to monitor the test, and a handful of users, (2) The final prototype, with all its scribbles and arrows, becomes part of the design specifications (Snyder, 2003).

At this early design stage, paper prototyping can be combined with a cognitive walk-through, a form of test that has a user go through a task or process. Because no one could possibly mistake the prototype for the real thing, you are likely to get a wealth of feedback about what process might work better or what labels and functions make more sense to the user. Some developers believe this leaves open the possibility that users might ask for something the system does not currently accommodate. The answer to that dilemma is: "All the better! Here's a chance to create a site with a clear competitive advantage." Usability demands that the human-computer interface puts the user's needs before the system's limitations (see

Brinck, Gergle, & Wood, 2002 and Hoekman & Spool, 2009, for more on interface design).

To capture what users are thinking, the facilitator will ask the user to "think aloud." It's really the only way a tester can get into the users' minds as they try to accomplish a goal. The "think aloud" protocol is also used in user lab studies. Video recording these paper prototype walk-throughs isn't necessary, but it can be helpful. Both paper prototype tests and usability lab studies can be video recorded to capture not just the "think aloud," but also the interface prototype and users' reactions as they go through the tasks. Creating digital images of different stages of the prototype is also very useful and provides additional documentation for the design rationale.

Usability testing with paper prototypes is ideally suited to the discovery process. The test team is not constrained by what is already built into the system being tested. There are some behavior protocols important to follow such as "observers should not speak or use body language" and "the 'computer' should not explain itself to the user" (Snyder, 2003). Bending the rules in the interest of getting at an elegant solution is sometimes appropriate, and creativity is more valuable than rigid application.

Card Sorting

Perhaps you're confident of the words you must use but not how they should be organized. Perhaps you have a lot of categories or sections in your Web site and you are uncertain how users expect to see them organized. This is a job for a *Card Sort Test* (Maurer & Warfel, 2004).

As the name implies, a card sort requires the test participant to sort cards according to the user's mental model of the relationships between the words or statements. Each card has a word or statement printed on it. Once the user has organized the cards, perhaps adding a few with words that weren't available, the test facilitator records the sort in a spreadsheet or in an online sorting tool. A cluster analysis of the results from several test participants gives designers an excellent view into how users refer to important concepts in their own language. Card sorts can be conducted with individuals and groups depending on what kind of information you are trying to elicit. Often card sorting does double duty—it helps with validating and discovering the lexicon of the site user with regard to the task as well as the organization of the site's information.

Table 2: Methods Often Used in Usability Testing

Usability Test	Participants	Expertise/Result
Paper Prototype	4-5 actual users In-house users if not part of project	• Combination of in-house resources and professional facilitator **Result:** Usable interface design, detailed specifications, "wireframes"
Card Sort	10-12 actual users	• In-house resources **Result:** Usable interface language
Affordance	4-5 in-house users unfamiliar with the interface	• In-house resources **Result:** Usable interface design. Information is easy to find. Actions are intuitive.
User Labs	6-10 actual users for each user profile	• Professional facilitator, monitor and participant recruiter • Usability lab facilities or portable usability lab • Best when developers and client are the observers **Result:** Full report with highlights video of serious problems. Serious problems classified according to severity and frequency.
Heuristic Evaluation	4-5 users with list of heuristics or guidelines	• Best results when using usability professionals **Result:** Full report of serious problems. Serious problems classified according to process logic and design consistency.
Expert Review	As few as a single expert, as many as 3 or 4	• Best results when using usability professionals with user profiles and list of critical tasks **Result:** Full report of serious problems. Serious problems classified according to process logic and design consistency.
Content Analysis	As few as a single researcher, as many as 3 or 4	• Best results when used for socio-technical research **Result:** Qualitative data on modality, content density, and match of content to user needs
Surveys	From 300 to millions	• Best results when using a statistical research professional with good survey-building skills **Result:** Statistical data on customer satisfaction and completes. Correlations between user profiles to survey answers.
Remote Testing	From 300 to millions	• Best results when testing fully functioning test site and brief, immediate follow-up survey. Requires using statistical research professionals and sophisticated technical resources who can code the data capture for critical tasks. **Result:** Statistical data on click stream and completes. Correlations between user profile and click streams to survey answers.

Formal Usability Studies

A formal usability study can be expensive, but done early enough in the design process it can pay for itself in development time and dollars spent more productively. It is essentially qualitative research that requires a skilled team of people to design and conduct the tests, and to interpret the hours and hours of video recording to discover critical errors. The test team is generally composed of a user, a facilitator, a test monitor, and multiple observers. Tests are done on a number of task scenarios and are usually videotaped. Every effort is made to ensure that user behaviors remain unbiased. For instance, while the test participant is told that there are observers in another room, the facilitator is careful not to give the participant the impression that anything said or done in the course of the test will offend or please people in the observation room.

Careful attention is paid to "normalizing" the setting in which the test takes place. This may involve the use of either stationary or portable "lab" equipment designed to represent the user's natural environment and props that simulate the user's typical experience. For instance, a usability study of a consumer financial planning Web site would consist of a comfortable room with a standard configuration personal computer or laptop situated on a desk in a room with natural lighting. There might be houseplants and other homey decorations in the room intended to make the user feel comfortable and "at home." The cameras capturing the user and the screen might be discreetly mounted in the ceiling or wall. The facilitator may be located in this room or in an adjoining room using either a two-way mirror wall or closed circuit TV. Also in the adjoining room is the test monitor who closely observes the participant during the test, ensuring that nothing compromises the test, and perhaps taking notes as the test progresses. The observers are also in the adjoining room and often have their own agenda. The facilitator does not take notes. He or she never betrays interest or concern about what the participant is doing either through speech or body language.

The most reliable results come from testing at least 12 users for each major user group. However expensive this might seem, it is not nearly as expensive as building a complex Web site or system without user testing only to find there are major flaws in the interface or information and process flows. It is not unusual for companies with limited resources to split the difference: use half the testers in an early stage of development, capture 80 to 90 percent of the most egregious errors and interface problems, then use the other half of the testers to evaluate the "almost-ready-to-launch" site. In most situations, you are not conducting scientific research requiring statistical validity. You are trying to improve the site by analyzing

where users have problems. The objective is the number of participants that yields the best level of information (Rubin, Chisnell, & Spool, 2008).

The "Think-aloud" Protocol

Usability testing is often compared to market research with focus groups, but there are important differences. In a focus group you collect opinions and attitudes, and these are very important. In a usability test, you are observing behavior—what people actually do when using your Web site, not just what they say they might do. However, it is sometimes difficult to interpret these behaviors.

A long, silent period of intense scrutiny of the computer screen could be an indication that the participant is reading important information, or it could be that he or she is lost and looking for a clue as to what to do next. The former is a positive outcome, the latter suggests that your interface needs work. But how do you tell the difference?

To get inside the head of the test participant, usability professionals use a technique called "think-aloud" (Dumas & Redish, 1999). The participant is instructed to voice what he or she is thinking and doing throughout the tasks. The test facilitator instructs the participant and models the "think-aloud" protocol before the test begins. However, participants often forget to "think-aloud" as soon as they are gripped with solving a problem. It is then that the facilitator gently reminds the participant by asking, "What are you thinking right now?" This gives the test monitor and observers an audible window into the participant's decision process. As difficult as it is for designers to accept, the participant is *never* wrong. If he or she has drawn an unanticipated conclusion or has proceeded down a different path than the one designed to accomplish the task, it is the structure and interface of the product that is the culprit.

Conclusion

Users historically blame themselves when things go wrong. Lately, perhaps due to the increased media coverage concerning usability, things are changing and they are much more likely to give credit and blame where it is due. According to Boston Consulting Group research (2001), when consumers encounter problems purchasing online, they are now blaming the Web site and not themselves for failures. While the overall percentage of consumers who experienced failures while visiting a site dropped, the percentage of users who stopped shopping at the particular site

where they experienced problems rose from 28 to 41 percent. As a result, the downstream costs can be significant.

Ben Shneiderman, the University of Maryland and Charles B. Kreitzberg, CEO of Cognetics, Inc. (Kreitzberg & Shneiderman, 2001), said in their essay that making computer and Internet usability a priority implies that usability testing is essentially objective and empirical. Anyone involved in the creation, development, or study of a Web site must be well-versed in usability testing methods regardless of whether it is a discount method like heuristic evaluation or expert review, or a full-blown usability lab with multiple participants. As users themselves become more active co-creators of the content, it becomes increasingly important to quickly and efficiently determine what works and what doesn't. There is far less tolerance in the user community for Web-ware that doesn't do what is promised.

The bag of tricks for usability testing is growing. The number of usability technology sponsors at the annual Usability Professional Association Conference is testament to the fact that it's a thriving and necessary business. This is largely due to the nature and proliferation of end-use technologies like software and Web-ware. Template-driven content management systems like Facebook, Blogger, and WordPress, where users are publishers, offer a dizzying array of interface possibilities, not all of which are usable. Of increasing interest is the ability to remotely test features and functionality using real sites and real users; however, the scale of this kind of testing suggests that it works best for large online companies. No matter what kind of usability testing we do, nothing beats the compelling image of a real human interacting with the technology—the sometimes excruciating frustration of not understanding what the system wants us to do, and the euphoria of hearing a user say, "Huh! That was easy."

References

Boston Consulting Group. (2001). Targeting high value customers: the key to profitability in multi-channel retailing. Revised January 2002.

Brinck, T., Gergle, D., & Wood, S. (2002). *Usability for the Web: Designing Web sites that work.* Boston: Morgan Kaufmann Publishers.

Cooper, A. (2004). *The inmates are running the asylum.* Indianapolis, IN: Sams (Pearson Education).

Dumas, J., & Redish, J. (1999). *A practical guide to usability testing.* Portland, OR: Intellect.

Hoekman, R., & Spool, J. (2009). *Web anatomy: Interaction design frameworks that work.* Berkeley, CA: Newriders Press.

Inan, H. (2002). *Measuring the success of your Web site: A customer-centric approach to Web site management*. Australia: Pearson Education Australia.

Kreitzberg, C., & Shneiderman, B. (2001). Making computer and Internet usability a priority. In R. J. Branaghan (Ed.) *Design by people for people: Essays on usability*. Bloomingdale, IL: Usability Professionals' Association.

Kress, G., & Van Leeuwen, T. (1996). *Reading images: The grammar of visual design*. New York: Routledge.

Krug, S. (2005). *Don't make me think: A common sense approach to Web usability (2nd edition)*. Berkeley, CA: Newriders Press.

Krug, S. (2009). *Rocket surgery made easy: The do-it-yourself guide to finding and fixing usability problems*. IN: Newriders Press.

Lamantia, J. (2003). Analyzing card sort results with a spreadsheet template. In *Boxes and Arrows*. Retrieved May 24, 2005 from www.boxesandarrows.com/view/analyzing_card_sort_results_with_a_spreadsheet_template

Maurer, D., & Warfel, T. (2004). Card sorting: a definitive guide In *Boxes and Arrows*. Retrieved May 24, 2005.

Mayhew, Deborah J. (1999). *The usability engineering lifecycle: A practitioner's handbook for user interface design*. San Diego, CA: Academic Press.

Nielsen, J. (2006). F-shaped patter for reading web content. In *Jakob Nielsen's Alertbox*, April 17, 2006. Available at http://www.useit.com/alertbox/reading_pattern.html.

Norman, D. (1999). Affordance, conventions and design. In *jnd.org*. Retrieved October 30, 2005.

O'Connell, R. (2005a). How to design and test for common sense: Navigation affordance and labeling. In *Mequoda Library*. Retrieved October 30, 2005.

O'Connell, R. (2005b). The 1-2-3s of Usability Testing. In *Mequoda Library*. Retrieved October 30, 2005.

Quin, S., & Adam, P. S. (2007). What are the differences in reading news in print and online? *Eyetracking the News* (St. Petersburg, FL: Poynter). Available at http://eyetrack.poynter.org/.

Ross, M., Nowicki, J., Solomon, D., Yarbrough, L., & Schwendeman, C. (2000). *Designing the user experience poster*. Bloomingdale, IL: Usability Professionals' Association.

Rubin, J., Chisnell, D., & Spool, J. (2008). *Handbook of usability testing: How to plan, design, and conduct effective tests (2nd edition)*. New York: John Wiley & Sons, Inc.

Snyder, C. (2003). *Paper prototyping: The fast and easy way to design and refine user interfaces*. Boston: Morgan Kaufmann Publishers.

Spool, J. (2009). Components, patterns, and frameworks! Oh, my! In *Usability Interface Engineering*. Retrieved May 20, 2009, from http://www.uie.com/articles/.componentspatternsframeworks/

Spool, J., Perfetti, C., & Brittan, D. (2004). *Designing for the scent of information*. North Andover, MA: User Interface Engineering.

Spool, J., Scanlon, T., Schroeder, W, Snyder, C., & DeAngelo, T. (1999). *Web site usability: A designer's guide*. Boston: Morgan Kaufmann Publishers.

Chapter Seven

How Do Users Evaluate Web Sites?

Ulla Bunz
Juliann Cortese

The purpose of this chapter is to examine user perceptions and evaluations of Web sites by focusing on personal criteria users apply to assess sites and whether or not these criteria match criteria touted in usability literature. Participants were asked to examine two versions of a Web site that varied in their degree of usability and to evaluate the sites focusing on impressions, interest in information presented, motivation for examining the site, and like/dislike of the site. Web site evaluation criteria mentioned by participants were photos/images, depth of information, visual appeal, organization/layout, and colors—all components that often appear in usability analyses. An interesting finding is that users rated Web sites with the lowest usability to be the best. Analysis indicated that as long as a Web site achieves a certain level of usability, users are satisfied. High usability is not necessary.

Visual communication and design literature often discuss the opposition between form and function, yet concede that the two actually share more of a symbiotic relationship than that of opposition, if utilized appropriately. Specifically, "Good design defuses the tension between functional and aesthetic goals precisely because it works within the boundaries defined by the functional requirements of the communication problem" (Mullet & Sano, 1995, p. 11). This can be particularly true of Web site design. Web sites combine the use of visual and verbal elements to communicate to their audiences. But to communicate effectively, both the visual and verbal aspects must be compelling in order to draw users in and keep them engaged. Various disciplines and bodies of literature can be consulted in order to construct an effectively communicative Web site that enhances both verbal and

visual components: rhetoric, marketing, library science, human-computer interaction, and human factors design or usability.

Yet, there is more involved in effective message delivery through a Web site. Human nature is highly subjective and illogical, and following technical design criteria to fulfill psychological notions or writing persuasive prose does not necessarily lead to effective Web site communication or even a positive response to a Web site by its average user. Furthermore, we live in a world that is visually intense, and we must actively work to make sense of this world. Producers of visual communication facilitate this process by creating powerful images that can aid the viewer in remembering content presented (Lester, 2003). Viewers must actively engage content in order to perceive and remember what they see. Attention to detail in terms of visual communication elements (use of color, balance, harmony, and design elements) might help in our perception process. The purpose of the research discussed in this chapter is to examine how users perceive and evaluate Web sites, and why they perceive and evaluate them in this particular way. As Zettl (2005) points out in his discussion of media aesthetics theory, a medium can no longer be considered a neutral channel but is instead "an essential component in the decoding (analysis) and encoding (production) processes" (p. 366). The process of perception is an important component of media aesthetics theory.

The research at hand focuses on the terminology, descriptions, and factors that emerged from people's use of Web sites in their own words. Usability, then, has been treated more as a matter of perception that is socially constructed when users interact with a Web site and meaning is created. However, this research does not disregard previous work onto which this study built.

Related Literature

Usability, often called ergonomics in Europe, is more a process than a thing. In simple terms, usability refers to the ease of use of a product, system, Web site, or even a process such as channeling large masses of people through museums, elevators, etc. The more intuitive, in other words, the less explanation needed, the higher the usability of, for example, a Web site. With Web sites specifically, designers try to develop standards that support movement throughout a site and on individual pages so subtly that users are only aware of them subconsciously. Usability, therefore, has less to do with making things "pretty," and more with making things "work." Though usability research can be divided into the three main schools of thought—engineering (e.g., Mayhew, 1999), cognitive psychology (e.g.,

Norman, 1986; 1988), and design—the study discussed in this chapter builds most on the notions developed in the school of human factors usability design.

The usability design literature is a growing body of work (e.g., Bevan, 2000; Coe, 1996; Dorazio & Stovall, 1997; Henry, 1998; Hix & Schulman, 1991; James, 2001; Jordan, 1998; Lansdale & Ormerod, 1994; Lindgaard, 1992; Nielsen, 1992b; Nielsen & Loranger, 2006; Schriver, 1997), specifically with regard to guidelines aimed at improving Web site design (e.g., Adler, 1992; Binstock, 1999; Brinck, Gergle, & Wood, 2002; Brooke, 1996; Dillon, 1994; Gould & Lewis, 1985; Krug, 2000; Morkes & Nielsen, 1997; Nielsen, 2000; Preece, 2000; Ravden & Johnson, 1989; Rubin, 1994; Schneiderman, 1997; Spool, 1997). The usability literature provides long, but inconsistent lists of specific usability criteria from a more design-oriented perspective that ought to be followed in Web site design. Nielsen (2000) is one of the most quoted usability scholars regarding Web site design. However, other usability criteria and checklists from, for example, system design have been and are being applied to Web site design (e.g., Brooke, 1996; Ravden & Johnson, 1989[1]). With a focus on systems, according to Ravden and Johnson (1989), usability criteria fall into 10 categories: visual clarity, consistency, compatibility, informative feedback, explicitness, appropriate functionality, flexibility and control, error prevention and correction, user guidance and support, and system usability problems. WAMMI (Web site Analysis and MeasureMent Inventory), a Web usability questionnaire (Nomos Management, 2001), also lists criteria that a usable Web site should fulfill, including attractiveness, controllability, efficiency, helpfulness, learnability, and global usability. The question remains—even if all of these criteria could be fulfilled and even if the average Web site user was able to recognize them—would he or she actually use these same criteria in a subjective evaluation of whether a particular Web site "worked" for him or her? It might well be that Web site usability depends more on the person than on the Web site. Since the purpose of this line of research is to investigate how users evaluate Web sites, the above considerations lead directly to the first research question:

RQ1: What personal criteria do Web users apply to assess a Web site?

Though the literature provides detailed information on what makes up a usable Web site, the underlying assumption is that only Web site characteristics (positive and negative) *perceived by the user* will lead to the user's understanding and assess-

ment of the Web site. These perceived criteria may or may not correspond with literature-defined or usability expert criteria, leading to the second research question:

RQ2: Do criteria utilized by Web users defining a good Web site match those criteria advocated in the usability literature?

The literature tends to define "objective" usability criteria, though usability assessment in the end depends on the perception of the user. Some studies (e.g. Nielsen, 1992a) indicate that there is little difference between an "expert's" and a "naïve user's" evaluation of usability. Others report the opposite (e.g., Desurvire & Thomas, 1993). Still others report that a combination of both is the most precise usability assessment (e.g., Virzi, Sorce, & Herbert, 1993). This study seeks to add to this body or work by analyzing open-ended answers.

Methods

In November 2001, 110 students enrolled in the basic public speaking course at the University of Kansas were recruited as subjects for this study. Demographics for this sample are described below. Each subject completed the study questionnaire in front of a computer in the Communication Studies computer lab. Subjects used a written, concurrent protocol survey questionnaire developed from pilot studies discussed in more detail elsewhere (Bunz, 2002). A concurrent protocol survey questionnaire asks participants to answer questions directly after Web experiences and before moving on to the next task. A questionnaire administered at the end of a session would require recall that would likely be imprecise, especially when inquiring about issues such as time spent on particular Web pages, or emotional reactions.

Questionnaire Description

The 12-page questionnaire used for this research consisted of 152 items in two main parts. Part 1 of the questionnaire consisted of 51 items, which included demographic items, the CEW (Computer-Email-Web) fluency scale (Bunz, 2001; 2004), the Georgia Tech (1998) Web survey, and items of the CMC (Computer-Mediated Communication) competence scale (Bunz, 2003). Results of these scales and items are discussed in detail in Bunz (2002).[2] Part 2 of the questionnaire was

designed to assess and evaluate Web sites. Here, 17 items belonged to the personal involvement inventory (Zaichkowsky, 1985), and 12 items were based on the student motivation scale adapted from various sources (Beatty, Behnke, & Froelich, 1980; Beatty, Forst, & Stewart, 1986; Beatty & Payne, 1985; Christophel, 1990; and Richmond, 1990).[3] Each subject viewed two Web sites during the course of the study and completed Part 2 of the questionnaire for both sites viewed.

Before being handed a questionnaire, each subject was informed of the purpose of the study. Subjects were asked to imagine they had won a free trip for spring break to one of three destinations: a beach, a city, or a national park. Nine Web sites were compiled for this study. The three destinations had three Web sites associated with each one, and these Web sites varied in their level of usability: high usability, moderate usability, or low usability. Usability level was determined through literature criteria and previous research (Bunz, 2002). Subjects were asked to choose one of the three categories and received a copy of the appropriate questionnaire. The questionnaire asked subjects to evaluate two Web sites in their chosen category. The beach Web sites were about Panama City Beach Spring Break. The city Web sites were about Las Vegas. The national park sites were about Mesa Verde National Park in Colorado.[4] Two Web sites were presented to each subject for viewing in a rotating order based on the location of choice.

As subjects evaluated two Web sites, they answered the same cluster of 21 items two times, once for each Web site. Items 1 through 4 were open-ended questions developed from pilot studies (Bunz, 2002; 2003). These items tapped subjects' impressions, interest in information presented, motivation for examining the site, and liking or disliking of the Web sites.

Item 1 asked, "What were the first things visually and content wise that you noticed on this Web site? Please give examples or reasons." Item 2 asked, "What page would you like to look at in more detail, or what kind of information will you look for now? Please also explain *why* this is of interest to you." Item 3 stated, "Since you last looked at this piece of paper, have you been moving slowly through the site (looking at one or two pages), or have you been moving fast through the site (looking at numerous pages)? Please explain *why* you are moving through the site the way you are. Please also explain *what* in particular you have been looking at or for. Please make sure you give examples." Finally, Item 4 asked, "Now that you've had some time to get acquainted with the Web site, please provide at least three reasons why you like this site, AND at least three critical comments. Please always make sure you give a brief explanation of *why* you like or criticize the Web site."

The usability scale of the questionnaire consisted of 17 items adapted from Ravden and Johnson's (1989) systems usability questionnaire. The original questionnaire investigates the usability of computer systems. Out of the 17 items, 10 items provided a basis for a more formal usability assessment. The items were arranged on a 5-point Likert scale from "strongly disagree" (1) to "strongly agree" (5). The items were constructed in four subscales adapted from the different parts of Ravden and Johnson's (1989) original questionnaire. No factor analysis was conducted to confirm the presence of subscales due to small sample size ($N =$ 110). The four subscales identified in the earlier work included visual clarity (five items), consistency (five items), content (three items), and navigation (four items).

Together, the open-ended items and the 17 usability scale items made up the 21-item cluster that each subject completed for each of the two Web sites he or she evaluated. The last item of the survey (Item 101) was open-ended. It asked: "Finally, now that you have seen and assessed two Web sites on the same topic, please provide a few comments on which one you liked better. Please make sure you also explain *why* you like it better."

Method of Analysis

To assess subjects' answers on the survey components of the questionnaire, basic frequencies—including means, standard deviations and coefficient alphas—were assessed for all quantitative items. To find some answers to Research Question 2, chi-squares were calculated to investigate whether Web site ranking was significant. Responses to the open-ended items were used to find answers to the two research questions. Responses were coded into typologies evolving from the data itself. As answers to the open-ended items were straightforward, no second coder was used. Often subjects wrote keywords such as "pictures," or brief sentences such as "I want to see more photos." Keywords such as "pictures" and "photos" were used to create the categories for the typologies. As each of the 110 subjects looked at two different Web sites and answered each question two times, a criterion mentioned 220 times would have been mentioned by 100% of the sample. All other percentages were calculated on this basis.

Sample

The subjects for the study were drawn from undergraduate public speaking students at the University of Kansas. A total of 110 subjects completed the survey.

Out of these, 66% were female, and 34% were male. Their year of birth spanned a decade from 1973 to 1983, making subjects between 18 and 28 years of age at the time of research. The average age was 20 years. Subjects indicated majors in all schools and colleges at the University of Kansas. The largest number (26%) included students in the College of Liberal Arts and Sciences, followed by the School of Business (16%), and the School of Journalism (15%). Only 4% of subjects were students in the School of Engineering. These subjects could be assumed to have higher initial interest and/or ability to use technology, but the small number (n=4) does not warrant controlling for this major or excluding subjects.

Overall, subjects have been using the Internet for four to six years (61%), or seven or more years (21%), which speaks for an increasing diffusion of Internet technology in high schools. However, subjects have taken only one (21%), two (23%), or three (20%) computer classes, courses or seminars throughout their lifetime. It can be suspected that most of their technology training has been informal, and expertise is self-taught.

Results and Interpretation

Basic Frequencies and Internal Reliability

With regard to the usability scale (Ravden & Johnson, 1989), subjects rated most positively (meaning highest on usability) the Web site that had the lowest usability according to expert criteria, indicating that experts and non-experts may evaluate usability differently and also indicating that usability is only one factor in Web site utility. It is possible that higher usability actually distracts average users. Subjects' mean usability evaluation of the high-usability Web site was 3.99 (SD = .87; range 1 to 7). Internal reliability of this evaluation was high at .95. Subjects' mean usability evaluation of the medium-usability Web site was 4.21 (SD = .65; range 1 to 7). Internal reliability of this evaluation was also high at .90. Subjects' mean usability evaluation of the low-usability Web site was 4.66 (SD = .85; range 1 to 7). Internal reliability of this evaluation was .93.

The usability scale used consisted of four sub-scales: visual clarity, consistency, content, and navigation. These were adapted from Ravden and Johnson (1989) rather than determined by factor analysis. The internal reliabilities for these subscales on all usability levels ranged from .68 to .91. For an overview of all internal reliability alphas, means, and standard deviations discussed in this section see Table 1.

Table 1: Internal Reliability (Cronbach's Coefficient Alpha) for all Web Sites on the Involvement, Motivation, and Usability Scales

| | Web Site Usability Level According to Expert and Literature Criteria | | | | | | | | |
| | High | | | Medium | | | Low | | |
	α	M	SD	α	M	SD	α	M	SD
Usability	.95	3.99	.87	.90	4.21	.65	.93	4.66	.85
Visual Clarity	.85	3.97	.88	.68	4.25	.73	.80	4.71	.98
Consistency	.87	3.93	.92	.77	4.17	.73	.83	4.57	.92
Content	.76	4.21	.98	.71	4.56	.91	.80	5.09	1.09
Navigation	.91	3.86	1.00	.79	3.93	.73	.81	4.38	1.00

Research Question 1: Web Site Assessment

Research Question 1 was concerned with user evaluation of Web sites. Specifically, it asked, "What personal criteria do Web users apply to assess a Web site?" Answers to this question were drawn from open-ended items, specifically items 1, 2, and 4 of the questionnaire, previously detailed in the section *"Questionnaire Description."* Item 1 intentionally focused the subjects on visual and content factors. "Visual" criteria might refer back to aesthetic needs and "content" to cognitive needs. The "why" of Item 2 tried to get at people's motivations and possible explanations or reasons for being drawn to a certain part of the Web site.

Analysis showed that subjects did not always distinguish clearly between visual and content criteria. For example, headers and link menus were frequently mentioned with regard to both. Overall, with regard to visuals, subjects mentioned colors (including background colors) and graphics (images and photographs) most, independent of the category of Web site. Color was mentioned by 50% of the sample, and graphics were mentioned by 57% of the sample for this particular item. This did not include advertising graphics, which were mentioned by only 7%. It is also important to note that several of the features mentioned by subjects did not exist on all Web sites, including advertisements. Eighteen percent of subjects also mentioned animated graphics, equally not existent on all home pages. In their answers to Item 2, subjects explained why they had such a desire for imagery, namely, to form an impression. Subject 91 states, "Photos—to see other people

having fun at this destination," echoed by Subject 97, who says, "Photos. Because I like looking at pictures of where I will be visiting." Subject 133 agrees, "SB [Spring Break] videos—it would be fun to see what people actually do + see people actually having fun." And Subject 181, "Pictures—I want to see sceneray [sic] of where I am going First!" In visual communication design, creators can direct a viewer's eye using contrast to create a form of tension to be resolved by the viewer (Dake, 2005). Similarly, research on brain activity has indicated that brain cells are stimulated more by object differences than by intensity (Lester, 2003). Therefore, color and graphics would tend to stand out and be noticed by the viewer over textual elements.

When talking about colors, subjects tended to note the dominant colors of the Web site, and headers that were of a different color. Not all mentions of color were positive, as some subjects indicated likes or dislikes of the colors used. Similarly, some subjects only indicated that visually they noted graphics first, and others specifically explained whether they had liked the graphics they saw or not. The attention to color indicated by subjects is not surprising as it is a main focus in aesthetics theory. Within the tenets of this theory, color serves three functions: provides information about objects and events, adds to visual balance, and helps to create mood, excitement, and expression of quality (Zettl, 2005). Furthermore, in media aesthetics theory, color is considered a component of "lighting," the interplay of light and shadows (chiaroscuro). From a design perspective, color is thus a very important element of Web design.

Regarding content, subjects commented most on the available links or menu bars (26%), and the range and depth (presumably the level of detail and overall coverage of the topic) of the information provided on the Web site (25%). Again, some mentioned depth or completeness of information, while others mentioned the lack thereof. Interestingly, some subjects had obviously ventured off the home page and looked at other pages in the site before answering this item. Others based their evaluation on the home page alone. Instructions had only told subjects to "take a few moments to quickly click through the Web site to form a first general impression" before answering the first item. Thus, subjects interpreted this statement differently.

Few subjects actually mentioned specific Web pages or topics that they had noted on the Web site, and very few (8%) mentioned layout or navigation of the site in any way. Overall then, subjects' evaluation of Web sites as assessed by Item 1 was rather superficial, as could be expected after asking them to look over the Web site "quickly." Common attention-getting devices such as colors, pictures, or

lists of links attracted their attention. Yet, overall, the Web sites seemed to hold subjects' attention, as only one person mentioned that "nothing" attracted attention.

Answers to Item 2, asking what subjects wanted to look at and why, show that indeed, subjects wanted more in-depth information than they had gathered so far. As subjects looked at the Web sites under the notion of going on a spring break trip, it is not surprising to find that the majority (57%) wanted specific information about activities and things to do. Examples of such requested information includes hiking trips, nightlife, events (such as concerts), and general entertainment. Far fewer (23%) were interested in finding information on the location, including pictures. As explanations for their choices, subjects mentioned repeatedly that they wanted to see people doing what they anticipated doing, or wanted to know what to expect, or wanted to see what they were expecting to find when going there. The following statements clearly show that subjects had preconceived notions that they wanted to be either confirmed or refuted. For example, Subject 92 states, "Pictures—I want to see people having fun, plus I want to see what the beach looks like." Subject 191 states, "Entertainment—I want to know exactly what my options are and how I am going to do these activities." Finally, Subject 186 states in response to the question of what he/she wants to look at next, "The pictures page, and maybe info on activities. I like to see the place where I am going to go. If I wanted to read about it I would pick up a book. Also for Activities I want to know what they have set up—because they know the area and I don't so I want to know what things they have planned and if those things satisfy my interests." Subject 135 states, "I want to know what is in store. I want to get a feel for what I would experience." And Subject 114 plainly admits, "I went directly to the 'Let's Party' page because I like to get wasted."

The interpretation that subjects have preconceived notions they hope to have confirmed or refuted by the Web site is supported by the fact that quite a few mentioned wanting to look for accommodation or lodging (18%), and 8% even said they were looking for prices, even though they had been told they had won a free trip. Accommodation and prices tend to be of major importance when planning any trip, right after deciding on location, or even influencing that choice.

Study participants also seemed to have preconceived notions about Web sites' content and components. As Subject 139 admitted when asked where he/she was going to go next, "Caution—it grabs your attention to wonder what is dangerous." Subject 144 reports, "I clicked on 'Cool Links' because I thought that it would

show me some fun things that the park had to offer, but that disappointed me, too."

Overall, the criteria for assessing a Web site tend to be criteria that subjects are familiar with in other contexts: eye-catching visuals, quality information, and availability of information that is expected. This is in line with our process of perception as we select information to attend to based on previous knowledge (Lester, 2003). This process is cyclical in nature in that the more we know about a subject the more we sense further information regarding that subject. The more we sense, the more we select to attend to that subject. The more we select, the more we perceive. Perception then leads to remembering, which leads to learning, which leads to knowledge. The process then continues with this increased knowledge and proceeds through the cycle again and again.

Additional criteria that subjects mentioned in Item 4 for assessing the Web site included issues related to design and information. For instance, design issues noted included: unique features (webcams), search options, availability in more than one language, loading speed, consistency in design, clutter, and broken links. Information issues included: credibility of information, professionalism, level of entertainment or fun, currency of the Web site, level of helpfulness, spelling, and possibilities for feedback, or contact information. One comment was made on a Web site being racist, and two comments were made on a Web site being sexist. As none of these were listed more than a maximum of four times (equaling less than 2%) per Web site category (with the exception of "fun" that was listed eight times for the Panama City Beach category), they are not analyzed in more detail here. Other comments made under Item 4 are discussed in more detail in the following section.

Research Question 2: Non-expert and Expert Usability Assessment

Research Question 2 specifically investigated usability assessment of Web sites. It asked, "Do Web site criteria perceived positively by subjects match those criteria advocated by the usability literature?" As subjects were non-experts and non-experts tend to find fewer usability faults in Web sites than experts (e.g., Bailey, Allan, & Raiello, 1992; Desurvire & Thomas, 1993), subjects' criteria will be discussed first and then compared to existing criteria. Answers to Research Question 2 were drawn partially from Item 4 of the second part of the questionnaire (items were detailed earlier in the section "Questionnaire Description"). In addition, re-

sults were drawn from Item 3 on the questionnaire. Of particular interest here were answers to the "why" part of the item ("Please explain <u>how</u> and <u>why</u> you are moving through the site the way you are."). Finally, the last item of the questionnaire (Item 101) asked respondents to undertake comparative judgments. It is important to note that subjects responded to this last item only once, not twice as all other items, so percentages were calculated out of a total of 110 possible replies, rather than out of 220.

Results show that subjects mostly skimmed or browsed quickly through the Web sites. The following statements are examples of commonly expressed sentiments and behaviors. Subject 166 states, "Fast, I tend to skim–read stuff untill [sic] I find something that grabs my interest." And Subject 135, "I looked at numerous pages to attain a pretty much overall view of the site. I can always go back later to look a little further & closer." Web site components that did grab subjects' attention tended to be colors and images. Subject 191 states, "I am looking through the site quickly until something pops out at me because time is valuable to me. I have been looking for colors that excite me or link to pictures of the activities." Both Subject 127 and Subject 140 report interesting behavior when they say they only read information after their attention had been grabbed by an interesting picture. These statements provide an important indicator as to attention-getting devices on Web sites. Subject 127 writes, "I scanned the information. When I saw an interesting picture, though, I stopped & read to see what it was. I then read the info around it." And Subject 140, "I moved at a pretty rapid pace + I looked @ 3 pages. I just glanced at the 3 pages that caught my interest + glanced over them for anything else to catch my interest. I looked at the pictures + if the pictures interested me, I read the words." As Zettl (2005) explains, computer displays that combine text and images often seem scattered across a screen. He believes that continuous content is rendered discontinuous through the infusion of images, especially if scrolling is required. Nonetheless, comments such as the ones cited above clearly indicate the need for breaking up continuous text with images as it is the images that catch attention and motivate Web users to read, instead of just browse.

Subject 138 reported learning throughout the process of the study, changing movement speed due to the repeat activity. For the first Web site, "I have been moving slowly giving myself time to read carefully all the things I can do. I always do that to make sure I make the right choices." And for the second Web site, "Faster than before because I already have some feedback about what I am looking for." And Subject 163 reported learning of some other kind, "Slow. I was learning

about Betting Guidelines and getting rated. I forgot about the survey. I have been looking for my advantage against the casinos. I'm thinking, 'If I lose $250 at the tables but get a free night's stay, I've come out even.'"

Overall, 63% of subjects reported moving quickly through the Web sites, while 27% reported moving slowly. The remaining subjects who reported neither "fast" nor "slow" in their answers either did not report any speed or reported conflicting answers, such as using both terms. When looking at the three categories of Web sites individually, subjects moved fastest through the beach Web sites, where 69% reported moving quickly and 17% reported moving slowly. Movement through the other Web sites was about equal, with 60% reporting fast movement and 32% reporting slow movement for the national park site, and with 60% reporting moving fast, and 33% reporting moving slow through the city Web site.

Subjects provided numerous reasons for their speed of movement through the Web sites. Overall, 27% reported skimming and browsing to gain an overall impression, while only 10% reported seeking specific information. As before, lack of information (6%) or depth of information (15%) were important determinants here given as reasons for moving fast or slow. Equally, appealing photos (10%) and general interest (7%) were given as reasons. Ten subjects (5%) mentioned that they were conscious of being in a "research study" and that this affected their speed of moving through the Web sites. On the other hand, there is the example of Subject 163, who learned something of interest to him on the Web site, and forgot about the survey completely. Other subjects reported moving slowly through the site, as they got interested in the content. For example, Subject 146 said, "I read the entire Park Info page. Why, I really wanted to know what it said. I didn't read any other page." Or Subject 179, "I'm moving slowly to read all of what it has to offer, yet I'm anxious to see what all it has."

A close look at more of subjects' statements reveals that the percentages above do not tell the entire story. For example, Subject 152 was doing a targeted search, and reports moving fast. "I was moving through the site rather quickly because the information was not what I was looking for. I wanted descriptions of restaurants, reviews, not just a list." On the other hand, Subject 94 also reported on a targeted search, while moving slowly. "I have been moving slowly only observing 3 pages so far because I have only been looking for the topic of Entertainment." Thus, speed of movement through a Web site may not be related in a linear way to browsing versus doing a targeted search.

Other reasons subjects gave for their movement through the Web sites were mentioned rarely. The following reasons were given by less than 2% of subjects:

organization of the Web site, turned off by home page, short and/or easy, not appealing, appealing, not interested, color, information overload, user-friendly site, persuasive, habitual behavior, don't like the Web itself, time constraint, details, beautiful, not really going (onto the imaginary trip).

In Item 101, the last item on the questionnaire, subjects evaluated why they liked one of the Web sites better than the other one they had seen. Responses to this item resembled answers to Item 4 that also focused respondents' attention on a particular Web site. In Item 4, 57% of subjects said they liked one Web site because of the depth of information it provided. In answer to Item 101, 27% stated they liked one Web site better than the other for the same reason. They liked one Web site better than the other because of its "visual appeal" (17% for Item 101; 20% for Item 4); because of the "images" (13% for Item 101; 47% for Item 4, though only 4% used this criterion to evaluate their overall impression of Web sites in Item 4); because of the Web site's "organization" (12% for Item 101; 25% for Item 4); and because of its "colors" (10% for Item 101; 26% for Item 4). They also liked one Web site better than the other because they thought it more "interesting" (7%) without specifying what this evaluation was based on.

Other reasons for preferring one Web site over another included design aspects of the Web sites, such as simplicity, consistency, number of links or options, user-friendliness, loading speed, and navigation; and information/content aspects of the Web sites, such as persuasiveness, absence of advertisements, animation, educational information, professionalism, patriotism, and even brevity of information.

Very few respondents noted issues of punctuation and spelling errors, but those who did mention such mistakes usually had strong opinions. As states Subject 125, "I question the professionalism b/c I saw 'your' instead of 'you're' and 'care' instead of 'car.' That REALLY bothers me!"

Interestingly, several participants distinguished between the visual appeal of a Web site and its content when weighing one Web site against another. Whether this is a remnant from Item 1 that asked to distinguish between the two or something that comes naturally to subjects cannot be determined. Subjects disagreed with each other on their evaluations and the importance of visual appeal quite drastically, drawing at times opposite conclusions from one another. For example, Subject 162 liked the "tacky" Web site better because of its content, while Subject 163 concluded that the better-looking site must also have good information. Some subjects really liked flashy design, such as Subject 168. "The 2nd one [Mesa Verde site with high usability; hereafter MV-H] b/c it was more colorful, had more pic-

tures, + seemed to give more detailed info. This made the site more interesting, + less boring. I wanted to look at every part of the site. Made me want to visit Mesa Verde, unlike the first. The second site, sold Mesa Verde better."

On the other hand, some subjects preferred less colorful, more straightforward design, such as Subject 161. "I liked the 1ˢᵗ one [Las Vegas site with medium usability; hereafter LV-M] so much better, it was bland looking, but it was much easier to find the information that I was looking for. In my opinion, the whole point of a Web site is to get out information, so that's why I like the 1ˢᵗ one better." Yet again, for other subjects both were important, such as for Subject 90, who stated, "I liked the first [Panama City Beach with medium usability; hereafter PCB-M] better. It seemed to be of higher quality of design, organization, & content."

Several subjects remarked on quite a different kind of visual appeal, namely the appeal of the people displayed on the photographs on the Web site, both positively and negatively, but no one put it quite like Subject 114: "The use of pictures helps a lot. But if your [sic] going to use pictures, at least use pictures of attractive people. Come on." This last statement in particular reveals that Subject 114—and possibly other subjects in the study as well—lacks what Messaris and Moriarty (2005) refer to as visual literacy. According to those authors, visual literacy combines elements of critical thinking/viewing (i.e., "the ability to analyze the rhetorical aims of a visual message," p. 491), and the ability to think in visuals and understand their deeper meaning. The understanding of deeper meaning is of particular importance here as it entails that the meaning of a visual goes beyond just the superficially apparent. Messaris and Moriarty (2005) say:

> The meaning of an image is not just a matter of the people and places that appear in it, or the action that it depicts. How these people or places or actions are portrayed—in close-up or long shot, in balanced or asymmetrical composition [...]—are essential ingredients of the creation of visual meaning (p. 483).

By criticizing only *what* is on the picture displayed without taking into consideration *how* it is displayed, Subject 114 fails to interpret the entire message that the visual sends. Though over-interpretation of a single remark should be avoided, this example indicates that possibly, the average Web user has a lower level of visual literacy than Web designers. Web designers must take that into consideration and "design down" to the level of the average user.

Several participants commented on the intended audience of the Web sites, at times concluding that a certain site was more family- or more student-oriented.

For example, Subject 172 states, "I like the first [PCB-M] better because it was better suited for someone my age." Or Subject 152, "A good site [LV-M], but for the family vacation, not the student on Spring Break." These comments indicate that possibly subjects 172 and 152 are applying the critical thinking component of visual literacy to the Web sites they are viewing. Having been exposed to mass media such as television for years and possibly having developed a level of media literacy as detailed by Burch (2005), possibly the average Web user has developed more of an ability to detect rhetorical messages and visual falsehood (i.e., the critical thinking component of visual literacy) rather than an understanding of the images themselves.

Interestingly, the overall ranking of the usability Web sites within their three preference categories reveals that participants ranked the Web sites in the same order as their usability ranking according to literature criteria. These results are displayed in Table 2. The only exceptions are the Las Vegas Web sites with medium and low usability, whose ranking is reversed in the subject ranking as opposed to the literature ranking. Clearly, Web users' levels of visual literacy should be investigated in more detail in future research.

Table 2: Web Site Ranking According to Literature and Subjects

Literature Usability Ranking			Subject Preference Ranking		
High	Medium	Low	High	Medium	Low
LV 1	LV 3	LV 2	LV 1	LV 2*	LV 3*
MV 2	MV 1	MV 3	MV 2	MV 1	MV 3
PCB 1	PCB 2	PCB 3	PCB 1	PCB 2	PCB 3

*Note: * Marks disparate results.*

To assess whether significantly more people ranked one Web site higher than another, chi-square analysis was conducted within each category of Web sites. This test was appropriate as an equal number of subjects saw each of the various combinations of sites.

For the national park category, Mesa Verde, results indicate that the sample proportions are significantly different from the hypothesized values of 1/3, 1/3, and 1/3, $\chi^2 (2, N = 28) = 12.50, p = .002$. Follow-up one-sample chi-square tests demonstrate that not significantly more people rated the MV-H Web site (n = 16) first as compared to the Mesa Verde medium usability (hereafter MV-M) Web

site (n = 11), $^2(1, N = 27) = .93, p = .336$. Follow-up one-sample chi-square tests also demonstrate that significantly more people ranked the MV-M Web site (n = 11) first as compared to the Mesa Verde low usability (hereafter MV-L) Web site (n = 1), $^2(1, N = 12) = 8.33, p = .004$, and significantly more people ranked the high usability Mesa Verde Web site (hereafter MV-H) first (n = 16) than ranked the MV-L Web site (n = 1) first, $^2(1, N = 17) = 13.23, p = .000$.

To put this into context and compare it to the usability literature-based ranking, according to the literature criteria, Web site MV-H had highest usability, followed by MV-M and MV-L. Thus, results would support an argument that the usability of both the high- and the medium-ranked usability Web site are higher than the low-usability Web site. However, results do not support the argument that the usability levels of the so-called high and the so-called medium usability Web sites actually differ according to the ranking of this subject sample.

For the beach category, Panama City Beach, results indicate that the sample proportions also are significantly different from the hypothesized equal values, 2 $(2, N = 36) = 9.50, p = .009$. Follow-up one-sample chi-square tests demonstrate that not significantly more people ranked the Panama City Beach high usability (hereafter PCB-H) Web site (n = 19) first as compared to the PCB-M Web site (n = 13), $^2(1, N = 32) = 1.12, p = .289$. As before, follow-up one-sample chi-square tests demonstrated that significantly more people ranked the PCB-H Web site (n = 19) first compared to the Panama City Beach low usability (hereafter PCB-L) Web site (n = 4), $^2(1, N = 23) = 9.78, p = .002$, and significantly more people ranked the PCB-M Web site (n = 13) first than they did the PCB-L Web site (n = 4), $^2(1, N = 17) = 4.76, p = .029$.

According to the usability literature ranking, the PCB-H Web site had highest ranking, followed by PCB-M and PCB-L. As with the Mesa Verde Web sites, these results would support an argument that both the high and the medium Web sites were evaluated significantly higher and possibly more usable than the low-usability Web site. However, the so-called high- and the so-called medium-usability Web site were not actually ranked significantly differently by the subjects of this sample.

Finally, for the city category, Las Vegas, results indicate that the sample proportions are not significantly different from the hypothesized equal values, $^2(2, N = 33) = 5.64, p = .060$, meaning the sample proportions are very similar to each other overall, though significantly more people ranked the Las Vegas high usability (hereafter LV-H) Web site (n = 17) before the LV-M Web site (n = 6), $^2(1, N = 23) = 5.26, p = .022$.

Though results show that significantly more people ranked the so-called high usability Web site higher than the so-called medium-usability Web site, results did not show that the medium-usability Web site was ranked higher than the low-usability Web site, or even, that the high-usability Web site was ranked higher than the low-usability Web site by the subjects of this sample. Overall then, chi-square results did not support the usability ranking of the Las Vegas Web sites according to literature criteria.

So, "Do Web site criteria perceived positively by subjects match those criteria advocated by the usability literature?" Results show that some of the criteria match, but not all. Results also show that other criteria not considered by the usability literature, such as interest in the topic, were of importance for this sample.

Limitations

Sample Limitations

The study reported on here drew its subjects from a pool of undergraduate public speaking students at the University of Kansas through a convenience sample. Though samples from "large Midwestern universities" are commonly drawn upon when researchers want to generalize their results, in the case of our research, results may not be generalizable to the same extent. College students are not representative for the entire population of computer, e-mail or Web users. College students present a narrow age range and also a narrow income range. The students at the University of Kansas also tend to be similar in race and ethnicity. They possibly have better technology access than many other people do. On the other hand, their experience with computer technology often is more related to word processing and other simple tasks. Thus, results presented may not be generalizable to other populations.

Experimental Limitations

Apart from sample limitations, there were other limitations that derive from the research process and methodology used. Subjects were in a computer lab and thus painfully aware of the research situation. Though each subject had his or her own computer, being aware of being in a research study may have influenced results, as was long proven by the Hawthorne studies. In addition, subjects were not able to choose the medium (Web), the kind of Web site within the category that they

picked (beach, national park, city), or the overall task associated with the research (going on spring break). Subjects also completed the same item cluster two times, once for each Web site they looked at. Learning could have taken place and skewed results. However, it was not possible to avoid these limitations. Changing the setting, such as allowing subjects to freely browse the Web until they found an interesting page, would have made it almost impossible to compare usability levels of sites to each other.

Concluding Remarks

The present study focused on gathering information about Web site assessment. The research questions investigated users' evaluation criteria (RQ1: What personal criteria do Web users apply to assess a Web site?), and whether these criteria matched literature criteria (RQ2: Do Web site criteria perceived positively by subjects match those criteria advocated by the usability literature?).

Results showed that many of the criteria identified by subjects were similar to the ones defined in the literature though subjects did not seem aware that they were using formal criteria but instead were relying on personal opinions. Careful examination of the results described earlier reveals that certain criteria were mentioned repeatedly by subjects. These include: photos/images, depth of information, visual appeal, organization/layout, colors. All these are generally components in usability evaluation, as defined e.g., by Ravden and Johnson (1989), and many also are used in the field of visual communication to study visuals, including Web sites. For instance, a main consideration for Web designers is the organization/layout of a site. The laws of Gestalt help to clarify how such organization should occur by indicating the importance of proximity, similarity, continuity, and closure (Mullet & Sano, 1995). It is part of human cognition to associate items that are close together, have similar attributes, fall along a continuous line, and indicate a sense of closure of an object based on the properties of the form. Often we engage in these cognitions without even thinking about them, but a designer of visual communication can certainly use these techniques to help a viewer more easily interpret and orient to a Web site.

Yet, people also know what they like and dislike, as findings indicated that subjects differentiated regarding the criteria. For example, subjects in general praised the existence of photographs, but still criticized the kind of photographs provided. Similarly, though depth/detail of information was generally considered a very positive attribute of a Web site, at times the amount of information was

called overwhelming. Not surprisingly, subjects wanted just the "right" kind and amount of information presented in just the "right" way and supplemented by the "right" kind of pictures. Audience-centered usability research dedicates itself to finding out what this "right" entails. One helpful approach in this regard may present itself through applying a visual rhetoric perspective. In this perspective, images must be symbolic, involve human action, and be targeted at a specific audience (Foss, 2005, p. 145). Clearly, many Web site images fulfill these criteria, especially clipart-type images. Applying a rhetorical perspective to the study of visual imagery may help identify key concepts in applied Web site design as they would take into consideration the generally accepted meaning of a visual image or color and emphasize the communicative force of such visual elements.

An additional important criterion emerging from the analysis was personal interest. Personal interest needs to be considered, and personal interest might be one of the criteria that decide what is "right" or not. Attributing personal interest such importance implies that two identical Web sites might be evaluated as "bad" and "good" if they differ in nothing but the topic. As one subject in the usability pilot studies said, "If it doesn't relate to me, I go right past it."

Subjects also ranked the Web sites based on their user experience, and evaluated the same Web sites based on a usability scale. Interestingly, results contradicted each other. Based on the scale, users rated the Web sites with the lowest usability to be the best. Based on the open-ended questions, users' ranking of Web sites was almost identical with expert ranking. Further analysis showed that potentially, higher usability is actually of no benefit to the average user. As long as a Web site reaches a certain level of usability, people can make do with it. There was generally no statistical difference between evaluation of Web sites with medium- versus high-usability levels. For designers of Web sites, this sends a clear message. There is no such thing as a perfect Web site. It only has to work. Results from the first research question show that visual appeals and graphics are most important to users. Designers and communicators should focus on those in their efforts of turning the Web into an effective communication medium. For researchers, a focus on the average Web user's level of visual literacy may illuminate some of these issues.

Notes

1. Although Ravden and Johnson (1989) is an older reference, the work is important to this analysis and provides an important usability analysis tool used in the research presented here.

2. The original study included an additional research question asking, "In what way does subjects' fluency with the computer, e-mail, or the World Wide Web influence the Web-site evaluation

process?" However, as results were not very conclusive, all reference to this research question and its methodological components have been excluded from this chapter. For a detailed discussion, see Bunz (2002).

3. The scales were used to assess a research question concerned with need gratification, asking, "What gratifications can Web sites provide based on user needs?" The research question and all references to these two scales were excluded from this chapter as they do not add to the primary question under investigation here. For a detailed discussion, see Bunz (2002).

4. For more information about the Web sites, see Bunz (2002), which explains how they were selected and where they can be found online, and which also provides screenshots of all nine Web sites used in the research process.

References

Adler, P. (Ed.). (1992). *Usability: Turning technologies into tools.* New York: Oxford University Press.

Bailey, R. W., Allan, R. W., & Raiello, P. (1992). Usability testing vs. heuristic evaluation: A head-to-head comparison. *Proceedings of the Human Factors Society 36th Annual Meeting* (pp. 409-413). CA: Monterey.

Beatty, M. J., & Payne, S. K. (1985). Is construct differentiation loquacity?: A motivational perspective. *Human Communication Research,* 11, 605-612.

Beatty, M. J., Behnke, R. R., & Froelich, D. L. (1980). Effects of achievement incentive and presentation rate of listening comprehension. *Quarterly Journal of Speech,* 66, 193-200.

Beatty, M. J., Forst, E. C., & Stewart, R. A. (1986). Communication apprehension and motivation as predictors of public speaking duration. *Communication Education,* 35, 143-146.

Bevan, P. (2000). Planning and implementing user-centered design. *CHI 2000 Tutorial.* Teddington, United Kingdom: Serco Usability Services.

Binstock, A. (1999, September). New mantra: Usability. *Informationweek,* 751.

Brinck, T., Gergle, D., & Wood, S. D. (2002). *Designing web sites that work: Usability for the web.* San Diego, CA: Academic Press.

Brooke, J. (1996). SUS: A 'Quick and Dirty' usability scale. In P. W. Jordan, B. Thomas, B. A. Weerdmeester, & I. L. McClelland (Eds.), *Usability evaluation in industry* (pp. 189-194). London: Taylor & Francis.

Bunz, U. (2001, November). The computer-email-web (CEW) fluency scale—Development and validation. Presented at the 87th National Communication Association Convention, Atlanta, GA.

Bunz, U. (2002). Usability and gratifications: Effective website communication through a user-centered website analysis model. Unpublished doctoral dissertation, University of Kansas, Department of Communication, Lawrence, KS.

Bunz, U. (2003). Growing from computer literacy towards computer-mediated communication competence: Evolution of a field and evaluation of a new measurement instrument. *Information Technology, Education, and Society,* 4(2), 53-84.

Bunz, U. (2004). The computer-email-web (CEW) fluency scale - Development and validation. *International Journal of Human-Computer Interaction*, 17(4), 477-504.

Burch, E. (2005). Media literacy, aesthetics, and culture. In K. Smith, S. Moriarty, G. Barbatsis, & K. Kenney (Eds.), *Handbook of visual communication* (pp. 503-517). Mahwah, NJ: Lawrence Erlbaum Associates.

Christophel, D. M. (1990). The relationships among teacher immediacy behaviors, student motivation, and learning. *Communication Education*, 39, 323-340.

Coe, M. (1996). *Human factors for technical communicators*. New York: John Wiley & Sons.

Dake, D. (2005). Creative visualization. In K. Smith, S. Moriarty, G. Barbatsis, & K. Kenney (Eds), *Handbook of visual communication: Theory, methods, and media* (pp. 23-42). Mahwah, NJ: Lawrence Erlbaum Associates.

Desurvire, H., & Thomas, J. C. (1993). Enhancing the performance of interface evaluators using non-empirical usability methods. *Proceedings of the Human Factors and Ergonomics Society, 37th Annual Meeting* (pp. 1132-1136). CA: Santa Monica.

Dillon, A. (1994). *Designing usable electronic text*. Southport: Burgess Science Press.

Dorazio, P., & Stovall, J. (1997). Research in context: Ethnographic usability. *Journal of Technical Writing and Communication*, 27(1), 57-67.

Foss, S. (2005). Theory of visual rhetoric. In K. Smith, S. Moriarty, G. Barbatsis, & K. Kenney (Eds.), *Handbook of visual communication* (pp. 141-152). Mahwah, NJ: Lawrence Erlbaum Associates.

Georgia Tech (1998). *WWW user survey*. Retrieved June 13, 2003, from http://www.cc.gatech.edu/gvu/user_surveys/

Gould, J. D., & Lewis, C. H. (1985). Designing for usability: Key principles and what designers think. *Communications of the ACM*, 28(3), 300-311.

Henry, P. (1998). *User-centered information design for improved software usability*. Boston, MA: Artech House.

Hix, D., & Schulman, R. S. (1991). Human-computer interface development tools: A methodology for their evaluation. *Communications of the ACM*, 34(3), 74-87.

James, M. (2001, May). Site usability key to converting casual users into e-shoppers. *New Media Age*, p. 7.

Jordan, P. W. (1998). *An introduction to usability*. Bristol, PA: Taylor & Francis.

Krug, S. (2000). *Don't make me think!: A common sense approach to web usability*. Indianapolis, IN: Que.

Lansdale, M. W., & Ormerod, T. C. (1994). *Understanding interfaces. A handbook of human-computer dialogue*. San Diego, CA: Academic Press.

Lester, P. M. (2003). *Visual communication: Images with message*. Belmont, CA: Wadsworth.

Lindgaard, G. (1992). Evaluating user interfaces in context: the ecological value of time-and-motion studies. *Applied Ergonomics*, 23(2), 105-114.

Mayhew, D. (1999). *The usability engineering lifecycle: a practitioner's handbook for user interface design*. San Francisco, CA: Morgan Kaufmann.

Messaris, P., & Moriarty, S. (2005). Visual literacy theory. In K. Smith, S. Moriarty, G. Barbatsis, & K. Kenney (Eds.), *Handbook of visual communication* (pp. 481-502). Mahwah, NJ: Lawremce Erlbaum.

Morkes, J., & Nielsen, J. (1997). Concise, scannable, and objective: How to write for the web. Retrieved January 29, 2002, from http://www.useit.com/papers/ ebwriting/writing.html.

Mullet, K., & Sano, D. (1995). *Designing visual interfaces: Communication oriented techniques.* Upper Saddle River, NJ: Prentice Hall PTR.

Nielsen, J. (1992a). Evaluating the thinking aloud technique for use by computer scientists. In H. R. Hartson, & D. Hix (Eds.), *Advances in human-computer interaction,* Vol. 3 (pp. 69-82). Norwood, NJ: Ablex.

Nielsen, J. (1992b). The usability engineering life cycle. *IEEE Computer,* 25(3), 12-22.

Nielsen, J. (2000). *Designing web usability.* Indianapolis, IN: New Riders.

Nielsen, J., & Loranger, H. (2006). *Prioritizing web usability.* Berkeley, CA: New Riders.

Nomos Management (2001). WAMMI. Web usability questionnaire. Retrieved March 21, 2001, from http://www.nomos.se/wammi/index.html.

Norman, D. A. (1986). Cognitive engineering. In D. A. Norman, & S. W. Draper (Eds.), *User centered system design* (pp. 31-62). Hillsdale, NJ: Lawrence Erlbaum Associates.

Norman, D. A. (1988). *The design of everyday things.* New York: Currency Doubleday.

Preece, J. (2000). *Online communities: Designing sociability, designing usability.* Chichester, England: John Wiley & Sons.

Ravden, S. J., & Johnson, G. I. (1989). *Evaluating usability of human-computer interfaces: A practical method.* Chichester: Ellis Horwood.

Richmond, V. P. (1990). Communication in the classroom: Power and motivation. *Communication Education,* 39, 181-195.

Rubin, J. (1994). *Handbook of usability testing: how to plan, design and conduct effective tests.* New York: John Wiley & Sons.

Schneiderman, B. (1997). *Designing the user interface.* Boston: Addison-Wesley.

Schriver, K. A. (1997). *Dynamics in document design.* New York: John Wiley.

Spool, J. (1997). *Web site usability: A designer's guide.* North Andover, MA: User Interface Engineering.

Virzi, R. A., Sorce, J. F., & Herbert, L. B. (1993). A comparison of three usability evaluation methods: heuristic, think-aloud, and performance testing. *Proceedings of the Human Factors and Ergonomics Society, 37rd Annual Meeting* (pp. 300-303). CA: Santa Monica.

Zaichkowsky, J. L. (1985). Measuring the involvement construct. *Journal of Consumer Research, 12,* 341-352.

Zettl, H. (2005). Aesthetics theory. In K. Smith, S. Moriarty, G. Barbatsis, & K. Kenney (Eds.), *Handbook of visual communication* (pp. 365-384). Mahwah, NJ: Lawrence Erlbaum Associates.

Chapter Eight

Visual Evaluation of the World Wide Web

Susan B. Barnes

Visual literacy is an important skill for understanding Web sites and the successful application of the design. This chapter describes the relationship between image and word, and basic visual literacy skills. As the Web emerges, new visual/vebal relationships are being developed for digital media, such as remix or mash-ups. The use of remix is often shown in YouTube videos that can go viral on the Internet. By presenting critical questions for Web users to consider when conducting a visual analysis of a Web site or remix, they will become more aware of the design and message. Also, by making users more aware of the visual literacy issues associated with Web design, they will become more visually literate and critical Web viewers.

Few visual or verbal symbolic codes have meaning in themselves. We learn their meanings through formal education, exposure to media messages, and interaction with others. Currently, we live in a world filled with visual imagery, such as advertisements, television, and YouTube videos; however, our educational system tends to focus on learning verbal rather than visual communication skills. According to Blair (1996):

> Visual communication, when understood in contradistinction to verbal communication, occurs without the mediation of words or language in the literal sense. It is true that what is communicated visually can be described verbally, or translated into verbal communication (p. 25).

In contrast to the educational emphasis on verbal skills, some information can be more clearly communicated with pictures. For instance, the international symbols for men's and women's restrooms are much easier to understand as visual graphic symbols, instead of numerous printed words. Similarly, seeing visual icons

on a Web page is an easy method for identifying computer commands. The Web is a digital technology that fosters the use of images as a mode of representation and interaction. As a result, the Web introduces new visual languages into the communication process (see Bolter, 1991).

Visual languages can enhance human intellectual capabilities. According to Kaplan (1990):

> New communication technologies, especially computers, are *levers* in the sense that they extend human mental capabilities. This metaphor refers to the ability of new information technologies to enhance human intelligence by freeing people from the drudgery of routine clerical tasks, exposing them to richer information environments, and allowing them to perform more complex analytic tasks (p. 39).

For instance, early interface designers realized it would be easier for office workers to operate a computer if the interface resembled objects from their normal workspace. In the desktop-style interface, small pictures or icons represent familiar office objects, such as file folders, file cabinets, and a trash can. Many real-world activities can be symbolically represented on the computer screen, including spreadsheets, word processing, and desktop publishing. Users can access data and execute commands on the computer's desktop by clicking on icons with the mouse.

Similarly, users can access information located on other Web sites with mouse clicks. Clicking on buttons to access information uses the idea of hypertext. One of the key characteristics of the World Wide Web is its use of hypertext, a way of organizing information and navigating through electronic space. Hypertext is a unique computer application because it uses technology that enables readers to pick what information they want by interacting with the computer.

Hypertexts have visual tools to help users navigate different reading paths in a document. Arrows enable readers to move sequentially from page to page. The house icon on the browser toolbar takes the reader back to the home page of the software browser. In contrast, a house icon on a Web site page will take a reader to the home page of that particular site. In addition to these icons, the browser has a printer icon that when selected will print out Web pages. Binoculars are the icon for searching, and a stop sign stops a page from loading. Text underneath the visual icon indicates its function.

Words vs. Images

Computer interfaces combine words and images. Words refer to objects and ideas. They describe and invoke. However, they can never represent visual presence in same way that pictures can. Mitchell (1994) states, "Words can 'cite,' but never 'sight' their objects" (p. 152). Although we live in a culture with a proliferation of images, it is also a culture that emphasizes use of the written word. Traditionally there has been a difference between text and image in American education. Mitchell (1994) states, "The corporate, departmental structure of universities reinforces the sense that verbal and visual media are to be seen as distinct, separate, and parallel spheres that converge only at some higher level of abstraction" (p. 85).

In education, there is a visualist/verbalist debate, which revolves around how we perceive images of the world and then construct representations through language, image, and numbers. Extreme verbalists deny that mental images exist in and of themselves because ideas need to be thought about through words. In contrast, visualists believe that images are a distinct form of mental representation. This debate has raged for a number of years, and it mirrors the traditional dichotomy of image and text that exists in education. Postman (1979) describes the difference between verbal and visual information as follows:

> Language is, by its nature, slow moving, hierarchical, logical, and continuous. Whether writing or speaking, one must maintain a fixed point of view and a continuity of content; one must move to higher or lower levels of abstraction; one must follow to a greater or lesser degree rules of syntax and logic. ... Imagery is fast moving, concrete, discontinuous, alogical, requiring emotional response; its imagery does not provide grounds for argument and contains little ambiguity. There is nothing to debate about. Nothing to refute. Nothing to negate. There are only feelings to be felt (p. 72).

The logical order of text versus the emotional impact of images is a reason why so-called serious Web sites tended to be text-oriented rather than image-oriented. However, extensive research in visual cognition is now linking visual perception to cognition and discovering neural mechanisms for visual object identification. For example, the work of Kosslyn (1994) has successfully enunciated the theoretical justification for adopting visual mental imagery as an element of cognitive processing (also see Barry, 1997). As a result, more Web sites are becoming visually oriented.

To help develop visual ability, Houghton Mifflin developed a series of K-8 social studies textbooks in which the visual information was equally as important as the verbal information. Pictures along with words explained social studies con-

cepts. According to Laspina (1998), the visual learning component of these text-books was created to formalize children's visual abilities, which are normally informally learned. For instance, most children develop their visual skills by watching television.

Newspapers also illustrate visual/verbal biases. Newspapers with high credibility often contain more text than graphic information. Print media that are primarily text-based with few pictures tend to be considered more "high class" and reliable because the stories are presented in more detail, such as in *The New York Times* or *Wall Street Journal*, which are becoming more visual with pictures. Additionally, newspapers that use pictures and large provocative headlines are literally designed to sell the paper to a more television-oriented audience. The catchy images grab attention in an effort to sell the media product. However, one newspaper that attempts to combine the use of pictures and legitimate news stories is *USA Today*. It is designed to reach a visually oriented audience. As digital technology makes it easier to design visual information and mix it with text, print media are gradually becoming more visually oriented.

Visual Literacy

Graphic designers can control the structure of the way in which visual information is organized and structured for the viewer. Rhee (1977) contends, "The way knowledge is structured and organized has important consequences for the use of knowledge in information processing" (p. 43). How visual images are arranged for viewers can persuade people to think, act, and behave in certain ways. The role of the graphic designer is to combine signs, symbols, words, and pictures into a total message. Meggs (1989) describes the graphic designer as follows:

> The graphic designer is simultaneously message maker and form builder. This complex task involves forming an intricate communications message while building a cohesive composition that gains order and clarity from the relationship between the elements (p. 1).

A difference between graphic design and other forms of visual art is the communicative function of the design. Some designers view their assignments as visual problems. For example, Gill (1981) was given an assignment to design a department store counter display for slippers. He turned the creative problem into the following question: What holds slippers? Answer: A dog. Therefore, the visual

solution to this assignment was to design display holders that looked like a dog holding slippers.

Many corporations hire design firms to create visual identity guidelines to be applied to all of their graphic communication. Corporations want a consistent application of their visual symbols to convey a strong and cohesive presence for their company in today's media environments. Logos and their visual representation are a major concern to corporations. For this reason, many corporations have asked students to remove logos from their Web sites because they are not properly displayed. Although we see the corporations' logo elements in visual communication messages every day, the basic design system applied to the message is not always apparent. Understanding how designers arrange elements on a page is part of the visual literacy learning process.

Graphic designers balance signs, symbols, words, and pictures into a visual hierarchy that leads the eye through the message. Web design adds navigation and the hypertext organization into this mix of visual and verbal elements. A good design will lead the eye through the message and viewers are not always aware of how this happens. Similarly, when you look at Web pages that have a consistent visual look, they convey a stronger sense of cohesive presence and credibility. To better understand how and why designers construct visual messages, people must become more visually literate.

Visual Literacy Basics

Visual literacy is necessary to understand visual messages. "Visual literacy is defined as a holistic construct that includes visual thinking, visual learning, and visual communication" (Suh, 1999, p. 13). Visual literacy theories deal with visual language, visual thinking, visual learning, hemispheric lateralization of the brain, mental imagery, levels of abstraction, cultural interaction, interactive theories dealing with symbol systems, and dual coding. Dual coding theory contends that cognition is served by two modality-specific systems for representing and processing information concerning nonverbal objects and language. One subsystem processes verbal information and the other processes visual information. In the mind, the interrelationships between these two subsystems support the dual coding of information. "A basic premise of DCT [Dual Coding Theory] is that all mental representations retain some of the concrete qualities of the external experiences from which they derive" (Sadoski & Paivio, 2004, p. 1330). Thus, we can learn from visual as well as verbal messages because there are two codes.

Miller (1998) contends, "Ultimately, students need to learn to read visuals with the same critical eye that they read texts" (p. 44). Similarly, Foss and Kanengieter (1992) argue that visual communication should be included in any basic course on communication. Their method describes three basic steps in the process of understanding visual messages: (1) identification of the presented elements, (2) processing of the elements, and (3) formulation of the message. Elements are listed and then grouped and organized. Finally, the groups are put together to form messages. Additionally, the aesthetic arrangement of elements can convey emotional connotations. For instance, balanced versus unbalanced layouts evoke different emotional feelings. Looking at the elements of a piece of visual communication and how they are arranged is an integral component of visual literacy.

Today, we live in a world full of visual media—television, newspapers, magazines, billboards, and the Internet. These media are filled with messages that fight for our attention. "While graphics can be used as 'hot spots' that allow users to traverse a Web hypertext link, it is also common for the role of graphics to be aesthetic or used to convey implicit information, such as a corporate image" (Diaper & Waelend, 2000, pp. 163-164). Designers use many visual techniques to capture and hold our attention. These techniques include layout, color, movement, typography, metaphor, and remix. Visually literate viewers better understand how images can be manipulated to make us think and feel different emotions.

Layout

The layout of a design can capture a viewer's interest and evoke emotional feelings. Laying out the art and copy on a page is a visual skill. The task is to place a variety of elements into an eye-catching and unified relationship. Some of the aesthetic principles from fine art, such as balance, contrast, and proportion apply to layout design. According to Miller (1998), in academic texts, "The size and layout of the visuals signal the importance of the content, while the color helps call attention to the content as well as symbolize ideational meanings" (p. 45).

A technique for creating balanced layouts of images and text is the grid system. Dividing a page into a grid structure with modular units creates a systematic balance for layout arrangements. Contrast is created by placing images over several modular units and leaving other modules white. The grid provides a framework for a wide variety of different designs and it creates continuity between pages. But the designer must make careful decisions about the size and placement of elements on the grid and the relationships between elements.

A visual hierarchy is a group of visual (and verbal) elements arranged according to emphasis in a layout. Emphasis is accomplished through contrasts, which stress the relative importance and separation or connection of graphic elements. Advertisers want to design layouts that visually stress persuasive messages. Visual literacy is learning to decode visually persuasive hierarchies and layout techniques.

Visual hierarchies are created to enhance the overall communication message. According to Reynolds, Gengler, and Howard (1995), "The content and structure of certain types of information in an ad message provides personally relevant meaning to a recipient, which determines brand persuasion" (p. 257). For example, to create a visual hierarchy in an advertisement, the designer must decide which component is the most important, less important, and least important. The most important element is generally either type-dominant or image-dominant. When the key selling message of the advertisement is stated in the headline, a type-dominant approach is used. In contrast, if a picture of the product is the most important selling point of the message, an image-dominant approach is better. Thus, the purpose of a visual hierarchy is to focus the eye on the most important component of the message being communicated.

Additionally, the balance or unbalance of a layout can make a viewer feel comfortable or uneasy. Establishing a visual hierarchy, balancing or unbalancing elements on the page, and placing elements on a grid can all evoke feelings relating to the visual message being communicated in a piece of visual communication. Good designers know how to evoke the feelings they want to communicate about a product or service through their selection of images, type, layouts, and colors.

Color

The use of color is another way that graphic designers direct our attention. According to designer Roger Black (1997), in a color hierarchy, the first color is white, the second color is black, and the third color is red. White is the best background color because black holds the highest contrast to white. The contrast between black and white makes pages easier to read. Designers who are concerned about legibility issues will try to avoid putting yellow type on orange backgrounds because there is not enough contrast between the figure and the ground to read the text. Contrast between colors on a page both draws attention to page elements and enhances readability. A good Web design will consider the ability of viewers to easily read text and symbols on a site.

After white and black, the next important color is red. According to Black (1997), red is the best color because:

> Yellow won't read against white, blue fades against black. But red is perfect. Red headlines sell magazines on newsstands twice as much as any other color. There are certain hard-wired facts about human visual response that you'd be a fool to ignore. Like instinctive reactions to colors. Red is nature's danger color and is a great way to add accent to a black-and-white page (p. 36).

Additionally, colors have symbolic connotations and some of these associations are culturally specific. For example, wedding dresses are white in the United States and often red in China. Red is also a color of danger and warning in the United States. It is used in stop signs and for fire engines because red captures our interest. Color can help communicate nuances of meaning that scream out for attention or whisper quietly in the background. But, these meanings are understood within cultural contexts. In American culture, designers tend to use bright colors in small areas to accent or highlight. In contrast, pale or dull colors are applied to large areas as a subtle tint.

Warm colors—red, yellow, orange—are more dynamic and active. They tend to attract more attention than cool colors—blue, green, purple. But in addition to having different levels of visual attraction, colors also have cultural connotations. White (1990) states:

> Innumerable surveys have been made, and studying and understanding reaction to color is an important science because purveyors of goods and services rely on these reactions to succeed in the marketplace. There are some useful pointers, for instance:

> Sugar is never packaged in green, because green carries connotations of sourness. It is packaged in blue, because blue is a color we associate with sweetness (p. 22).

However, not all colors have the same associations to all people. According to Burmark (2002), "Every culture on the planet lives in a world whose colors have assumed powerful metaphorical significance" (p. 31). When colors have an associated meaning, they can help to communicate an idea. For example, in the early days of Web design, black was the normal default color for text, and blue text generally meant that a link was connected to it. By clicking on the blue type, another page would be revealed. After the blue text was selected, its color would change to purple to indicate that it had already been selected. In contemporary Web design, selected links just usually change color.

The colors a Web designer uses can help to set a tone for the page. When analyzing Web sites, people should check to see if the colors support the verbal information being conveyed. A series of questions can be asked to better understand how color is used on a Web site. Does the site use basic default colors (blue and black text with a gray background) and convey basic information? If the site features green, does it discuss money, financial matters or environmental issues? If the site uses black backgrounds with reversed type, is it describing a serious topic or issue? Sites that use a rainbow of colors tend to create a visual "circus" effect and consequently tend to be taken less seriously. Simply stated, do the colors selected for the site match the type of textual information being presented? If there is a conflict between the colors and the message, the site may appear to be less credible.

Typography

Similar to colors, typefaces can have associated cultural meanings called typographic resonance. Typographic resonance is the connotative properties that typefaces possess in addition to their function as an alphabet. These connotations are developed through historical tradition, associations relating to the use of the typeface, and optical properties. For example, the typeface used in elementary school textbooks is generally Century Schoolbook. This is a serif typeface or a typeface that has a light line or stroke at the end of the letters. These strokes make alphabet letters easier for beginners to read. As a result of how it is culturally used, the Century Schoolbook typeface is often associated with the idea of schools and education.

Designers can also intensify a message by adding optical properties to type or by using historical typefaces. A simple optical effect is making a word bold to emphasize it. For example, students know that words set in bold in a textbook are important terms that should be studied to prepare for tests. Similarly, typefaces designed to look like handwriting (script) are generally used for personal invitations. This style of type is less formal and more difficult to read; therefore, it is not used in books for long, textual passages. Over the years, a number of different styles of type called "headline" or "display" type have been designed to add more decorative characteristics to type styles. As the name suggests, headline type is used for large headlines because when it is reduced down to the size of reading passages its special decorative features visually blur together and make the letters difficult to read. Headline type is designed to grab the reader's attention.

Whether or not a site is readable impacts its credibility. Currently, it is difficult to read some typefaces on a computer screen; therefore, some browsers are set with a default serif typeface because serif type has stronger character differentiation. However, non-serif type is now gaining more popularity online and some find these typefaces easier to read. Web designers who want people to read the text will try to make it legible or easy to print out. Moreover, sites with full texts of important information or texts that have been converted from print to electronic formats will often have a printing option. A printing option is an indication that the designers of the site think the material is valuable enough to be saved, printed, and read like traditional print-based media.

When visually analyzing a Web site, look to see if it has taken the following into consideration: People who write in capital letters do not always realize that it is difficult to read. More important, it is bad netiquette because in online chat and discussion groups writing in all caps indicates shouting. If someone is shouting his or her message on a Web page, it implies a lack of manners and low credibility. Thus, some of the behavioral habits established in text-oriented Internet communication apply to Web sites.

Movement

Type and images are digitally combined in Web sites. When the Internet was initially developed, it was primarily text-based and used as an academic and research tool. Student access to information available on the Internet was primarily through educational accounts. The text-orientation and use of the Internet within the context of education made it appear to be a serious academic medium. However, once the World Wide Web added point-and-click visual interfaces and graphics, the Internet began to resemble mass media, such as television and newspapers. As a result, the context of the Internet began to change. Today it is more difficult to visually distinguish between academic and commercial online information. Currently, the Internet is filled with remix, distracting graphics, and advertising.

Josephson (2004) used eye tracking to study eye movement on Web pages. She discovered that location is a strong variable in determining whether or not a user looks at banner advertisements, but that users are also visually attracted to banner ads with animation. When a moving image is placed on a Web page, it tends to grab our attention. Black (1997) describes adding video to a Web design as follows:

There are certain hardwired facts about human visual response that you'd be a fool to ignore. Like if you put video on a page, a reader won't look at anything else. As animals we've evolved to be aware of any motion around us. It might eat us—or it might get us something to eat (p. 121).

Web advertisers are aware of the impact of movement on a Web page. As a result, advertising banners displayed on Web sites that use animation are designed to grab our attention. Web advertising banners are deliberately designed to pull our attention away from the content of a site. Following the pattern of commercial media, some Web sites sell advertising space to help financially support their site. Presently, the Web is a medium still in development with new types of multimedia applications being created for it. Moreover, the Web disseminates both entertainment and information. At times it is difficult to determine, what type of information is being presented.

In other types of Internet advertising, the advertising pops up in a window that covers the page or appears in between page loads. Users have to close these pop-up windows on their computer screens. Good Web design will take you to relevant information within three mouse clicks; in contrast, manipulative designs will trap you in the site. It becomes difficult to link to another Web site or page. Moreover, "there are times when the presence of graphics will be in conflict with the user's goals in that they cause users to be distracted from their main task" (Diaper & Waelend, 2000, p. 164). Graphics can be used to both help people navigate a page and distract them from their task.

Metaphor

There are so many types of Web sites on the Internet that it helps to determine what type of site is being looked at—advocacy, business, information, news, personal, or entertainment (see Radford, Barnes, & Barr, 2006). News Web sites often attempt to visually parallel their mass media counterparts such as The New York Times site or CNN, which includes many video and audio clips. "Many Web sites are riots of diverse media forms—graphics, digitized photographs, animation, and video—all set up in pages whose graphic design principles recall the psychedelic 1960s or dada in the 1910s and 1920s" (Bolter & Grusin, 1999, p. 9). As Bolter and Grusin (1999) argue, many Web sites incorporate or remediate elements of earlier media. Familiarity with the mass media counterpart is helpful for understanding the purpose of a site and the type of information it contains. Moreover,

an understanding of the traditional medium sponsoring the site can help to determine the site's credibility.

Entertainment sites use visual metaphors that suggest the ideas of film, games, or fun. News sites attempt to have a more serious look and use visual elements from newspapers or magazines. Web designs and Web browsers are full of visual metaphors that represent physical objects and actions, such as the previously discussed "desktop metaphor." However, the use of online metaphors such as the desktop can be confusing, and it is helpful to understand how metaphor works.

A metaphor is a figure of speech in which one thing is spoken about in terms of something else. Simply stated, it is a comparison between things that are dissimilar. For example, if you compare a Macintosh computer to a Windows computer, then you are making a literal comparison between similar things. In contrast, if you say that a computer is like a thinking mind, then you are making a metaphor. Similar to a linguistic metaphor, a visual metaphor points a resemblance to something else. These metaphors can have a dual meaning.

"Metaphoric pictures present two meanings: one false, the other intended. Understanding the perception of pictures requires a 'mentalist analysis' in which assumptions are made about the experience and mental processes of the sender and the receiver" (Anglin, Towers, & Levie, 1996, p. 759). Understanding metaphors is based on a cognitive recognition of how two very different elements relate to each other. "Metaphor is often used in oral discourse that is instructive or persuasive. In persuasive discourse, speakers use metaphors to frame situations for their audiences. ...Metaphors that are widely circulated in popular discourse (e.g., the national news) can conventionalize unfamiliar or controversial values and practices, rendering them less vulnerable to scrutiny and criticism" (Kaplan, 1990, .p. 38).

Similarly, metaphors are frequently used in Web design to help frame the context of the site. Siegel (1996) describes this use of metaphors as follows:

> A strong metaphor can guide a visitor and glue a site together. Metaphors must be familiar, consistent, and appropriate for the modem speeds of the Web. Metaphors pull in visitors, making them feel at home while giving them features to explore. Examples of metaphors include galleries, comic strips, television channels, magazines, tabloids, store environments, museums, postcard racks, amusement parks, inside things (computers, human body, buildings, ant farm, and so on, safaris, cities, and cupboards). These can be done well, or they can be overdone (pp. 35-36).

The visual metaphor applied to a Web site needs to be examined. Metaphors must be appropriate for the audience. For example, an arcade-like metaphor would

not be appropriate for a virtual library or online magazine, unless it is a magazine about arcade games. Good metaphors will make a site easier to navigate; conversely, bad metaphors will expect the user to learn a new set of commands to enter, making it easy to get lost. Simply replacing words with visual icons does not make a metaphor. The metaphor should be clear on the opening Web page and remain consistent throughout the site. Identifying the type of metaphor used in a site will also help to identify the target audience and purpose of the site. Identifying the purpose of the site will help users determine both the credibility and usefulness of the information contained on it.

Remix

All of the above elements are used to create *remix* or *mashups*, which are a new type of visual presentation of information on Web sites. Digital media is needed to create remix. Remix is the ability of computers to combine text, video, images, and sounds together, and mash-up is a term used to describe a remix of digital data. Remix creates a new culture that is emerging on social networking sites such as Facebook, MySpace, and YouTube. The term *remix culture* was coined by Larry Lessig (2008) to describe a new type of digital artform. When we examine the cultural aspects of remix, we see that it is not just video. Remix is a process that is also being used to create books from the mashup or juxtaposition of quotes next to each other (see Kukutani, 2010).

The author of a new text is David Shields and the title of his book is *Reality Hunger (2010)*. Shields's pasted-together book and defense of appropriation underscore the contentious issues of copyright, intellectual property, and plagiarism that have become prominent in a world in which the Internet makes copying and recycling as simple as pressing a couple of buttons (Katutani, 2010, para. 4).

Remix challenges our notions of what copyright is. Currently, record and movie companies own the copyright to parts of our culture. Remix questions who owns the rights to culture. Snippets of cultural icons from movies with excerpts from musical recordings are juxtaposed together to create a new work. The visual ways in which the images and sounds are combined generate a new message. This new form of art needs to be added to our concepts of visual literacy and it uses many of the concepts previously described, such as color, layout, movement, and metaphor. Because remix is a new style of digital visual message, people need to develop critical skills for understanding remix and Web sites.

Developing Critical Web Awareness

All of the basic visual literacy skills apply to the analysis of a Web site. However, a visual analysis of a Web site also requires the viewer to look at the balance between design, usability, and navigation. Web sites created with a specific purpose and audience in mind are much easier to identify than general purpose sites intended for use by many different audiences. When entering a site, the viewer should try to determine the audience and purpose of the site. Functionality of a site can be diminished when users are unclear about the purpose and the type of information available. In contrast, visual designers try to enhance the look and accessibility of information located on a Web site. In Web analysis, some of the practical style guidelines for graphics designers have been adapted into critical questions to develop better visual literacy skills. Using these questions as a guide will enable users to critically examine Web sites from a visual perspective.

Design Questions

Sites designed for the access of information will make the amount of content located on the site clearly known. Additionally, the type of information available should be organized into logical units or document groups to help users find the materials located on the site. Moreover, the purpose and goals of the site should be clearly articulated. By turning aspects of site design into questions, users can conduct an analysis of a Web site. The following are questions relating to the graphic elements on the site that should be considered in conducting a visual analysis of a Web site:

- Are the graphics designed to grab attention, rather than provide information?
- Are the images being used as a form of visual persuasion to make users think or feel a certain way?
- What type of emotional messages do the images convey?
- What type of visual/verbal metaphors are being used in the site?
- Do images complement and support the text?
- Is the visual hierarchy and relationships among units obvious?
- Is the typestyle readable? Is there enough contrast between the text and the background to print out?
- Is the type broken up into small paragraphs to make it easier to read?

- Does the type have different weights, such as bold and italic, to make it easy to skim the page for important points?
- In remix, do the juxtaposition of the image and sounds create a different message than the individual elements of the remix?
- How does the artist use the juxtaposition of elements to create this new message?
- What types of cultural images, sounds, and text is being used in the site?

Usability Questions

A site that is well-designed will look more credible and reach its intended audience. To make a site work well, the designer needs to understand the Web medium. For example, pages should be designed to fit the audience's reading styles, and designers must understand how people are going to use the information. This includes understanding whether or not people are going to read online, download information into text files, or print it onto paper. The design of a site will impact on the site's usability. For example, computer users do not like to scroll through long texts. Users do not like to scroll. Therefore, large scrolling screens reduce the functionality of a site. Here are some critical questions to ask about the usability of a design:

- Is the information designed to be read on the screen or is there a printing option to download the material and print it out on a printer?
- Does the site indicate the volume of information contained in the site?
- Is the information arranged into logical units and document groups?
- Does the site have great graphics, but little information? Is it good looking but not functional?
- Does the site have a consistent look and feel? For example, are the headers and footers in the same location on every page?
- What types of logos are on the site? Are they corporate logos, software company logos, or another type of logo?
- How do the different types of logos relate to the site theme and information presented?
- Is the page designed for the computer screen? Or do users have to scroll through text?

Navigation Questions

Web users have multiple choices in how they select the order of pages they access on a Web site. As a result, users can read pages in ways the author never intended. For the author, "questions of navigational design become paramount" (Papson, Goldman, & Kersey, 2004, p. 1,620). A good Web design will consider the needs of the user and logically organize information in ways that make information easy to access.

The ability to easily find information within several mouse clicks is an indication that a site is designed for functionality. Moreover, well-designed sites will have escape links to take users back to the home page of the site. Sometimes when doing a search, users can end up in the middle of a site. They should be able to look for a visual or verbal link to the site's home page to find out more information about who is sponsoring the site and why. If users can't find a link or more information, the information should be checked with another source. The following are critical questions based on design functionality:

- Does the site use typical Web conventions, such as type changing colors when links are selected?
- Can you find relevant information within three mouse clicks?
- Does the site provide its own internal search engine?
- Is the site easy to navigate? What navigation features are included in the site?
- Does the site use images to help users navigate?
- Does the site provide a site map?
- Do users know where they are on every page? Does every page provide an escape to the home page or the beginning of the site?
- Does each page have an identifying name (or logo), date, and contact e-mail address?

Finding a balance between design, usability, and navigation can be difficult. For example, librarians who create sites often have to choose between overloading a page with information and organizing information into units that require additional mouse clicks to access. As a result, some highly legitimate sites with valuable information are not visually pleasing. On the surface, these pages don't attract our attention. We have to carefully read the text or scroll down the screen to functionally use the site. However, clever use of pull-down menus can provide users access to information and present an organized and aesthetic home-page design. Don't judge a Web site by its flashy graphics. Remember that usability and naviga-

tion may be more important to a designer than moving images. However, in remix the moving images can help to create the overall message. However, remix is often designed to entertain rather than attract attention.

Conclusion

Common sense, awareness of visual design techniques, and visual literacy enable users to better understand how Web sites convey visual messages. A more detailed examination of remixed messages can help us to understand how the individual elements in the work are combined to create a new message. As the Web continues to become a mainstream medium with new types of sites, artforms, and applications, users need to develop a set of critical visual skills to understand how Web images can be used to facilitate navigation, manipulate feelings, and persuade viewers to think and feel in certain ways. Remix is often designed to do the latter.

By asking questions about the design, usability, and navigation of a Web site, users will develop visual literacy skills for analyzing Web sites and remix. The credibility of information is reflected in how the designer organizes information on a page or in a video and presents it to the user. Images and typefaces have cultural connotations and their own shades of meaning that can influence how a Web site or remix is understood. Paying attention to all of these different visual elements will turn viewers into visually critical Web users.

References

Anglin, G. J., Towers, R. L., & Levie, W. H., (1996). Visual message design and learning: The role of static and dynamic illustrations. In D. H. Jonassen (Ed.) *Handbook of research for educational communications and technology* (pp. 755-794). New York: Simon & Schuster Macmillan.

Barry, A. M. S. (1997). *Visual intelligence.* Albany, NY: State University of New York Press.

Black, R. (1997). *Web sites that work.* San Jose: CA: Adobe Press.

Blair, J. A. (1996, Summer). The possibility and actuality of visual arguments. *Argumentation and Advocacy, 33*(1), 23-39.

Bolter, J. D. (1991). *Writing space.* Hillsdale, NJ: Lawrence Erlbaum Associates.

Bolter, J. D., & Grusin, R. (1999). *Remediation: Understanding new media.* Cambridge, MA: MIT Press.

Burmark, L. (2002). *Visual literacy: Learn to see, see to learn.* Alexandria, VA: Association for the Supervision and Curriculum Development.

Diaper, D., & Waelend, P. (2000). World Wide Web working whilst ignoring graphics: Good news for web page designers. *Interacting with Computers* 13, 163-181.

Foss, S. K., & Kanengieter, M. R. (1992). Visual communication in the basic course. *Communication Education*, 41(July), 312-323.

Gill, B. (1981). *Forget all the rules you ever learned about graphic design including the ones in this book.* New York: Watson-Guptill Publications.

Josephson, S. (2004). Eye-tracking methodology and the Internet. In K. Smith, S. Moriarty, G. Barbatsis & K. Kenney (Eds.) *Handbook of visual communication* (pp. 63-80). Mahwah, NJ: Lawrence Earlbaum Associates.

Kaplan, S. J. (1990). Visual metaphors in the representation of communication technology. *Critical Studies in Mass Communication*, 7, 37-47.

Kosslyn, S. M. (1994). *Image and brain.* Boston, MA: MIT Press.

Kukutani, M. (2010, March 17). Texts without context. *The New York Times.* Retrieved March 18, 2010, from www.nytimes.com.

Laspina, J. A. (1998). *The visual turn and the transformation of the textbook.* Mahwah, NJ: Lawrence Erlbaum Associates.

Lessig, L. (2008). *Remix: Making art and commerce thrive in the hybrid economy.* New York: The Penguin Press.

Meggs, P.B. (1989). *Image & text: The language of graphic design.* New York: Van Nostrand Reinhold.

Miller, T. (1998). Visual persuasion: A comparison of visuals in academic texts and the popular press. *English for Specific Purposes,* 17(1), 29-46.

Mitchell, W. J. T. (1994). *Picture Theory.* Chicago: The University of Chicago Press.

Papson, S., Goldman, R., & Kersey, N. (2004). Web site design: hypertext aesthetics and visual sociology. *American Behavioral Scientist,* 47(12), 1617-1643.

Postman, N. (1979). *Teaching as a conserving activity.* New York: Dell Publishing, Co.

Postman, N. (1985). *Amusing ourselves to death.* New York: Penguin Books.

Radford, M. L., Barnes, S. B., & Barr, L. R. (2006). *Web research. selecting, evaluating and citing, 2nd Edition.* Boston: Allyn & Bacon.

Reynolds, T. J., Gengler, C. E., & Howard, D. J. (1995). A means-end analysis of brand persuasion through advertising. *International Journal of Research in Marketing,* 12, 257-266.

Rhee, J. W. (1977). Strategy and issue frames in election campaign coverage: A social cognition account of framing effects. *Journal of Communication,* 47(3), 26-48.

Sadoski, M., & Paivio, A. (2004). A dual coding theoretical model of reading. In R. B. Ruddell & N. J. Unrau (Eds.) *Theoretical models and processes of reading* (5th edition), (pp. 1329-1362). Newark, DE: International Reading Association.

Shields, D. (2010). *Reality hunger: a manifesto.* New York: Knopf Publishing Group.

Siegel, D. (1996). *Creating killer web sites: The art of third-generation site design.* Indianapolis, IN: Hayden Books.

Suh, T. (1999). Visual persuasion. *Communication Research Trends,* 19(3), 3-17.

White, J. V. (1990). *Color for the electronic age.* New York: Watson-Guptill Publications.

Epilogue

An Interview with Hillman Curtis

Amanda Carlson
Sheree Josephson

Hillman Curtis is a filmmaker, designer, and author whose company Hillmancurtis, Inc. has designed Web sites for Yahoo, Adobe, Aquent, the American Institute of Graphic Design, Paramount, and Fox Searchlight Pictures among others. His film work includes the popular documentary series "Artist Series," as well as award-winning short films. His commercial film work includes spots for Rolling Stone, Adobe, Sprint, Blackberry, and BMW. His three books on design and film have sold close to 150,000 copies and have been translated into 14 languages. Hillman's work has been featured in numerous design publications worldwide. He has also lectured extensively on design and film subjects throughout Europe, Asia, and the United States.

Web site usability is dealt with by both Web designers and users. Designers seek to create a site that is functional and serves its purpose, while users ultimately judge the effectiveness of the designers' creation. Good usability is a crucial component to the success of a Web site. Designers must consider a host of factors when deciding what to implement into their design. These factors might include color schemes, layout, video, motion, navigation, and many other considerations. Not all Web sites that have a good usability history emphasize or use the same components in a similar way because each design is created to meet a specific purpose, theme, and branding idea.

For this chapter, we posed various questions to internationally recognized Web designer, filmmaker, and author Hillman Curtis about Web design. His responses provide professional insight into designing, keeping to a theme, and meeting the purpose of a Web site. Curtis also explains what has worked well in Web

sites he has designed and what he believes works well in other Web sites he hasn't designed. Our questions also uncovered other issues designers have to face and new options designers might use in maximizing the usability of their Web site.

Q&A Transcript from Hillman Curtis Interview: August 26, 2008

Q. Amanda: What process or methods do you go through as you design a Web site to make sure it's the most usable for your audience?

A. Hillman: My process is that I first work with the client to figure out what the central function of the Web site is and what job it has to do. Then we look at the theme of whatever the brand is for the person, place, or company. With those two things (I talk a little about this in my book), I actually start to identify a target— usually a target phrase or a couple of phrases, and that just comes from discussion with the client. But the most important thing is thematic and also functional. The next thing I do is generally build. I'm very much into the Josef Muller-Brockmann kind of grid, which is a Swiss design of the late '50s and '60s. I very much believe in grids. The next thing I'll do is actually start gridding out a comp in PhotoShop. Then comes what I call the suffering: It's the time to figure out what design is going to work for this site. There's just no way around it. You just have to pound through the bad ideas and the bad design. It helps to have this process in place, knowing that I am probably going to have to suffer a little before getting it right.

I'm also always aware of the importance of identifying a theme to guide the design. All companies and products are based on a story and a theme, and as a designer it's my job to kind of point to that theme at all times. Sometimes after we work with the client to determine the theme of their brand/company/product, we'll literally write that one phrase or the two words or whatever we come up with on sticky notes and paste them onto our computer monitors as we design. Having these things in place keeps me on track: the grids, the theme, and the targets.

Then, quite frankly, it's just the week or two of bouncing the visual ideas, info architecture, and interactive logic back and forth between a client and myself and my team until we land on something that we can feel good about developing over the course of the site. I should add that even once we have that, with these bigger

sites, a lot of the stuff goes out the window as we get deeper and deeper into the various functions of the site.

Q. Amanda: What do you consider to be great visual design in a Web site?

A. Hillman: The Web sites that I'm most attracted to are the ones that work really well. I think the purely visual sites can work. If it's like a Nike site or a movie site and its job is to create excitement around a product, then the visuals need to work in that manner. If it's a site that's trying to get you from A to B, then the visuals are generally going to take sort of a backseat, well that's the wrong word... backseat is not the right word... the visuals are going to serve that purpose. So, it's hard to answer what I think is great visual design. I guess the only answer is that it is visual design that supports the theme and the purpose of the product.

Q. Amanda: How do you evaluate the success of your Web page design?

A. Hillman: Whether I feel like having a big glass of red wine every time I see it. If it's good I want to celebrate it.

There are the obvious things, like the metrics. Our Met Opera redesign increased ticket sales. That was a clear success. The visual design of the Met Opera was also a clear success. That's a positive example. I'm trying to think of a negative one to counter, but first [let's discuss] the Met Opera. We came in and we did everything that I talked about, which is we spent a lot of time with Peter Gelb and his team trying to figure out what they were after. An obvious goal was they wanted it to sell tickets; however, the primary goal Peter Gelb had was to just open it up. Open up the Met Opera so that this art form, which is perhaps elitist in many people's minds, would be opened up. His goal was to try to communicate that it was an art form so that people who would go down to the open galleries in Chelsea would consider opera as well. I like what we did with it. I think we respected the logo types that Paula Scher of Pentagram came up with. We made it functional. It was clear and easy to navigate. We respected the demographic of that site, which is older, but at the same time gave it a more contemporary look. I'm very proud of the way it works, and I'm very proud of the way the information is organized and the clarity of navigation. It's also successful because ticket sales jumped 64% within the first three months of launch and continue to grow. So

that's one of those ones where we did a good job, and I can look at that one from every angle and always be happy.

The Yahoo home page (see Figure 1) we helped design was a success for a number of reasons: it increased the time people stayed on the home page, the traffic was up a little bit, and the numbers that came back were really good. The design I think is not—and this goes back to your earlier question—a visually beautiful design like I think the Met Opera is but it's functionally successful.

Figure 1: Yahoo.com home page

Q. Amanda: I've heard you talk about navigation, especially with the Met Opera. Do you think navigation is one of the bigger mistakes that is made today in terms of designing Web pages?

A. Hillman: I think that navigation is obviously the cornerstone of a Web site and its functionality. You have a lot of information and people need to get to that information. The navigation can be as simple as a search box and as complex as a multi-layered Flash-based navigation. It's a crucial step and we spend a lot of time trying to get it right, especially with these larger sites that we've been doing for the last few years. You know if you get it wrong. It's going to catch up to you in the latter stages of the design. The navigation is not to be overlooked and certainly should never ever be secondary to any kind of visual design or any kind of flashy messaging or anything. People appreciate something that works well and that is as strong a brand attribute as you can give someone.

Q. Sheree: During the design process, what do you do to make sure your Web site design works?

A. Hillman: Well, I mean again there are a number of things you can do and it may be sort of the mundane, not mundane, but corporate, let's put it that way. Like when we did the Yahoo site, we would sit behind one-way glass mirrors and watch people interact with our designs. Then there's the one where you just go with your gut. With something like the Yahoo, it had to be judged and measured on focus groups, which is good and bad. On something like the Met Opera, I don't know how we knew we had it right. It was so simple and we really weren't reinventing the wheel or anything. It's a global navigation and then it has a left side sub-navigation. It's a standard navigation system, but it does demand limitations.

With the Met Opera global navigation, I said we couldn't have more than six or seven links. That sounds sort of strict, but part of my job as a Web designer is to set limitations and force my team and the client team to work within those limitations. If, for example, you have 15 links on a global navigation it defeats the purpose. This is the same with the sub-navigation. If you're loading up a left-hand navigation and you've got 30 links there it becomes counterintuitive. That's one of the things we did with Yahoo. We designed the left-hand network navigation that's currently there and it's cut down considerably. They used to have a vertical system with 20 to 30 links in there. No one could find anything—at least not quickly. With this one we just set some limitations and had the teams work within

it, and we leaned on technology a little bit too, so that the left-hand navigation is dynamic and reacts to what the person has been using and visiting.

The Adobe site we did a long time ago is a great example. In fact, if you go to my site and you go to Site Design, hit Adobe and then hit that little question mark on the far right of the screen shot, there's a link that will take you to the style guide and it will show you the navigation that we came up with back in 2002 or something. That one is so great because it doesn't use any Java Scripter Flash or anything and it weighs about 5K, and at the time it was really appropriate, an appropriate way for us to lead people through a very large and complex site.

Q. Amanda: What are your two to three favorite Web sites you've designed? I assume the Metropolitan Opera is one of those.

A. Hillman: I do like that one. I like a site we did called PlayIndies. I felt it was very strong. I did really like the Fox Searchlight site, which you know came out a while back. I'm proud of Yahoo, but I don't know if it's something I would hoist on a flagpole outside my office. This one Flash site for a company called Sideshow is kind of neat. It's full-on Flash and it's got some fun stuff in it. I guess I'd go with those.

Q. Sheree: What are some of your favorite sites that you haven't designed?

A. Hillman: Well, I like Obama's site a lot. The reason I like it so much is that it's thoughtful. I mean it's like everything that should be on that site is on that site. It's just one of those examples of a site that really works. So, I like that. It's a very deep site. I like the Ted Conference site. These are just sort of my recent favorites. The Ted Conference, I think, handles video really well. Again, some of the visual aspects of the Ted don't knock me out, but just the way you can consume video content and everything you want that's appropriate around that content is there. You can download the video for free, you can comment on the video, you can find out more about the speaker, and you can find related videos. All that stuff that everyone works really hard to include and often in a way that's complex and confusing, they do very nicely.

Let's see, what else do I like? I like the Google stuff. Even though it's incredibly ugly, I think it's pretty useful. I mean it's one of those ones where the technol-

ogy shines way more than the visual design, but in a way it's sort of appropriate. So, the fact that you can jump around, such as if you have a date in your e-mail it generates a little link to add it to your calendar and all that kind of stuff. It's kind of cool.

Q. Amanda: I know that you also do a lot of videos, and you referred to one of the sites that you really like as the Ted Conference with the videos. What's best for a Web designer to keep in mind when implementing video on a Web page?

A. Hillman: Well, bit rate. Everything that's involved in your codec, in your compression is obviously going to be really important. You want to sort of figure out what you think the appropriate bit rate is going to be for your average user. Generally, if you're going for a mid-level DSL it's going to be somewhere in the 300s. If you want to kick up the quality and do sort of an Apple thing where you assume people have a fairly fast connection or don't mind waiting a couple of seconds, then you can kick it up to 768 or something. That stuff is important.

The other thing that is important is realizing that the psychology in watching a video online, for now, is still different from TV or movie. And so, I think shorter videos are more successful online. I think it's hard to get someone to watch a 20-minute piece on the computer, with the exception of these things like the iTunes movies that you download and you're sort of putting yourself in that movie-watching state. As far as advertising and promotion and stuff like that, I think six to seven minutes is a good target length. The other thing is we're still dealing with relatively small window sizes, although that too is changing with the Flash full-screen video. So, sometimes when shooting the video it's nice to sort of park that in the back of your head, and you might avoid extreme long shots or wide shots, that kind of thing. Then the other stuff, like the Ted stuff, is allowing people to grab the video, or comment on it, or that sort of thing. The big thing is allowing people to share videos by embedding that video in their blog or Web site, or sending it to a friend. That's part of the deal.

Q. Sheree: It's kind of a research interest of mine, but I'm starting to think of the really small screens that we're starting to watch some of this stuff on. What are you doing with that?

A. Hillman: Now what I'm doing, when I'm doing films, is I'm really leaning toward the computer. All of my films are downloadable to iPods and stuff for free off my site and quite a few people are downloading them. I think they play fine on those things. I don't mind watching bits of movies on a hand-held. To be honest, it's not a huge consideration for me right now. I feel like if the film plays well enough on a Web page, then I feel like it's going to make that transition fairly well. You should go to YouTube and do a search for David Lynch.

Q. Amanda: My last question stems from what I observed on your site. I thought it was effective how you use a lot of motion and things that change on your home page. How do you think that best plays into the design of a Web page?

A. Hillman: For example, on my home page where things cycle through, for me the decision was that I wanted a really big sort of cinematic image and so that necessitated this kind of cycling business. A site like Apple uses a big image, but it's just static and it just stays there until they're ready to promote a new product. I think with all these things you just have to weigh the pros and cons. Some sites will put multiple static images with text or something to try and get as much as they can. The only other time I use motion is in the site section, so when you click through the examples they kind of slide up. Again, you weigh the pros and the cons, and there's a slight technical issue that you hit because you're loading three images instead of one, but in this case the images are so light that it's hardly even a consideration. The movement's good. The movement has its own kind of emotional resonance and sometimes I guess a quick little move like that maybe reads fresh or fast or exciting or something like that. That's why I use it. One is to communicate or basically put out more images in one space than a static image would, and the other is sort of to communicate movement, which I think is a positive thing.

Summary

In summary, Curtis believes the success of a Web site is evaluated by its ability to fulfill its predetermined purpose and ultimate use by the intended audiences. The level of success varies from site to site. While some sites are deemed successful because of their use of numerous visuals, others need more information to guide their users. There are many features a designer can implement into a site that can significantly help or hinder its ability to serve its purpose. Additional features, such as motion or embedded video can be successful enhancements to a site when used correctly and when users can easily take advantage of their full benefits. In a society where users expect quick, easy, accessible information via the Internet, a Web site will stand out only if it is determined by its audience to be functional.

About the Contributors

Sheree Josephson is an eye-tracking researcher who has studied how people process visual information on the Web, on television, and in print. She has also used eye tracking to study cross-racial eyewitness identification using police lineup photographs. She has published several book chapters and scholarly articles in journals such as *Visual Communication Quarterly* and *Behavior Research Methods, Instruments, & Computers*. She is a full professor in the Department of Communication at Weber State University in Ogden, Utah. Before she completed her Ph.D. at the University of Utah in Salt Lake City, she worked as a journalist, most recently holding the title of graphics editor at two daily newspapers in Utah.

Susan B. Barnes is a full professor in the College of Liberal Arts and associate director of the Lab for Social Computing at the Rochester Institute of Technology. She earned her Ph.D. from the Media Ecology Department at New York University and studied with Neil Postman. She is the author of *Online Connections* and *Computer-Mediated Communication: Human Communication Across the Internet* and the editor of *Visual Impact*. She is one of the editors of *Interpersonal Mediated Communication* and has written numerous articles and book chapters about the Internet, human relationships, and visual communication.

Mark Lipton is an associate professor in the College of Arts at the University of Guelph. His current work with the Media Education Project considers how Canadian teachers engage with media and information and communication technologies in the classroom to assess how ICTs function within a broader context of teaching and learning. His research interests focus on media education and include work in the history of communication, semiotics, and visual communication. Lipton taught at New York University, worked as a resource and site advisor for New York City public school teachers, taught at the Harvey Milk High School in New York City, and held the Mellon Fellowship in Visual Literacy at Vassar College. In 2009, as a result of his work with the Media Education Project, Lipton was awarded the Jacque Ellul Award for Outstanding Media Ecology Activism.

Ulla Bunz is an associate professor in the School of Communication at Florida State University. She researches issues of technological fluency and computer-mediated communication competence, gaming, and cybergeography. Her research has been published in the *Journal of Communication*, *Computers in Human Behavior*, and the *International Journal of Human-Computer Interaction*, among others. She earned a Ph.D. from the University of Kansas in 2002.

Juliann Cortese is an assistant professor in the School of Communication at Florida State University. Her research focuses on Internet use, especially as it relates to learning, health informatics, and social networks. She has published articles in *Human Communication Research* and *Patient Education and Counseling*, and published a book titled *Internet Learning and the Building of Knowledge*. She earned a Ph.D. from Ohio State University in 2005.

Craig Baehr is an associate professor of technical communication and rhetoric at Texas Tech University. He is author of *Writing for the Internet: A Real Guide to Communication in Virtual Space* (Greenwood/ABC-Clio, 2010) and *Web Development: A Visual-Spatial Approach* (Prentice Hall, 2007). He has written articles and chapters on Internet writing, online publishing, and visual communication that have been featured in technical communication journals and textbooks. He is also the recipient of the Distinguished Technical Communication Award from the Society of Technical Communication.

Valerie V. Peterson is an associate professor of Communication who writes about visual communication, rhetoric, communication theory, sex and sexuality, popular culture, and pedagogy. Her published work includes academic articles, book chapters, encyclopedia entries, and other writings on such topics as rhetorical and communication theory, visual rhetoric, argument and identity, Sophistic thought, interdisciplinarity, sexual politics, and sex manuals. She is the managing editor of *Explorations in Media Ecology* and teaches at Grand Valley State University. She has a Ph.D. from the University of Iowa.

Roxanne O'Connell has long been involved in usability, stemming from her experience working with the Software Usability Engineering group at Digital Equipment in the early 1990s. She is an assistant professor of Communications at Roger Williams University, teaching visual communication and digital media. Her media research interests include digital media, particularly blogging and podcasting, perception, and visual rhetoric. As a teacher and publishing consultant with more than 20 years of experience in design, e-commerce, and marketing, she specializes in information design, audience research and Web site usability. She is finishing a Ph.D. at Salve Regina University.

Sally Gill has over 25 years of experience as a professional in the field of media communication. Before earning her Ph.D. in communication and rhetoric at Rensselaer Polytechnic Institute in Troy, New York, she was an award-winning copywriter for Hal Riney & Partners and a senior writer-designer for a digital communication firm in San Francisco. As an assistant professor at a private university in San Diego, she developed a program in communication design for digital media. She now serves as the public information and communication specialist for the Continuing Education Division of Santa Barbara City College in Santa Barbara, California.

Susanna Paasonen is acting professor of digital culture at the University of Jyväskylä, Finland. With an interest in Internet research, feminist theory, and popular media, she is the author of *Figures of Fantasy: Internet, Women, and Cyberdiscourse* (Lang, 2005) as well as the co-editor of *Women and Everyday Uses of the Internet: Agency & Identity* (Lang, 2002), *Pornification: Sex and Sexuality in Media Culture* (2007), and *Working with Affect in Feminist Readings: Disturbing Differences* (2010).

Amanda Carlton holds a bachelor's degree in English/Professional and Technical Writing with a minor in Communication from Weber State University in Ogden, Utah. As a student, she worked as a copy editor with the student newspaper *The Signpost*. She also coordinates and designs a neighborhood newsletter and continues to work on freelance projects while staying busy raising three children.

Index

Susan B. Barnes, *General Editor*

Visual communication is the process through which individuals in relationships, organizations, and cultures interpret and create visual messages in response to their environment, one another, and social structures. This series seeks to enhance our understanding of visual communication, and explores the role of visual communication in culture. Topics of interest include visual perception and cognition; signs and symbols; typography and image; research on graphic design; and the use of visual imagery in education. On a cultural level, research on visual media analysis and critical methods that examine the larger cultural messages imbedded in visual images is welcome. By providing a variety of approaches to the analysis of visual media and messages, this book series is designed to explore issues relating to visual literacy, visual communication, visual rhetoric, visual culture, and any unique method for examining visual communication.

For additional information about this series or for the submission of manuscripts, please contact Dr. Barnes at *susanbbarnes@gmail.com*.

To order other books in this series, please contact our Customer Service Department:

> (800) 770-LANG (within the U.S.)
> (212) 647-7706 (outside the U.S.)
> (212) 647-7707 FAX

Or browse online by series at www.peterlang.com.